Richard Pousette-Dart

Frontispiece:
Richard Pousette-Dart,
Notebook, 1970

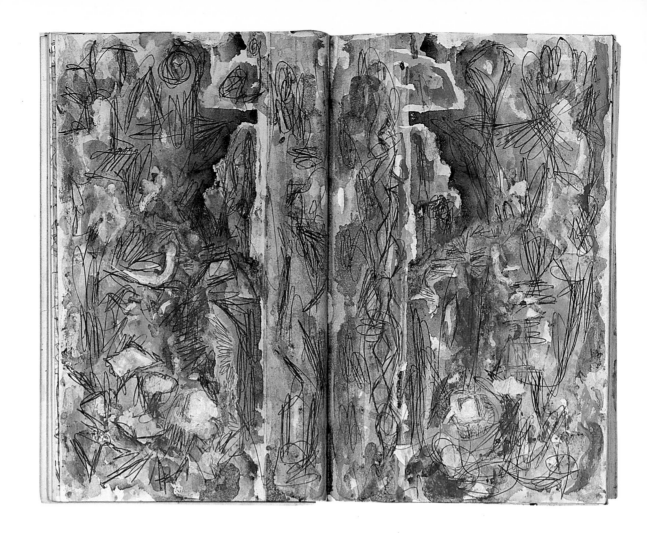

Richard
Pousette-Dart

Robert Hobbs and Joanne Kuebler

Indianapolis Museum of Art in cooperation with Indiana University Press

This exhibition was organized by the Indianapolis
Museum of Art and funded in part by the AT&T
Foundation, the National Endowment for the Arts
and the Indiana Arts Commission.

Exhibition Schedule:
Indianapolis Museum of Art
 October 14–December 30, 1990
The Detroit Institute of Arts
 February 10–April 7, 1991
The Columbus Museum, Columbus, Georgia
 September 28, 1991–January 5, 1992

Library of Congress Catalogue Card Number: 90-082236
ISBN Number 0-936260-51-3

Published by the Indianapolis Museum of Art, 1200 West 38th
Street, Indianapolis, Indiana 46208; telephone (317) 923-1331.
Distributed by Indiana University Press, Bloomington, Indiana
47405; telephone (812) 335-6804.

Designer: Nathan Garland
Editor: Debra Edelstein
Production Coordinator: Della K. Pacheco
Typesetter: Yvonne McCann
Printer: Amilcare Pizzi, S.p.A., Milan, Italy

Contents

Lenders to the Exhibition

The Detroit Institute of Arts

Hirshhorn Museum and Sculpture Garden,
Smithsonian Institution

Herbert F. Johnson Museum of Art,
Cornell University

Dr. and Mrs. Arthur E. Kahn, New York

Marisa del Re Gallery, New York

The Metropolitan Museum of Art

The Museum of Modern Art, New York

National Museum of American Art,
Smithsonian Institution

North Central Bronx Hospital
in cooperation with
New York State Facilities and
Development Corporation

Joanna Pousette-Dart

Whitney Museum of American Art

Foreword

The word "spiritual" figures prominently in nearly every review of Richard Pousette-Dart's work that has been written during the last half century. So do "transcendence" and "mystical." A reader of these reviews, knowing that Pousette-Dart had no formal training as an artist (other than what he absorbed from his talented parents) and aware of the powerful originality of his vision, might be forgiven for imagining that his work is a kind of pure emanation of the soul, without links to other art or roots in anything that has gone before. Nothing could be further from the truth. Pousette-Dart has created a unique, highly personal body of work through the pursuit of his own singular vision. But it is a vision steeped in the art of the past.

During his early years in New York, as Joanne Kuebler notes in her catalogue essay, Pousette-Dart spent many hours in the galleries of The Metropolitan Museum of Art and the halls of the American Museum of Natural History. Along with the works of van Gogh, Picasso, and Miró, he admired medieval and Byzantine art, American Indian artifacts, African and Oceanic carvings, and Luristan bronzes. Visionary American painters like Blakelock and Ryder occupied places in his pantheon alongside European Old Masters. The museum became Pousette-Dart's academy, its collections the archive in which his taste was formed and his eye sharpened.

Given the importance of the art of the past to the evolution of Pousette-Dart's own creative expression, it is hard to imagine a more fitting exhibition than this major retrospective of his work to inaugurate the Allen Whitehill Clowes Exhibition Gallery in the Museum's new Mary Fendrich Hulman Pavilion. On the floor above, the Harrison Eiteljorg Collection of African and South Pacific Art offers visitors an opportunity to see works of the kind that had a powerful effect on Pousette-Dart in his formative years as an artist. And in renovated galleries of the Krannert and Clowes pavilions, works from Asia, Europe, and the Americas take their place. Young artists from this region may find here, as did Pousette-Dart in the museums of New York more than fifty years ago, inspiration and sustenance for their own emerging creative vision.

Joanne Kuebler and Robert Hobbs, the curators of this exhibition, join me in expressing our gratitude to all who have helped make the exhibition possible: their fellow authors Donald Kuspit and David A. Miller, their colleagues here at the museum, the lenders, and especially Richard Pousette-Dart, who has not only lent many key works himself and given generously of his time, but also has created the splendid bronze door that connects the Allen Whitehill Clowes Gallery with the outside world. The door is a generous gift from Mr. and Mrs. Robert S. Ashby.

"A work of art for me is a window," Pousette-Dart has said, "a touchstone or doorway to every other human being." We are grateful to this master of modern painting for opening to us a doorway through which we can gain access to the world of his creative vision.

Bret Waller
Director
Indianapolis Museum of Art

Acknowledgments

It has been our pleasure to work with many energetic and generous people, whose spirit and dedication have helped make the exhibition and book a reality. Our most profound thanks go to Richard Pousette-Dart himself, for his creative vitality inspired and motivated all who were involved with this project.

Both Richard and Evelyn Pousette-Dart have been extremely generous in opening their house and archives to the stream of people from the Indianapolis Museum of Art who have worked on this exhibition. Evelyn Pousette-Dart has located paintings and contributed significant facts to the chronology; through her keen intellect and graciousness, she has created a stimulating and hospitable environment for her many visitors. Richard Pousette-Dart has patiently responded to repeated inquiries, allowed his sacred studio space to be invaded, and has permitted us to read and quote from his very private, unpublished notebooks and letters. We deeply appreciate Richard and Evelyn Pousette-Dart's cooperation with the endless details of the exhibition. We also wish to acknowledge the help provided by their daughter, Joanna Pousette-Dart, who is an important painter in her own right, and the assistance provided in the studio by Marlene Kleiner. We would like to express our gratitude for dedicated assistance to Joan Sonnabend, Marisa del Re, and William Maynes.

Professor Janet Kennedy first suggested Pousette-Dart as a topic for Joanne Kuebler's doctoral dissertation at Indiana University, and she has generously contributed her ideas throughout its evolution to an exhibition and book. Support for this project at the IMA during the early planning stages in 1985 was provided by Helen Ferrulli, former Director of Education. In addition Hollister Sturges, former Chief Curator, and Robert A. Yassin, former Director, both believed in the art historical significance of this project and allocated funds for initial research. We are grateful to Marcia Palmer for her invaluable assistance during the planning stages of this exhibition. E. Kirk McKinney, Jr., a member of the Board of Trustees and President and Chief Executive Officer for the two-year period before the exhibition opened, has been an enthusiastic supporter of the exhibition. And we are grateful to Bret Waller, Director of the Indianapolis Museum of Art, for his support and interest in this exhibition.

Our invaluable assistant throughout this entire project has been Harriet G. Warkel. She brought her broad knowledge of American art history to this project and worked in many capacities, including serving as a tireless research assistant and compiler of the chronology. She obtained comparative photographs from a variety of sources and oversaw a myriad of details for both the exhibition and the publication. The project would never have become a reality without her willing and highly professional assistance.

Because a number of early Pousette-Dart works are being exhibited for the first time, there has been a need for expert conservation. We have been exceedingly fortunate in being able to rely on the expertise of David A. Miller, Senior Conservator of Paintings at the IMA, who has detailed both his analyses and those of other conservators in the illuminating essay included in this publication. In addition to Miller's help, we extend our gratitude to the following members of the IMA staff: Martin J. Radecki, Chief Conservator; Claire Hoevel, Associate Conservator of Paper; Michael Ruzga, advanced intern in paintings conservation; Suellen Mazzuca, Administrative Assistant; Hélène C. Gillette, Assistant Conservator of Objects; Linda Witkowski, Associate Conservator of Paintings; and Jean Kalwara, Julia A. Dennin, and Irena Calinescu, Conservation Technicians. We are also pleased to acknowledge the assistance of the following private conservators who have treated works for this exhibition: Rustin Levenson and Harriet Irgang, New York Conservation Associates, Ltd.; Leni Potoff, Leni Potoff, Inc.; and James Bernstein, conservator in private practice.

In completing this book, we have been fortunate to have the insightful editing of Debra Edelstein and the superb design of Nathan Garland, whose sensitivity to Pousette-Dart's paintings contributed enormously to the quality of the book. Stephen Kovacik, IMA Photographer, has spent months making documentary photographs and images for reproduction in this book. His devotion to the project and understanding of Pousette-Dart's oeuvre

can be seen in the sensitive photographs reproduced here. His accomplishments will, for the first time, make accessible to the public a vast number of Pousette-Dart paintings and drawings that have never before been photographed. He has been aided in his endeavor by his diligent staff, Susan W. Boyles and Lawrence J. Kline. We are grateful to Della K. Pacheco, IMA Publications Manager/Editor, for her skillful direction of all aspects of this publication, and to Yvonne L. McCann for her fastidious typesetting of the text. Working with such highly skilled professionals on this publication has been an enlightening and valuable experience.

A large part of the credit for this exhibition is due to the efforts of the staff of the Indianapolis Museum of Art. Their enthusiastic support and professional expertise have been invaluable in bringing this project to fruition. Among the curatorial staff, Ellen W. Lee, Senior Curator; Theodore Celenko, Curator of African, South Pacific, and Precolumbian Art; Martin P. Krause, Curator of Prints and Drawings; and Barry L. Shifman, Associate Curator of Decorative Arts, have been particularly generous with their expertise and advice. We thank William Butler, Curatorial Assistant, and Julia Rosas, Curatorial Associate, for their help on this project. We are indebted to Debbie Martinez, curatorial secretary, for her dedication to the project and her remarkable efficiency both in typing multiple drafts of the manuscript and in attending to the endless details of the exhibition, publication and the bronze door project. We would also like to acknowledge the special assistance provided by the following members of the IMA staff. Our thanks to the Registration Department, especially Vanessa Burkhart, Registrar;

Cathy Davis, former Associate Registrar; Deborah A. Scott, Assistant Registrar; and Jesse K. Speight for their careful guardianship of the works. We also want to thank the entire staff of the Exhibits Design and Installation Department, particularly Sherman O'Hara, Chief Designer, and Laura B. Jennings, Exhibits Designer, for their creative installation of the exhibition. Our gratitude is also extended to the Print Room Manager, Angela Berg, who was responsible for matting and framing all the works on paper for this exhibition, and to Martha Blocker, Librarian, and Anne Marie Quets for their assistance in locating publications for research.

For this exhibition the Education and Marketing and Communications divisions have organized superb programs and have thoughtfully disseminated information about the exhibition and related activities.

In Education we thank Carolyn Metz, Director; Sue Ellen Paxson, Associate Director; James W. Burkett, Cathleen Donnelly, Terry Jones, Mark V. Kratzner, and Anna M. Thompson. In Marketing and Communications we are grateful to Mary Bergerson, Director, and Mona Slaton, Andrea Badger, and Judith Fries.

We would also like to acknowledge the support and interest of the Development Division under the leadership of Mack P. McKinzie. We thank Susan L. Albers for the many hours she spent developing grants for the exhibition and programming. Thanks are also due to Linda Huddleston and Mary Welch. For their unfailing support we thank Matthew Cornacchione and his staff, and Isabel Martin, Mark Rutledge, Ginger Hoyt, Christie L. Barnhorst and Jeffrey L. Bewley. Our special thanks to all the IMA docents, and especially to Kay Dietrich, Louis J. Kigin, Catie Lichtenauer, Midge Mann, and Kathleen Miller.

There are two special projects connected to the exhibition that should be brought to your attention. The monumental bronze door created by Richard Pousette-Dart for the north facade of the Hulman Pavilion was made possible by a generous gift from Mr. and Mrs. Robert S. Ashby. The late Mr. Ashby was the former chairman of the board of the IMA. We extend our thanks to Edward Larrabee Barnes and Richard Klibschon for their interest in the door and their unfailing assistance from the planning stages through installation. Our deepest gratitude to Richard F. Polich, President of Tallix, Morris Singer, Chris McGrath, Vincent Nardone, Richard Johansen and all the crafts people at the foundry in Beacon, New York, who worked with Pousette-Dart to create the door. We are also grateful to Martin J. Radecki, Thomas Byfield, Charles Wellman, and to former IMA staff member Judith McKenzie for helping make the door a reality.

The IMA also commissioned from the gifted composer David L. Ott a symphonic piece entitled *Music of the Canvas*, inspired by the paintings of Richard Pousette-Dart. To him and to Susan T. Ott, the music copyist for the manuscript, we owe a

debt of gratitude. We also wish to acknowledge
Raymond Leppard and the Indianapolis Symphony
Orchestra for the premiere performance of the piece
on October 11, 1990 and James P. and Anna Seim
White for the generous gift that made the commis-
sion possible.

We wish to thank the directors and curators of the
museums participating in the tour of this exhibition.
At The Detroit Institute of the Arts we express
gratitude to Samuel Sachs II, Director, and Jan van
der Marck, Chief Curator and Curator of Twentieth-
Century Art; and at The Columbus Museum to
Anne Timpano, Director, and Anne Harrell,
Curator. We thank the lenders of both public and
private collections who have so generously agreed to
part with their works for the duration of this tour.
They are listed separately in this book.

We would like to acknowledge with deepest grat-
itude the AT&T Foundation, The National Endow-
ment for the Arts, and the Indiana Arts Commission
for their generosity in funding the exhibition and
publication.

The following friends and associates have con-
tributed to this project in a variety of ways: Karen
Bussolini; Patricia Haines; Corinne, Marjorie, and
Charlie Hobbs; Caroline and Thomas Kuebler; Mark
and Kathy Lindquist; Ann and Paul F. Muller;
Patricia Rose; John Scofield. We value their interest
in the exhibition and book, their belief in us, and
their sacrifices and understanding when the
Pousette-Dart project took priority in our schedules.

Finally, we are indebted to Donald Kuspit, professor
of art history and philosophy at the State University
of New York at Stony Brook, for contributing an
insightful and thought-provoking essay to this pub-
lication, an important contribution to the scholar-
ship on Richard Pousette-Dart. We also wish to
acknowledge our appreciation of the scholars and
critics who have written about Richard Pousette-
Dart's work in the past. In particular we wish
to acknowledge Lawrence Campbell, Judith Higgins,
Sam Hunter, Hilton Kramer, Paul Kruty, Gail
Levin, Lucy Lippard, Carter Ratcliff, Barbara Rose,
W. Jackson Rushing, Martica Sawin and Lowery
S. Sims.

Joanne Kuebler Robert Hobbs

*" I am an artist of the concealed power of the spirit
not of the brute physical form"*

—Richard Pousette-Dart, Notebook entry, 1939

Concerning Pousette-Dart

Joanne Kuebler

A Childhood with Artists and Poets

Richard Pousette-Dart, one of the originators of the Abstract Expressionist movement, has been creating paintings, drawings, sculptures, and photographs for over fifty years. Since his first one-man exhibition in 1941, he has exhibited regularly in major museums and art galleries around the world. His large body of multifaceted works is infused with an intense personal vision, reflecting his convictions about the spiritual nature of art. Few American artists have enjoyed such a supportive, creative environment as the young Pousette-Dart. He was encouraged by his mother, a poet, and his father, a painter and writer, to pursue an artistic career, which both of them viewed as a vocation embodying the highest spiritual values. Those values were translated into a search for new means of artistic expression that could make visible what cannot be seen. The results, Pousette-Dart explains, are works that embody "a quest for reality; not the obvious surface reality of outer forms but the related continuing realities of all the sights and sounds, sensations, dreams, memories . . . the intuitive visions that are part of the daily life of all of us."[1]

He shared with the artists who would become his Abstract Expressionist colleagues an interest in communicating deeply felt experiences and in exploring the physical characteristics of materials to create a new formal vocabulary to express spiritual values. However, his recondite style, which matured before the end of the 1930s and continues to evolve to this day, remains deeply personal. His art has eluded facile definition because of his continual quest for the "transcendent," the domain beyond experience. Guided by a highly individual sensibility, he is unswayed by "isms," movements, or art historical fads. He goes to great lengths to protect himself from the influences of the commercial marketplace, in order to stay in tune with his own inner sources of creativity. A visionary artist, his abstractions invite contemplation; they are expressions of private, spiritual states communicated, paradoxically, through a sensual and refined use of pigment.[2]

Richard Pousette-Dart was born on June 8, 1916, in Saint Paul, Minnesota, to Nathaniel Pousette and Flora Louise Dart, who, as a sign of mutual respect and equality, had combined their last names at the time of their marriage. Richard grew up in a rich cultural milieu, surrounded by art, poetry, and music. Flora (1887–1969) and Nathaniel (1886–1965), created a stimulating environment and supported a wide variety of intellectual and artistic pursuits.[3] The family library was filled with books on art theory, literature, music, and philosophy. Nathaniel's broad-ranging interests in art can be seen in books and periodicals he edited and in his collections of American prints and African, South Pacific, and American Indian artifacts, which his son inherited.

Flora was an accomplished pianist and later in life studied the violin, cello, and flute. Her circle of friends included many musicians, who frequently gathered at her house for concerts and lively discussions about the interpretation of musical compositions. Her son recalls that she and her friends often played Bach's compositions and were always trying to "get inside the meaning of the music."[4] She collected musical manuscripts and was intensely interested in music theory, poetry, and philosophy. The elder Pousette-Darts' friends included artists, musicians, and art critics who enlivened the house in Valhalla, New York, with their discussions about art, aesthetics, and politics. This creative atmosphere was an extension of their own upbringing, for Flora once described her father as a "music-loving poet" and her mother as a "poetry-loving musician,"[5] and Nathaniel's father, Algot Pousette, was an accomplished artist and silversmith.

It was unusual for American parents in the 1920s to foster artistic careers for their children. But Nathaniel and Flora, with deep convictions about the importance of integrating art and life, supported Richard's desire to be an artist, and he praises his parents as "wonderful, creative personalities who sought above all to give [him] love and freedom."[6] Nathaniel encouraged his son to explore the world and to seek beauty in the artistic expression of cultures as diverse as those of fourteenth-century Siena and the South Pacific. His parents gave him his thirst for "the deeper meaning of all things"[7] and his belief that art "is an intense précis of abstract experience."[8] Like his mother, Richard wrote poetry and thought about the connections among all the arts. As Flora wrote in the preface to *I Saw Time Open*, a collection of poems, "Although each of the arts gives organic structure to a different aspect of beauty, all are rooted in the same aesthetic experience."[9]

1 *Fugue Number 4*, 1947
Oil on linen, 92 x 62 inches
Collection of the artist

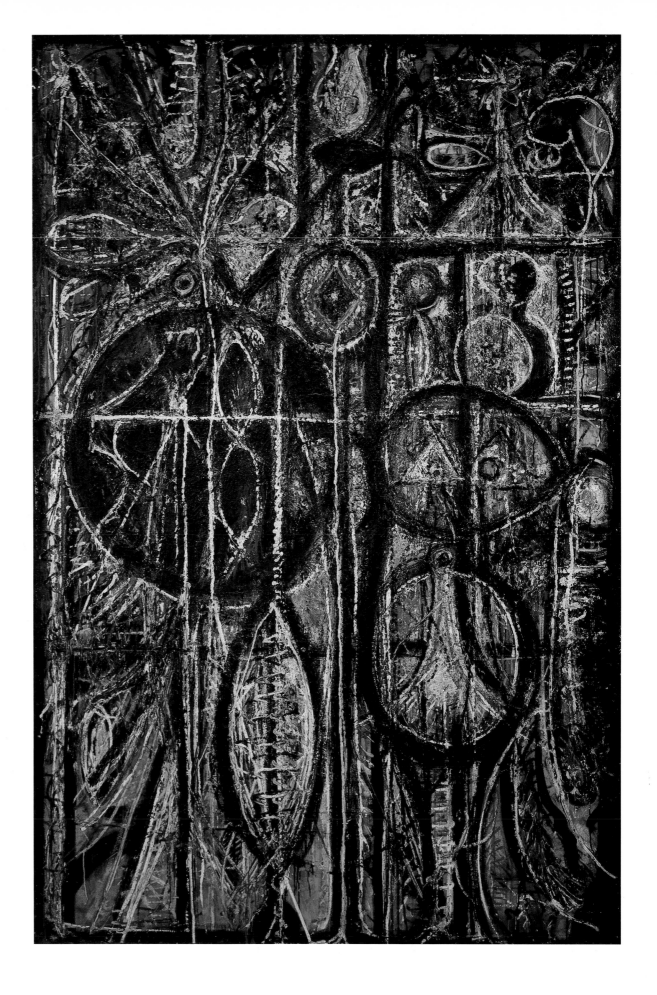

Flora Pousette-Dart, photographed by
Pousette-Dart

A number of her poems relate to correspondences
between music and poetry, and later Richard sug-
gested parallels between art and music in his paint-
ings *Symphony Number 1, The Transcendental*, ca.
1941–42, and *Fugue Number 4*, 1947 (1). In her
writings Flora frequently questions the nature of the
world, seeking a reality that is behind appearances.
A passage from the preface to *I Saw Time Open* is
typical:

*At rare intervals there come to everyone moments of
ecstatic revelation. Some portion of a familiar land-
scape, some aspect of daily life, some idea hitherto
accepted as commonplace is suddenly lighted up as
though by a giant search light—and in this moment
of illumination everything falls into place: the secret
of life is revealed, the riddle of the universe is
solved. Such moments occur in solitude outside of
time, and they seem incommunicable. Yet in
themselves, paradoxically, they convey an over-
whelming realization of human brotherhood, and
imperatively demand expression.*[10]

Those revelations, for Flora, found expression in
poetry, through which she experienced "a mystic
communion with all mankind."[11]

Flora Pousette-Dart's belief in meditation and
solitude as a path to spontaneous enlightenment
reinforced her son's lifelong passion to seek the
truth by following his own path; he is an artist who
has always struggled to find his own thread of
creativity. His reflections on art often echo his
mother's thoughts about expressing a reality that
transcends appearance, and they reveal his own in-
terest in spirituality. He wrote, "Mine is an abstract
vision fired by mystic shapes not by description."[12]
By the late 1930s, when Richard met the artists
later known as the Abstract Expressionists, his
artistic sensibility had already been shaped by his
early childhood experiences.

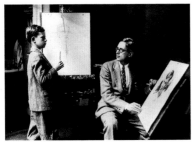

Nathaniel and Richard Pousette-Dart
(Photo: NYT Pictures)

Richard Pousette-Dart never had formal artistic
training and claims to be a self-taught artist;
however, as a small child he spent many hours
watching his father at the easel and absorbed from
him a great love for art and an interest in exploring
both the language and techniques of painting. He
remembers sitting in an old rocking chair in his
father's attic studio and discussing painting and life
with him.[13] The communication between the two
later developed into a strong interchange of ideas,
and by the 1940s Nathaniel's writings and paintings
reflect the influence of his son. The bond between
the two is perhaps best captured in a photograph

taken for *The New York Times* in 1928. Here
twelve-year-old Richard and his father sketch each
other's portraits.

Nathaniel was an accomplished artist, teacher, and
writer who was active in the New York art world
from the 1920s through the 1950s. He edited a
series of books on prominent American artists
(including Childe Hassam, Robert Henri, Winslow
Homer, John Singer Sargent, Abbot H. Thayer, and
J. A. M. Whistler)[14] at a time when American artists
received very little critical attention. In 1941 he was
a founding member of the Federation of Modern
Painters and Sculptors, formed to encourage artists
to explore aesthetic rather than political issues.
As an active member, and one-time president,
Nathaniel organized exhibitions, recruited members,
and encouraged artists to promote their own work.

Nathaniel's early years were spent in Saint Paul,
where as a young artist he was a friend of Paul
Manship. In 1904 he went to New York to study
with William Merritt Chase and Robert Henri. From
1907 to 1911 he attended the Pennsylvania Acad-
emy of the Fine Arts, where he received scholar-
ships that enabled him to spend the years 1909 and
1910 studying art abroad.[15] The exposure to Euro-
pean art had a profound impact on his own artistic
development, and in later years he often spoke
about the importance of his European sojourn. An
early light-filled landscape by Nathaniel Pousette-
Dart reflects the influence of his teacher, Chase,
who introduced American painters to Impression-
ism. Although Nathaniel used the high-keyed
colors, broken brush strokes, and simplified forms
of Impressionism, his work was similar to other
American Impressionists who were reluctant to
dissolve forms to the same extent as the Europeans.
Paintings from the 1930s suggest the influence of
Robert Henri, who played a major role in shaping
Nathaniel's views on art and later was one of the
artists he included in his *Distinguished American
Artists* series. Henri emphasized the importance of
real-life experiences over style. Nathaniel's paintings
from the 1930s and 1940s are also similar to those
of the Regionalists Thomas Hart Benton, Grant
Wood, and John Steuart Curry in their interest in
scenes of rural America, realistic approach to land-
scape, and use of an expressive, linear style. Using
both oil and watercolors, he translated isolated
country houses and barns into expressive forms
through the use of heavy outlines and dramatic

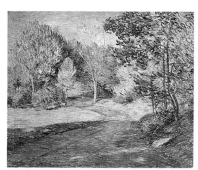

Nathaniel Pousette-Dart, *Impressionist Landscape*, ca. 1920s

shadows. The influence of Vincent van Gogh's passionate landscapes and Albert Pinkham Ryder's mood-evoking night skies can be seen in Nathaniel's paintings of the late 1930s and early 1940s. He paid direct homage to these artists in *van Gogh Evening* and *Ryder's Moon*.[16]

Though the main body of Nathaniel's oeuvre from the 1930s and 1940s is conservative, a number of his published statements about art and several known abstract compositions of the early 1950s[17] indicate his openness to abstraction and his belief that art should express inner emotions. For Nathaniel that meant following an independent path: "I belong to no school of painting. My whole effort is bent toward finding and expressing my own thought and feelings."[18] The artist, he believed, must above all be guided from within, for "Creation emerges from the subconscious,"[19] with the result that "every artist expresses what he is in every line, tone, texture, color, and form he puts on his canvas."[20]

Nathaniel believed that intuition tempered by reason would lead to an artist's main objective, "the expression of powerfully-felt concepts."[21] The artist must tap into the "emotional and mysterious" aspects of man's nature. In the foreword to his book *American Painting Today* Nathaniel discusses the roles of intuition and intellect. He states that intuition is the starting point for creativity, while the intellect plays an important role in ordering and clarifying the intentions of the artist. He presents both viewpoints by quoting the philosopher Dr. James A. Diefenbeck, who described the intentions of the artist as "an effort to clarify and crystallize his feelings, to order and portray inner emotions in an objective form so that they become explicit and understandable."[22] Nathaniel's foreword ends with the powerful words of Benedetto Croce: "Art is imagination or intuition, the first primitive stop of the spirit, sharply differentiated from knowledge obtained through the intellect."[23]

Nathaniel Pousette-Dart's allegiance to a romantic, intuitive basis for artistic creation was shared by his son, Richard, who writes about using intuition as a catalyst,[24] a means of tapping sources in the inner recesses of the mind which are then consciously shaped by the artist's intellect. The result, says Richard Pousette-Dart, is an "art that lies behind the cloth of surface things; it is always deeper than appearance and must be delved for." He explains, "Within or about every living work of art or thing of beauty or fragment of life, there is some strange inner kernel which cannot be reached with explanations, clarifications, examinations, or definitions."[25]

Richard Pousette-Dart has stressed the exploratory nature of his painting, which seeks knowledge beyond the limits of ordinary experience. He abstracts from nature in order to reveal universal essences or truths. "All abstraction," Nathaniel once wrote, "has its basis in nature."[26] It is a belief echoed by Richard, who argues that his "art transcends and transforms nature, creates a nature beyond nature, a supra nature, a thing in itself—its own nature, answering the deep need of man's imaginative and aesthetic being."[27]

It is finally the artist's own need for expression that drives him to create, for, in the words of Louis Danz, quoted by Richard's mother in the preface of her book *I Saw Time Open*, "the art is pulled out of him by aesthetic necessity, as the spider's web is pulled out of the spider by biological necessity."[28] That image of an art that is both rooted in the subconscious and transcendent is echoed by Richard Pousette-Dart in a passage that celebrates the influence of both his parents:

I strive to satisfy my soul through expression, creating structures which have significance and beauty as things within themselves—a life which goes onward and onward in its feeling—its joy of being—its desire to interpenetrate and mingle and to be a part of all other life.[29]

Richard Pousette-Dart began painting and drawing at the age of eight and later described these early drawings as "abstract paintings . . . connection[s] of lines and different shapes and forms, making an amorphous grid I always tended to come at nature through abstraction, rather than to come at abstraction through nature."[30] At the age of ten he filled a notebook with pencil sketches, attesting to a serious early interest in artistic activity.[31] Richard was a sensitive and introspective person whose refined artistic sensibilities were apparent by the time he was in high school. In a paper for a psychology course at Scarborough-on-Hudson High School, entitled "Personality in Art," Richard discusses the power of abstract art to express universal truths: "The greater a work of art, the more abstract and impersonal it is, the more it embodies universal experience, and the fewer specific personality traits it reveals."[32]

In 1936 Richard Pousette-Dart briefly attended Bard College, but, knowing that he wanted to be an artist, he left before the end of the academic year, saying that "he preferred to think for himself."[33] He started to paint and sculpt seriously around 1936 and with his father's help became an assistant to the sculptor Paul Manship. He moved to Manhattan in 1937, where he spent his days for the next year doing lettering for the sculptor and his evenings working on his own paintings, sculptures, and drawings. He objected to the academic qualities of Manship's work and believed that Manship was unaware of the power of form to act directly on the unconscious. In a letter to his mother written on May 12, 1938, Pousette-Dart referred to his perception of "the innumerable animal forms of our reality and our [un]consciousness" and noted Manship's unawareness of this feeling and his own desire to "release it in some work of my own."[34]

During these early days in New York, when the very foundations of the New York School were being laid, Pousette-Dart spent many hours in The Metropolitan Museum of Art and the American Museum of Natural History studying the iconography and styles of the art of a wide variety of cultures. He gravitated toward Byzantine and medieval art, Sienese and Florentine painting, and the Spanish and Dutch masters, and he admired the late-nineteenth- and early-twentieth-century French painters and van Gogh, Picasso, and Miró. Important American sources were Ralph Albert Blakelock and Albert Pinkham Ryder.[35] His interest in Native American, African, and South Pacific sculpture is well documented through his paintings, sculpture, and notebooks from that period.

In the late 1930s Pousette-Dart began keeping notebooks filled with sketches, poems, letters, lists of books that had impressed him, philosophical and theological ruminations, and personal diary entries. The notebooks reveal his strong spiritual impulse and his intention to explore artistic experience as a means to spiritual ends. He has never questioned the natural spiritual function of art. A notebook entry from the summer of 1939 proclaims, "Art is religion—religion is crystallization in form, action or thought, of time the mind of space, space the body of time." In an entry from 1942 he asserts, "Art is fabric for spiritual conversation" and asks the question "Why paint?" He responds, "As creative prayer to God, joy in finding—to be in awareness of reality." He took the connection between art and religion one step further in an address presented at the Union Theological Seminary in 1952:

I believe all of the great religious personalities including Moses, Jesus, and Buddha, were in truth artists, and I believe every great painter is religious. My definition of religion amounts to art and my definition of art amounts to religion. I don't believe you can have one significantly without the other. Art and religion are the inseparable structure and living adventure of the creative.[36]

For Pousette-Dart, then, "Art is always mystical in its final meaning."[37] His personal philosophy is realized in his art through an amalgam of meditation and intuitional communion with the forces of growth and creativity. He creates his own philosophical constructs based on respect for all living creatures,[38] a deep belief in individualism, and an unwavering conviction about one's ability to create meaningful experience through self-exploration and artistic expression. His individualism, which has led him to rely on the unseen but felt power from within, was reinforced by his interest in literature, especially the writings of the Americans Emerson, Thoreau, and Whitman. It was also strengthened by the American intellectual milieu of the 1940s, which advocated individualism as an antidote to the politically motivated group activities of the 1930s, which the Abstract Expressionists wanted to transcend. "The artist," Pousette-Dart asserts, "must beware of all schools, isms, creeds or entanglements which would tend to make him other than himself. He must stand alone, free and open in all directions for exits and entrances, and yet with all freedom, he must be solid and real in the substance of his own form."[39]

Pages from ''Knights of Pythias'' notebook, 1950s, with drawings from the early 1940s

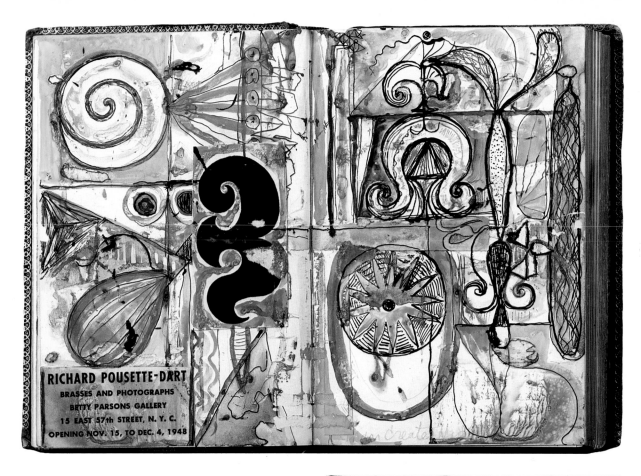

Pages from notebook, late 1980s

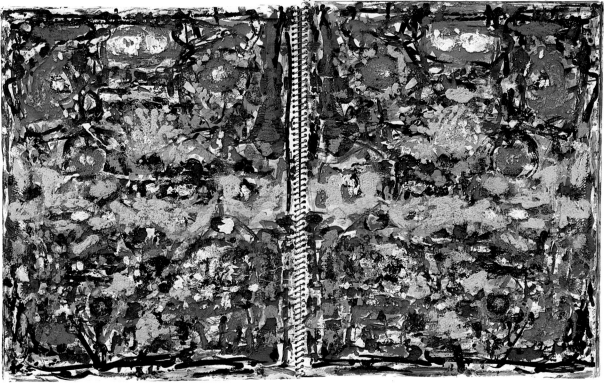

The Early Years in New York

When Pousette-Dart arrived in Manhattan, the city was fertile territory for young artists. In 1936 the seven-year-old Museum of Modern Art presented important survey exhibitions of Cubism and Surrealism that were organized by its first director, Alfred H. Barr, Jr. His exhibition *Cubism and Abstract Art* provided New York artists with exposure to key works of the modern European movements and to the philosophies that formed the modernist aesthetic. Barr presented the history of twentieth-century abstraction as an evolutionary process beginning with Cubism, and he brought together, in well-defined groupings, most of the important movements of the century. The exhibition had a profound impact on American artists. By 1940, according to the critic Clement Greenberg, "a number of relatively obscure American artists already possessed the fullest painting culture of their time."[40] Barr's 1939 exhibition *Picasso: Forty Years of His Art* added to the wealth of European sources available to American artists, and in Pousette-Dart's paintings and notebook sketches of that year the Cubist and Surrealist influences of Picasso are very much in evidence. A watercolor, *Gothic Garden* of 1940 (2), has a focal point of brilliant red, jewel-like biomorphic forms nested in an ovoid shape and contained within a gridded spatial structure related to Analytic Cubism. Delicate calligraphic lines unifying the design recall the playful imagery of Joan Miró.

In the late 1930s Pousette-Dart supported himself in New York by working as a secretary in a photographic studio that specialized in retouching color photographs. These were turbulent years, both emotionally and financially. He married twice, first Blanche Grady, a dancer, and then Lydia Modi, an artist.[41] Both marriages ended in annulments. In 1939 Pousette-Dart gave up his job to devote all of his time to painting and sculpture.

The outbreak of World War II awakened the artist's belief in pacifism, which had first been expressed during his high school days. In 1935 he had written an essay for the senior class magazine entitled "I Have Been Called a Dreamer." While most of his fellow students wrote essays about travel or sporting events, Richard's essay was a call for pacifism. He wrote: "I have been called a dreamer because I believe that militarism has no place in education and that war can be done away with. . . . Is it not significant that the greatest teacher in the history of the world is known as the Prince of Peace?"[42] The 1940 and 1941 notebooks are filled with poetic references to death, destruction, and the horrors of war. He became a conscientious objector, refused to carry a draft card, and sent letters protesting the war to the president, senators, and his draft board. In a letter to the New York Draft Board he stated his refusal to undergo an army medical exam.[43] During the war, when conscientious objectors were prosecuted, Richard wrote to officials of the draft board to request that he be sent to prison to protest the atrocities of war and to emphasize his belief in pacifism. A sympathetic draft board official threw away Richard's card, and he was not prosecuted.

In 1946 Pousette-Dart married Evelyn Gracey, a poet he had met at the Willard Gallery. They lived in a cold-water brownstone on East 56th Street in New York near the East River. Their first child, Joanna, was born in 1947. In the late 1940s Pousette-Dart exhibited in New York with the emerging Abstract Expressionists and was a somewhat reluctant participant in their group activities at Studio 35, the school founded by William Baziotes, David Hare, Robert Motherwell, and Mark Rothko that later became a studio and exhibition space for New York University art students. Studio 35 was a gathering place for the Abstract Expressionists, who often attended the Friday night lecture series. Pousette-Dart shared his colleagues' strong belief in the importance of subject matter for abstract art and like them wanted to correct the increasingly widespread notion that abstract art had no content beyond its formal vocabulary. In 1950 he posed with the other Abstract Expressionists for the famous *Life* magazine photograph of "The Irascibles," a title given to the artists because of their well-known discontent with the conservative jury for the exhibition *American Painting Today* at The Metropolitan Museum of Art. The controversy contributed to the growing public interest in Abstract Expressionism and signaled the reluctant admission by the artists themselves of their shared vanguard status, though they fiercely maintained that they were not a stylistically coherent group. This remarkable photograph gave the artists a shared monumental presence, and yet each person is visible as a distinct individual. Pousette-Dart seems somewhat aloof from the other artists in the photograph, perhaps presaging his departure from group activities and affirming his memory of that time: "I was fiercely by myself and doing my own stuff. I guess I was even belligerent about my aloneness."[44]

2 *Gothic Garden*, 1940
Watercolor on paper, 9 x 6 inches
Collection of the artist

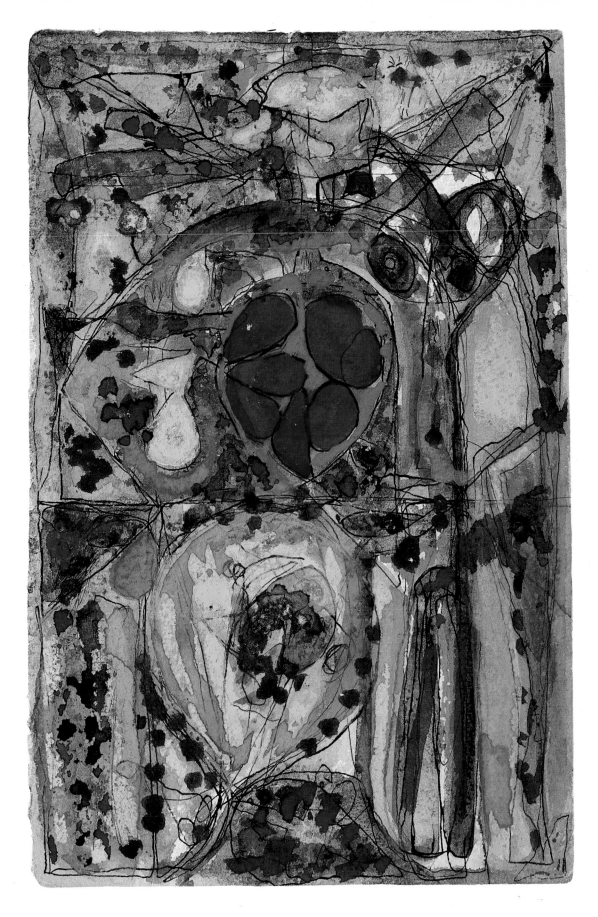

The Suffern house and studio, Fall 1989

With increasing public recognition for his work (The Museum of Modern Art purchased *Number 11: A Presence*, 1949), he sought a refuge from the pressures of the commercial gallery system and began to look for a place to work outside New York.[45] Galleries were not hospitable environments for his work, as is affirmed in a notebook entry about an artist's need for solitude, the importance of seeing an artist's work in the context of a larger body of work, and the need to integrate creativity with daily life:

Paintings are not properly seen in galleries but only in the solitude and wholeness of their studios where casually, easily, mystically one may be in touch with the whole meaning of the man—where no special few are shown polished and isolated or enthroned but the slightest is mixed among with the most bold and grand and the significance is not of one nor another but of the harmonies as well as the discords arising out of the whole play. Art is only significant as it takes us to the whole man and gives us new insights and opens secrets toward the unknown heart of our total mystic awareness.[46]

In 1951 Pousette-Dart left the city to work in isolation in Sloatsburg, New York. During this year he continued to be recognized by the New York art world through inclusion in a group exhibition at The Museum of Modern Art[47] and through the formal awarding of a Guggenheim Fellowship. The Pousette-Darts' son Jonathan was born in 1952. In 1954 they moved to Christmas Hill Road in Monsey, New York, and four years later moved to their current residence in Suffern. They purchased and renovated a fieldstone carriage house, located in an isolated setting at the foot of the Ramapo Mountains. The carriage house, part of the former estate of the wool baron William McKenney, was constructed in 1916 by stone workers from France. For over three decades Pousette-Dart has lived and worked in this bucolic haven.

"The Irascibles," 1950. *Top, left to right:*
Willem de Kooning, Adolph Gottlieb, Ad
Reinhardt, Hedda Sterne. *Middle:* Richard
Pousette-Dart, William Baziotes, Jackson
Pollock, Clyfford Still, Robert Motherwell,
Bradley Walker Tomlin. *Bottom:* Theodoros
Stamos, Jimmy Ernst, Barnett Newman,
James Brooks, Mark Rothko. (Photo: Nina
Leen, *Life Magazine* © 1951 Time, Inc.)

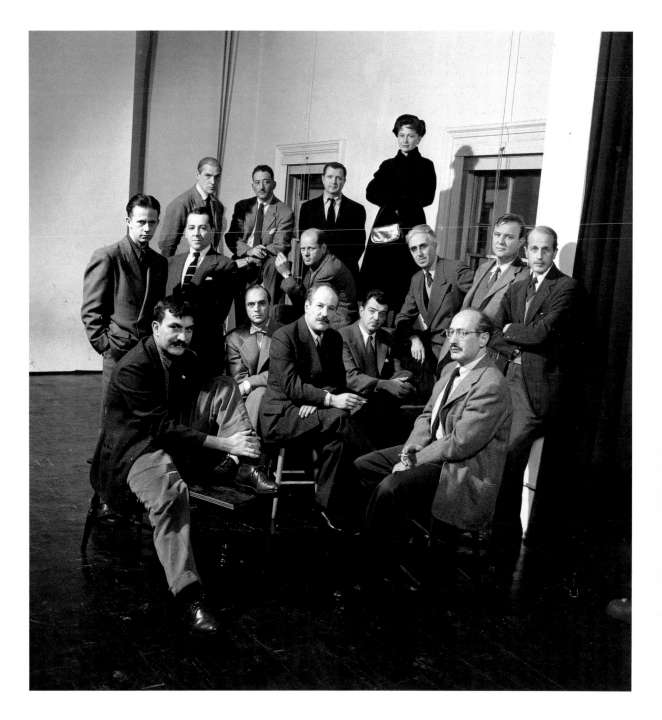

John Graham, ca. 1937, photographed by Pousette-Dart

John Graham, *Blue Abstraction*, 1931. Oil on linen, 25⅝ x 36⅛ inches. The Phillips Collection, Washington, D. C.

Diverse Sources for an Artistic Sensibility

Pousette-Dart shares with the other painters who became the Abstract Expressionists a concern for the centrality of content. Like William Baziotes, Adolph Gottlieb, Barnett Newman, Jackson Pollock, Mark Rothko, and Theodoros Stamos, he used throughout the 1940s mythic and totemic symbols as well as elements of biomorphism to infuse his paintings with spiritual content. He differs, however, from his contemporaries in his emphasis on the contemplative aspects of the creative process, which was reinforced by his readings of Lao Tzu and other Far Eastern philosophers. His paintings are a reflection of life as a continuum of changing relationships with infinite possibilities for creativity, vitality, and interpretation. He wants the viewer to have his or her own creative experience with the paintings that parallels but does not duplicate the artistic impulse behind their creation. This is achieved through the complex physical qualities of the paint and the large scale of the canvases, which fill the viewer's field of vision. In paintings dating from the early 1960s, surfaces are characterized by a quietude and balance achieved through an assiduous application of paint and multiple reworkings of the surfaces. Pousette-Dart's work is not confined by the criteria critics established for Abstract Expressionism. Although he is similar to the so-called Action painters in eschewing preliminary drawings and in frequently applying paint directly from the tube, he is not an Action painter because intuition and spontaneity are used only as a starting point for the creative process. His surface textures, built up in some cases with twenty or thirty layers of paint, are highly refined and controlled to create the harmony and balance that are central to his aesthetic.

Many ideas expressed in Pousette-Dart's notebooks from the late 1930s and 1940s parallel the thoughts of John D. Graham, an influential artist and theorist who was highly visible in the New York art world at that time. Pousette-Dart created a photographic portrait of the nonconformist Graham.[48] Although Graham was an accomplished painter, he is better known for his ideas on aesthetics. His ability to place theories from multiple disciplines (like psychology and anthropology) into a systematic theory relating to art made him influential in the New York art world. His aesthetic theories, which played a role in encouraging artists to study psychology and seek out sources for abstraction in non-Western sources, are elucidated in his book *System and Dialectics of Art*.[49] This eccentric book is often

contradictory, disorganized, and mundane; however, there are some brilliant passages that are essential to an understanding of the intellectual foundation of Abstract Expressionist thought and the growing awareness of both European intellectual discourse and Jungian and Freudian theory. Pousette-Dart expressed concern about Graham's dogmatic approach to art, but admired his book and still has in his library a well-worn, signed and numbered copy of the first edition of Graham's book, which is inscribed by its author.[50]

One of the cornerstones of Graham's aesthetics was a belief in the spiritual continuity between so-called primitive and modern people. He apparently was influenced by his compatriot Wassily Kandinsky's treatise *Concerning the Spiritual in Art*. Kandinsky wrote that in art this continuity can be revealed through ''a revival of the external forms which served to express those inner feelings in an earlier age. An example of this today is our sympathy, our spiritual relationship, with the Primitives. Like ourselves, these artists sought to express in their work only internal truths, renouncing in consequence all consideration of external form.''[51] Graham, with his grounding in psychoanalytic theory, expresses this relationship in terms of the unconscious: ''The purpose of art in particular is to re-establish a lost contact with the unconscious (actively by producing works of art), with the primordial racial past and to keep and develop this contact in order to bring to the conscious mind the throbbing events of the unconscious mind.''[52] Graham believed that art offered ''almost unlimited access to one's unconscious,''[53] and he was especially interested in the Jungian theories of tapping the unconscious as a source of creativity and in the use of automatism and accidents to create chance compositions (which he believed should be rationally modified by the artist).

Pousette-Dart also owned Graham's painting *Blue Abstraction*, 1931.[54] The composition is similar to that of Pousette-Dart's *Untitled, Birds and Fish*, 1939 (3), and *East River*, 1939 (57). In *Untitled, Birds and Fish* Pousette-Dart uses bird and fish forms[55] that are both ancient religious symbols and ubiquitous American Indian motifs. The fish was a secret symbol for early Christians and is a symbol of Christ; the bird motif is pervasive in Egyptian hieroglyphics. The biomorphic forms and skeletal structures in this painting suggest both primordial beginnings and death; these forms are linked to

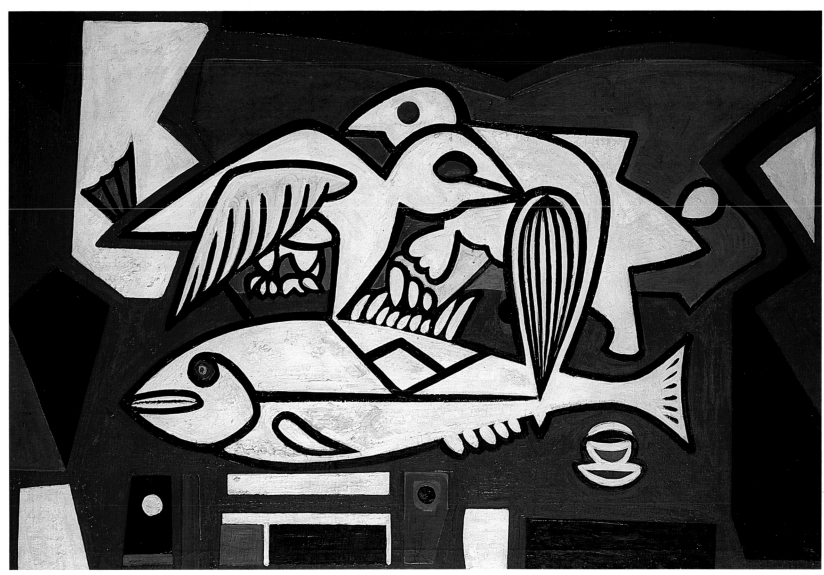

3 *Untitled, Birds and Fish*, 1939
Oil on linen, 36¾ x 60 inches
Collection of the artist

Small Cubist watercolor, ca. early 1940s, pasted into "Knights of Pythias" notebook, 1950s

twentieth-century realities by their juxtaposition with a field of abstract shapes related to Neo-plasticism and biomorphic Surrealism.

Pousette-Dart's encounter with Graham reinforced ideas that he had shared with his father about the importance of intuition and spontaneous expression as a catalyst for creativity; however, his belief that intuition must be tempered by intellect prevailed. In the early 1940s he wrote, "The accidental in art bores me, high beauty is a conscious moving upon an achievement of pure principle."[56] This is borne out in the mastery of Pousette-Dart's technique, in which he carefully created structured compositions, using grids in the 1940s and 1950s as an infra-structure for his totemic, mythic images from the unconscious. Later in the 1960s he fused the images more completely with their surrounding grounds through the use of controlled color luminosities that create holistic pictorial icons. These powerful images, created through the methodical application of paint in multiple layers, with subtle tonal gradations, cannot be separated from their color fields (4). Pousette-Dart's belief in combining an intellectual and intuitive approach explains his interest in Analytic Cubism, as seen in his paintings and drawings from the late 1930s and early 1940s. The simplified forms and frequent use of an infra-structure or grid to control spatial depth are related to the innovations of Cubism. Notebooks from the period contain photographs of Cubist sculptures (heads) and of Matisse's *Jeanette* series, Cubist drawings, and even a small Cubist painting, with biomorphic forms superimposed on a grid.[57]

Pousette-Dart's works of the late 1930s are fully realized symbolic still lifes and stylized figural compositions, which show the influences of Picasso and Cubism. A series of heads from 1938–39 (49–51) indicates his complicated and subtle rela-tionship to Picasso's African- and Iberian-influenced female heads. The stylized, flattened forms, the mismatched lozenge-shaped eyes, and the flat plane of the nose in Pousette-Dart's *Head of a Woman*, 1938–39 (49), recall similar features in Picasso's *Two Nudes*, 1906. *The Edge*, 1943 (62), with its tightly controlled infrastructure, a grid in mono-chromatic tones, is close to the 1911–12 Analytic Cubist works of Picasso and Braque.

In the 1940s many New York artists believed that African, South Pacific, and Native American art reflected archetypal forms embedded in the universal unconscious of man. This theory was popularized by Jung, whose concept of a collective unconscious included a theory about ancient symbolic modes of thinking, which enabled tribal man to create art through ceremonial means. Pousette-Dart's early childhood exposure to African, South Pacific, and Northwest Coast American Indian artifacts laid a strong foundation for his developing artistic sensibilities. He said: "The most exciting work of our time grows out of primitivism. Nobody has defined so clearly the principles of dealing with pure form. The primitives make architectural monu-ments from the head or figure or animal abstracted from their visual and life experience."[58]

Pousette-Dart was not a serious student of psycho-analytic theory, nor had he made a first-hand study of Jung's theory, but like his colleagues he had a general vocabulary of references to Jungian psycho-logy that derived from popular sources such as Graham's interpretations and discussions with other artists in informal settings. Pousette-Dart clearly understood Jung's ideas about archetypal imagery and the unconscious, and they are central to an understanding of his oeuvre. In his notebooks from the 1930s and 1940s, he often wrote about the distinctions between the conscious and the uncon-scious: "Art is old-new fruits of the subconscious mind."[59] In one notebook Pousette-Dart diagrammed "the polarity between the 'subconscious mind' and the 'conscious mind' with the central axis repre-senting goodness—art—microcosm—wisdom—pure self-truth" and noted, "Art is the result[ing] mani-festation of the conscious mind body reacting upon a submind spirit—the crystallization resulting when they meet—unknown experience reacting upon known experience creating a superhuman mystic body."[60] And when he wrote, "Symbols are but signs, reminders of essence, signals of cosmic awareness,"[61] he reflected Jung's tenet that through the use of myth, totem, and ritual, primitive man was able to transform his consciousness.

By fusing mythological American Indian symbols with spontaneous gestures related to Jungian theory, Pousette-Dart and the other Abstract Expressionists believed they could create universal symbols that would express inner truths. Pousette-Dart often visited the American Museum of Natural History and had a special affinity for Northwest Coast Indian paintings on wooden boards, Eskimo sculp-ture of feathers and balsa wood, and African sculpture.

4 *The Fountain*, 1960
Oil on linen, 75½ x 56 inches
Collection of the artist

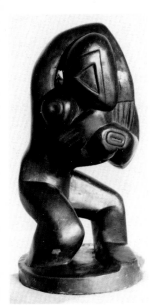

Henri Gaudier-Brzeska, *Red Stone Dancer*, 1913. Red Mansfield stone, polished and waxed, 17 x 9 x 9 inches. The Tate Gallery, London.

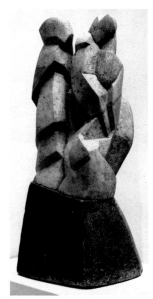

Henri Gaudier-Brzeska, *Birds Erect*, 1914. Limestone, 26⅝ x 10¼ x 12⅜ inches. The Museum of Modern Art, New York. Gift of Mrs. W. Murray Crane.

Works from the late 1930s, such as *Bird Woman*, 1939–40 (58), and *Primordial Moment*, 1939 (56), show the influence of American Indian iconography, which Pousette-Dart explored for its conceptualized styles used to communicate universal and spiritual qualities.[62] His view of African and American Indian art, like that of the other Abstract Expressionists, had been conditioned by exposure to European Cubism and Surrealism, which emphasized the special qualities of the non-European mentality that could be appropriated by the modern artist. They were drawn to American Indian art because, in addition to its formal, evocative qualities and its abstract motifs and universal themes, it was native to North America and provided a legitimate touchstone for developing an "American" style. However, they rarely used this art as a sole influence, preferring instead to refer to primitivism through association with a number of tribal cultures. Pousette-Dart has stated that early works like *Bird Woman* "had an inner vibration comparable to American Indian art. I felt close to the spirit of Indian art. My work came from some spirit or force in America not Europe."[63] American Indian art also offered artists a new basis for an evocative form of expression that was related to primordial, and hence universal, experience. Ancient patterns of thought could be linked to modern patterns of thought through the use of archetypal forms and mythic content from prehistoric, archaic, and American Indian sources.

Pousette-Dart's use of Native American, African, and South Pacific iconography was part of his search for "significant form" that goes beyond the spontaneous gesture in which creative expression begins. He admired the theory of visual art and the definition of "significant form" expressed by the English critic Clive Bell. In the 1930s and 1940s he read Bell's books and continues to refer to Bell's ideas today. Bell defined "significant form" as the one quality common to all works of visual art. He said that it "stands charged with the power to provoke aesthetic emotion in anyone capable of feeling it."[64]

Pousette-Dart's own vocabulary of significant forms, characterized by geometric, biomorphic, and animal shapes, emerged in the 1930s in his small brass sculptures, paintings, and drawings. They continue to be an integral part of his work today. A number of the early brasses are related to works by the French sculptor Henri Gaudier-Brzeska, whose sculpture Pousette-Dart admired.[65] Associated with the Vorticist artists in England, Gaudier-Brzeska was

an outspoken proponent of tribal art. In late 1913 or early 1914 he began creating sculptures inspired by the art of Africa and the Pacific Islands.[66] The Vorticists were drawn to African art for what they believed were its "anti-intellectual, expressionist qualities."[67]

Gaudier-Brzeska's sculptures were often a hybrid of African and Greek sources. In *Red Stone Dancer*, ca. 1913, the exaggerated proportions and bent-legged stance are from African sources, while the raised arm and the contrapposto position are derived from Greek sculpture. In his carved sculpture of 1914, *Birds Erect*, the deep faceting is related to both Vorticism and tribal art; the sculpture illustrates his ideas about the power of formal relationships. In 1914 Gaudier-Brzeska wrote: "Sculptural feeling is the appreciation of masses in relation. Sculptural ability is the defining of these masses by planes."[68]

Pousette-Dart shared Gaudier-Brzeska's belief that tribal sculpture instinctively projected a three-dimensional quality that evoked power and mystery through iconographical means. His *Woman Bird Group*, 1939 (5), depicting a bird with her offspring,[69] exhibits striking similarities to Gaudier-Brzeska's *Birds Erect*. Both combine an interest in the juxtaposition of highly stylized abstract biomorphic forms with totemic imagery suggesting primordial presences. The bird is a symbol of thought, imagination, and the swiftness of spiritual processes and relationships.[70] The faceted mother bird, with sharply pointed beak, hovers above its open-mouthed young in a protective attitude that "projects a primal instinct for survival"[71] and suggests the miracle of growth and change. The interplay of deeply faceted forms (the archaizing bulging eyes and body forms) with defined spaces creates an expressive staccato rhythm. This sculpture is more closely related to African sources than to those of the American Indian or South Pacific cultures. William Rubin has pointed out that African sculptures are usually interesting from almost any angle and have "tactile sculptural mass," while most South Pacific sculptures are relatively flat and are generally intended to be viewed either from the front or in absolute profile.[72] The bold, simplified shapes in *Woman Bird Group* emphasize sculptural mass and imbue the form with vitality.

5 *Woman Bird Group,* 1939
Bronze, 24¾ x 18⅞ x 23⅞ inches
National Museum of American Art,
Smithsonian Institution
Gift of Mr. and Mrs. Frederic E.
Ossorio

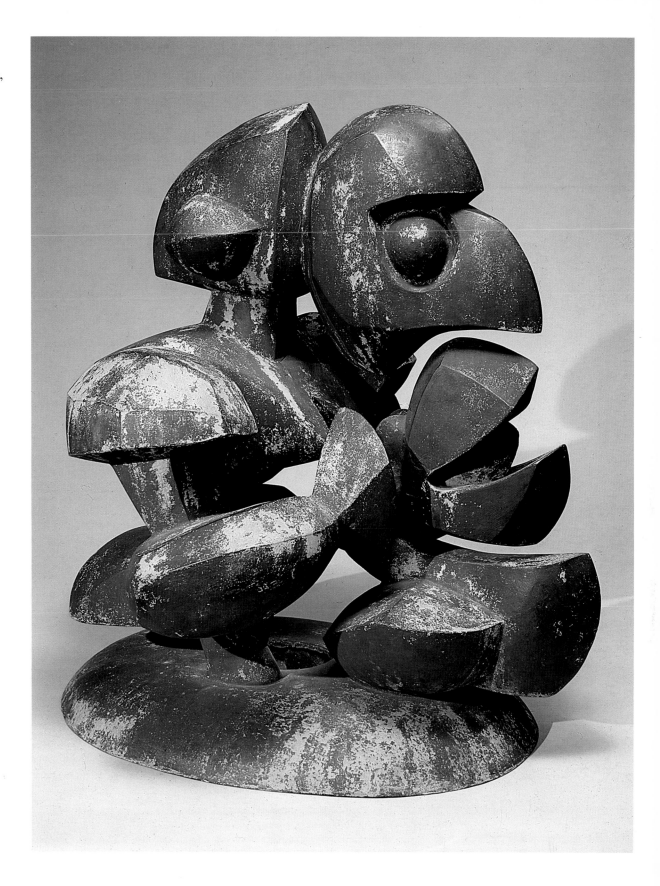

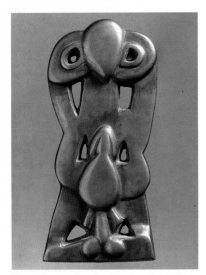

Henri Gaudier-Brzeska, *Doorknocker*, 1914. Bronze (variant of the original brass), 6⅞ inches high. Musée National d'Art Moderne, Centre National d'Art et de Culture Georges Pompidou, Paris.

Richard Pousette-Dart, *Two Figures*, 1938–39. Mixed media, 17 x 14 inches. Collection of the artist.

Gaudier-Brzeska created a number of small brass forms, called watchcharms, doorknockers, or paperweights, which symbolized "fecundity or virility."[73] *Doorknocker*, a small, hand-carved brass of 1914, is one of only a few works by Gaudier-Brzeska that can be directly related to a specific tribal art. It was inspired by the Maori jade ornaments (*hei-tiki*) from New Zealand.[74] These works were important for Pousette-Dart, who began in 1936 or 1937 to create small (2 by 3 inch), hand-carved brass sculptures (6). Both Gaudier-Brzeska and Pousette-Dart employ a Cubist reduction of form and meld machine iconography with biomorphic shapes in several of their small, symbolic brass sculptures (7). Similar forms can be found in other aspects of Pousette-Dart's oeuvre. The artist emphasizes that they are forms that were inherently in his imagination, whether expressed in sculpture or paintings (8).[75]

In his sculpture Pousette-Dart believes in an intuitive approach to materials through direct carving. He expresses this idea in a notebook entry from 1938, in which he asserts that "the cut object labored by hand with pointed tool from a solid block will ever be the superior sculptural means."[76] Cut from thick sheets of metal and hand filed, Pousette-Dart's brasses are totemic images, discrete symbols, which are intended to be worn or held. He compares them to early Chinese bronzes and to jades that were created to be held in the hand so that they "keep an actuality of themselves." He adds: "Mine is a tactile approach to art. People have mostly lost their tactile sense. I set up an asymmetrical flow in the metal. It is the fluidity people need to have The hand is a spiritual thing and is never still."[77] The brasses, he says, are "living things that become radiant when you wear them."[78]

Notebook pages dated May 1940 indicate that Pousette-Dart was looking at Iranian bronzes. On these pages he pasted photographs of Luristan bronzes from ca. 1000 BC.[79] The brasses are also related to South Pacific Maori jades, Precolumbian gold objects, and goldweights from West Africa. During the 1940s Pousette-Dart collected goldweights of the Asante people of Ghana, which were cast in brass.[80] These weights include geometric, human, and animal forms and utilitarian objects such as daggers, fans, and drums.

Some of Pousette-Dart's own brasses are pure abstract symbols, circles, ovals, rectangles, crosses, or letter combinations; others relate to biomorphic forms, suggesting birds, fish, and figural imagery

(9). The notebooks are filled with sketches of these important brasses, which are the "significant forms" in his own imagination realized through a contemplative, inward journey of self-exploration. In 1943 and 1946 the brasses (and several forms in silver) were exhibited at the Willard Gallery and in 1948 at the Betty Parsons Gallery.[81]

The artist prefers to work with brass rather than gold or silver because "brass can be more radiant and the value of precious metals would make the forms vulnerable to being melted and sold for their material. Working with brass appeals to me," he adds, "because it has no inherent value; its value comes only from the creative act of the artist."[82] Pousette-Dart continues to create brass sculptures in a variety of forms and sizes.

He has also explored the boundaries between sculpture and painting. In 1951 he received a Guggenheim Fellowship and during that year produced a remarkable array of paintings, wire sculptures, and collages that show experimentation with a wide range of nontraditional art materials.[83] Sculptures created with twisted filaments of wire have metal scraps randomly applied; some are sprayed with orange paint. Small found objects are embedded in collages and relief sculpture; they seem to be randomly placed, but they were actually arranged with a rhythmic order and unified by paint that is encrusted with sand and plaster. The artist gathered found objects, clothespins, bottle tops, buttons, safety pins, spoons, and fragments of photographs with an eye for their expressive potential in the creative process. Pousette-Dart's *Stone Panel (Mirror)*, 1948 (10), a collage with found objects and photographic fragments, juxtaposes disparate objects that take on new meanings through their complex internal relationships. Pousette-Dart sets up a dialogue between imagery and technique, a process explored by Picasso and Braque in 1912 with their development of Synthetic Cubism, in which techniques and materials stimulate the imagination and mimic the processes of the mind.

6 Untitled Brass Sculpture,
number 61, ca. 1940, 4⅛ inches

7 Untitled Brass Sculptures,
numbers 15, ca. 1942, 5 inches;
and 98, ca. 1940s, 3⅞ inches

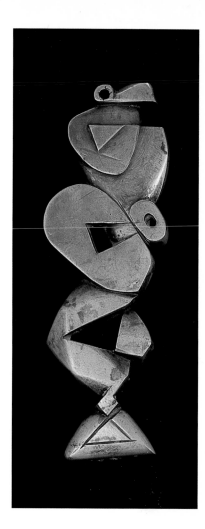

West Africa (Ghana), Asante people,
Goldweights. Brass. *Left to right:* peapod,
1⁵⁄₁₆ inches; fan, 1⁷⁄₁₆ inches; cock, 1⅝
inches; geometric, 1¾ inches; figure, 1¾
inches; dagger, 1⅜ inches. Indianapolis
Museum of Art. Gift of Mr. and Mrs.
Harrison Eiteljorg.

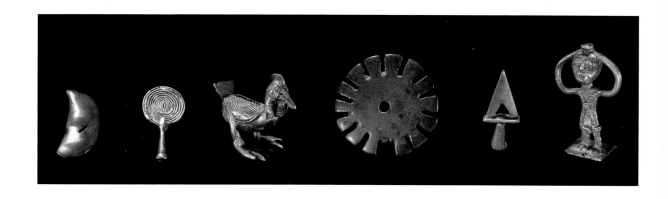

8 Untitled Brass Sculptures.
Clockwise from lower left:
numbers 23, 1989, 3 inches; 40,
ca. 1950, 3 inches; 87, ca. 1982,
5¼ inches

9 Untitled Brass Sculptures. *Top:*
numbers 21, ca. 1939, 3½ inches;
50, ca. 1937, 3½ inches; 62, ca.
1942, 4½ inches; 32, ca. 1937,
3 inches. *Bottom:* 80, ca. 1952,
3½ inches; 33, ca. 1938, 5 inches;
90, ca. 1943, 5½ inches; 91, ca.
1942, 5 inches.

10 *Stone Panel (Mirror)*, 1948
Oil and mixed media on stone,
35¼ x 21¾ inches
Collection of the artist

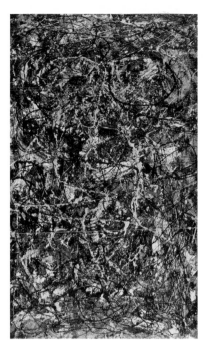

Jackson Pollock, *Full Fathom Five*, 1947.
Oil on canvas with nails, tacks, buttons, key,
coins, cigarettes, matches, etc., 50⅞ x 30⅛
inches. The Museum of Modern Art, New
York. Gift of Peggy Guggenheim.

A Pioneer Abstract Expressionist

In the 1940s, the formative years of the New York School, Pousette-Dart lived and worked in the Abstract Expressionist milieu even though he made an attempt to isolate himself from other artists to preserve his creative identity. He maintained his independence from the group and later wrote: "I was not close with any of them, the artists of the 40s. I knew them all—they all knew me but there was nothing of the camaraderie that people think there was. The relationship was more that these were a group of artists struggling—[and] working."[84] He developed works that at times were close to those of Graham and his contemporaries Pollock, Baziotes, and Gottlieb. He shared their preoccupation with myth and symbolism and used totemic imagery and references to primordial sources throughout the 1940s. But his paintings display a degree of conceptual control that distinguishes him from his contemporaries in two distinct ways. First, he used underlying compositional grids that function like Cubist infrastructures, controlling the surface depth; second, his careful application of paint and fine tuning of surface textures distances him from the freely brushed and poured paintings of his contemporaries. Pousette-Dart's *Fugue Number 4*, 1947 (1) has a grid-like structure that locates the biomorphic forms within a narrowly defined chamber of space, while Pollock's *Full Fathom Five*, 1947, has a less structured composition, created by pouring paint on canvas. The balance and harmony in Pousette-Dart's painting is achieved through the interweaving of white paint throughout the composition, which carefully echoes the biomorphic forms and the compartments of the grid, while maintaining its own independence from the forms beneath.

World War II was an important catalyst for the development of Abstract Expressionist subject matter and form. The war produced epic changes in history and in the way people thought about the stability of the world and the political, social, and intellectual climate. "The history of my generation," Barnett Newman said, "begins with the problem of what to paint. . . . [T]he war . . . made it impossible to disregard the problem of subject matter."[85] The destructive power of nuclear armaments was made clear with the dropping of the atomic bomb on Hiroshima, and the depth of the potential for human cruelty was brought into focus as the horrors of the death camps became known in this country in the early 1940s. In the waning days of World War II, and during the Cold War that

followed, the Abstract Expressionists addressed these issues through allegory, metaphor, and symbol as they sought a new abstract language to express interior states of mind.

Pousette-Dart's paintings from this period reflect his preoccupation with the devastation of World War II. *Crucifixion, Comprehension of the Atom*, 1944 (11), and *The Atom, One World*, 1947–48 (67), refer to the historical crisis directly through imagery and titles that evoke the effects of atomic bombs, global war, and annihilation. The mushroom-shaped cloud of destruction is the central motif in *The Atom, One World*, while human suffering, as embodied by the crucified Christ, is the subject of *Crucifixion, Comprehension of the Atom*. The tradition of using the crucifixion as a vehicle to express transcendental suffering is well known in Western iconography. Matthias Grünewald's *Isenheim Altarpiece*, 1515–16, provided modern artists with "one of the few traditional expressions of suffering potent enough to correspond to the spiritual and physical ordeal of the modern world."[86] It inspired both Max Ernst's *Crucifixion*, 1913, created on the eve of World War I,[87] and Picasso's *Crucifixion*, 1930.[88] Like Picasso, Pousette-Dart combines the romantic idea of expressing supernatural experience through natural means with biomorphic imagery.

Pousette-Dart's preoccupation with the war, and its emotional and psychological effects, is expressed in his paintings from this period. The political and economic shifts brought about by the depression and the war caused him and the other Abstract Expressionists to gradually turn inward, creating individualistic works that had no overt social messages. The Surrealist interest in subliminal content, known to the New York artists through the presence of many of the great European Surrealists in New York during the 1940s, had a liberating effect on American artists. John Graham stressed the importance of automatic writing, a technique, he argued, that evolves from both training and improvisation and that an artist should use in combination with thought and feeling.[89] Like other American artists, Pousette-Dart was not interested in losing himself in automatist trances; however, the idea inherent in automatism that the artist was not responsible for the "legibility of the depiction"[90] reinforced his interest in exploring the unconscious as a means of expressing spirituality. This aspect of automatist theory gave artists license to create

11 *Crucifixion, Comprehension of the Atom*, 1944
Oil on linen, 77½ x 49 inches
Collection of the artist

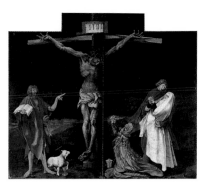

Matthias Grünewald, *The Isenheim Altarpiece*, ca. 1510–15. Center panel, Crucifixion, approx. 106 x 121 inches (closed). Musée Unterlinden, Colmar. (Scala/Art Resource)

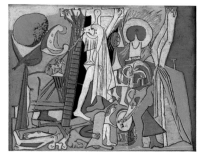

Pablo Picasso, *Crucifixion*, 1930. Oil on wood, 20⅛ x 26 inches. Musée Picasso, Paris. (© 1990 ARS N.Y./Spadem)

images they did not understand and that they were not obligated to explain. Pousette-Dart, like Graham, believed that the unconscious and intuition were pathways to a greater vision. Pousette-Dart wrote, "as intuition is the greater real eye—as subconscious is the superhuman mind."[91] Pousette-Dart was among the artists who used spontaneity as a new approach to the creative process, a means of tapping the potential of the unconscious. But like other Abstract Expressionists, and perhaps to a greater extent than his colleagues, he replaced pure psychic automatism with a more controlled form that addressed both painterly and iconographic concerns in keeping with his philosophy about the importance of the intellect in the creative process.

The impact of the Surrealists' presence in New York during the 1940s can be seen in such Pousette-Dart works as *Within the Temple*, 1945 (12), and *Golden Eye*, 1945–46 (13), both curvilinear compositions employing the organic imagery of cells and eyes that recall the works of Miró and Matta (see also 14, 15). These freely drawn images indicate that Pousette-Dart was well-versed in Surrealist techniques. However, many of his works have linear elements that structure the compositions and indicate that his use of automatism was only a starting point in his search for "significant form." The use of spontaneity, tempered by intellect, enabled him to express emotional content through a set of themes related to his own personal and cultural history. He expressed spiritual values through an aesthetic of metamorphosis, related to Surrealism, "to make visible what cannot be seen."[92]

Spontaneity in Pousette-Dart's work is also linked to his intuitive reactions to materials throughout the painting process. For him, "Art [expresses] the gamut of experience, emotional and intellectual— beautifully expressed with material integrity."[93] His paintings frequently change radically during their creation as meaning emerges from the creative act itself. In a catalogue for the Willard Gallery in 1945, he wrote, "Painting is a feeling thinking, a material awareness of spirit, a sense of direct experience which transcends any intellectual method."[94] In his drawing *Untitled*, ca. 1941–50 (16), a large, primitive biomorphic cell defines a compositional structure in an environment populated by smaller cellular shapes. The forms float in an aquatic field created by a freely applied color wash. This combination of iconography with process is characteristic of many works created by the Abstract Expressionists in the 1940s,[95] such as Rothko's *Baptismal Scene*, 1945, and Newman's *Untitled*, 1945.

The juxtaposition of structured composition and clearly delineated forms with a sense of freely applied "spontaneous" colors links his monumental *Symphony Number 1, The Transcendental*, ca. 1941–42 (17), one of the first large-scale works of the Abstract Expressionist movement, with European Cubist and Surrealist antecedents. Pousette-Dart uses the artistic process as a metaphor for creation and growth. He and the other Abstract Expressionists create forms that link an iconography of the unconscious with the process of creating the work of art. He emphasized the importance of the act of painting and explored, and was guided by, the physical properties of the paint itself. In *Symphony Number 1, The Transcendental* energized circular areas appear to be literally dripping paint, and textures vary as Pousette-Dart juxtaposes heavily impasted areas with sweeping, calligraphic lines. The underlying grid provides a structure for the biomorphic and geometric forms he employs to communicate content from within.

In this painting the abstract images are on the edge of recognition, in the Jungian sense of being familiar yet unknown. The forms in the painting can be read as natural phenomena or sophisticated mechanical anomalies. Ultimately, the forms elude definition, precluding a simple reading of the painting. They are tenuously and ambiguously suggested, which leaves the viewer with an overall impression of ancient and cosmic symbols, suggesting first glimmers of consciousness.

The painting pulsates with energy and resonates with somber tones of deep purples, crimsons, and ochres. Quasars, microorganisms, ancient scythes, horns of a bull, and abstracted animal forms suggest cosmic events, exploding galaxies, or primitive beginnings. Bird forms in the lower left are similar to ancient American Indian birdstones. Curvilinear forms in the upper left recall the shapes of ancient bannerstones known to Pousette-Dart through his frequent visits to the American Museum of Natural History in New York. Using a dense metaphorical vocabulary of symbols linking our consciousness with the past, Pousette-Dart has created a sense of continuity with ancient origins. He has made explicit his intention to avoid romanticized or easily accessible imagery. "Surface and outward appearance," he says "are often deceptive and superficial, even seductive, but the basic core of a painting must always be the same: concern with inner intention and meaning."[96] In creating *Symphony Number 1,*

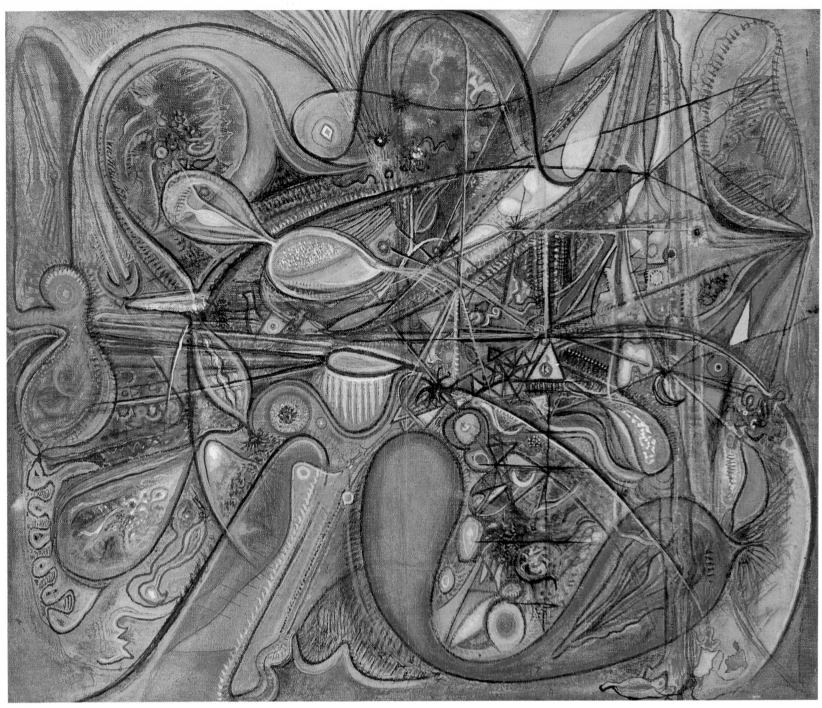

12 *Within the Temple*, 1945
Oil on linen, 20 x 24 inches
Collection of the artist

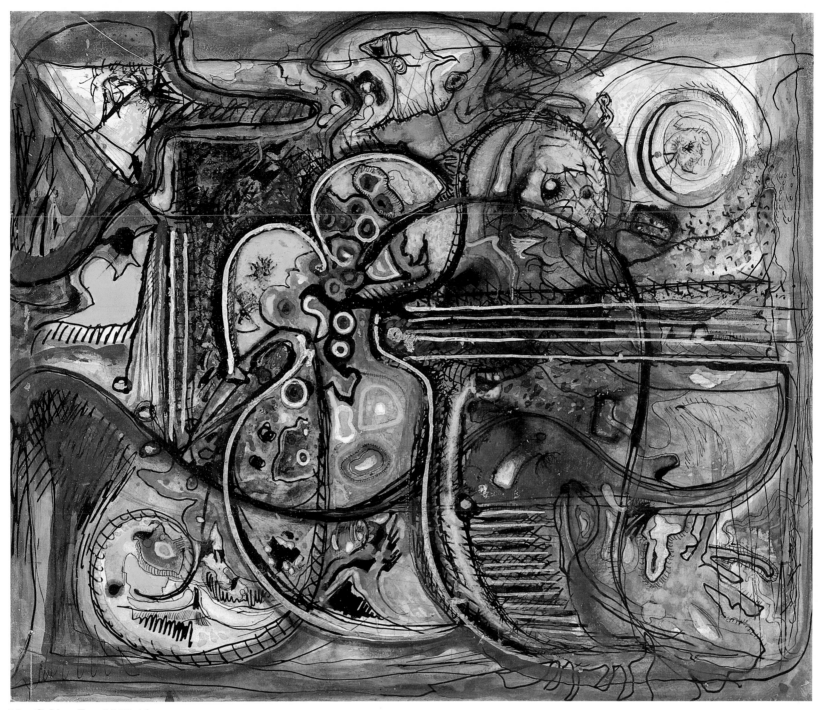

13 *Golden Eye*, 1945–46
Watercolor and ink on gesso
board, 20 x 24 inches
Collection of the artist

14 *Garnet Realm*, 1941–43
Mixed media; watercolor,
pen and ink on paper,
31⅝ x 22⅞ inches
Collection of the artist

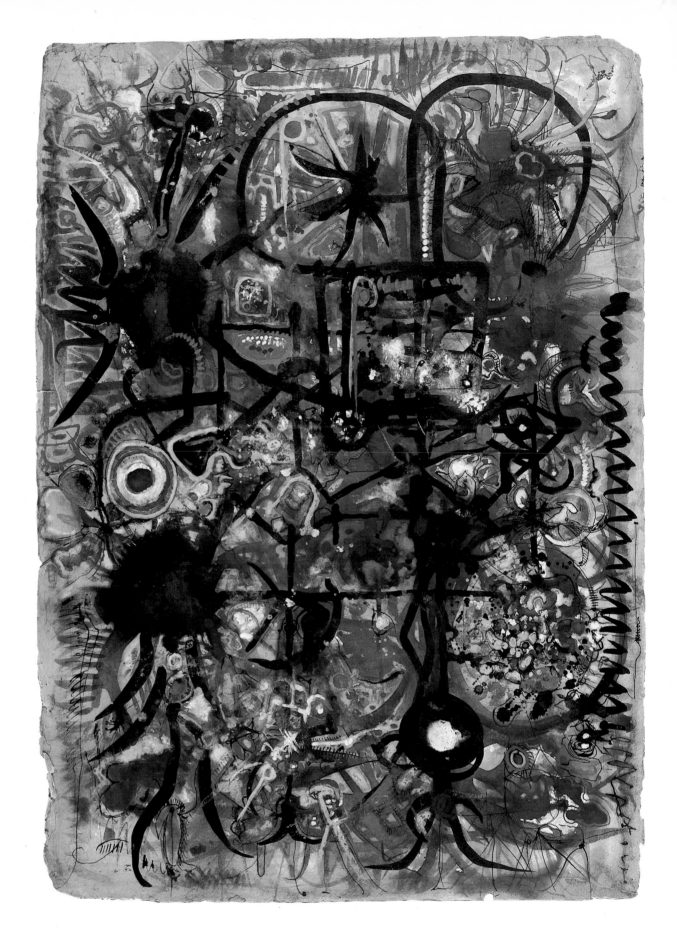

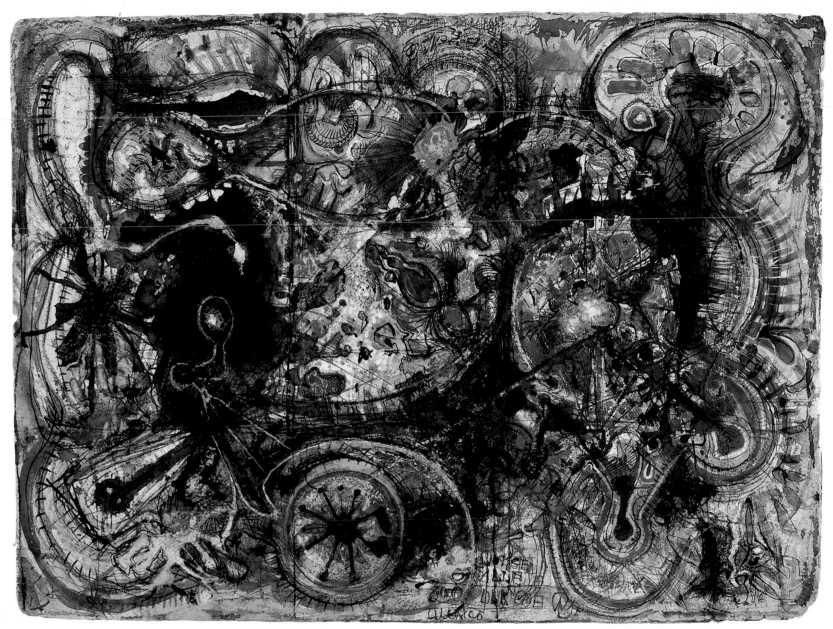

15 *Abyss of Blood*, 1941–43
Mixed media; watercolor,
pen and ink on paper,
22⅞ x 31½ inches
Collection of the artist

16 Untitled, ca. 1941–50
Watercolor and gouache on
paper, 8 x 6½ inches
Herbert F. Johnson Museum of
Art, Cornell University
Gift of Mr. and Mrs. John M.
Goodwillie

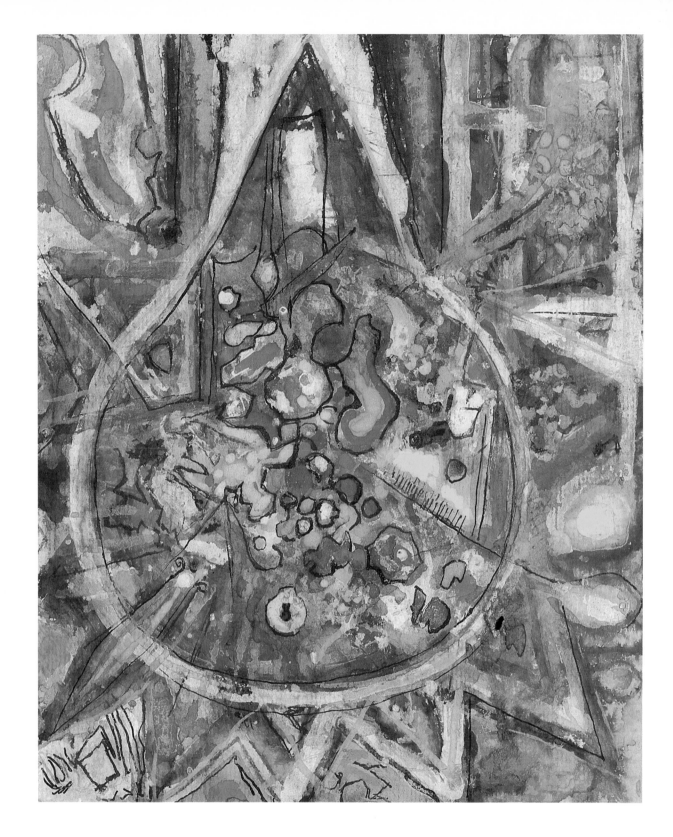

Detail of *Symphony Number 1, The Transcendental*, ca. 1941–42

North American Indian (Ohio), *Birdstone*, slate, 4⅜ inches long, and North American Indian (Arkansas), *Bannerstone*, stone, 3 inches wide. Both late archaic/early Woodland period, 3000–300 BC. Indianapolis Museum of Art. Gift of Mr. and Mrs. Earl C. Townsend, Jr.

The Transcendental the artist wanted to avoid a facile reading of the painting that would obviate the spiritual intentions and preclude direct experience of the iconography of process and the imagery suggesting the force and resiliency of the unconscious.

In this painting, as in other paintings from this period like *Fugue*, 1940 (18), the influence of Analytic Cubism can be seen in the use of a layered and rigidly ordered geometric grid that confines the compositional elements within a relatively narrow chamber of space. The thick impasto of *Symphony Number 1, The Transcendental* both conceals and reveals the horizontal and vertical structure, which is activated by a series of circles, semicircles, and ovals interwoven into the fabric of the grid. The circles appear to be spewing vitality and life forces in a series of related equivocal motions (actions and reactions) that are at once analogous to the random explosions of a meteor and to the ordered interior motion of a clock. Pousette-Dart explores motion and time as expressions of the transcendental. A visit to his studio today confirms his lifelong fascination with clocks and mechanical objects[97] and his curiosity about "how things work."[98]

As their titles suggest, *Symphony Number 1, The Transcendental* and *Fugue* have affinities with music. The polyphonic and fugal passages of Bach's compositions are echoed in these paintings and in many others. John Graham's description of music also provides an interesting touchstone for a reading of Pousette-Dart's compositional structures for these paintings. Graham wrote: "Music consists of series of silences, pauses, i.e. spaces tightly bound by sound into an organic pattern. Small silences, opposed to large silences, curved silences to angular silences, etc. Silence is a portion of space measured by time."[99] Graham related the idea of silence in painting to space,[100] which can be used to express transcendence. Pousette-Dart expressed similar ideas about musical and spatial relationships: "Sometimes I feel my paintings exist not on canvas but in space, like musical progressions."[101] The biomorphic forms in *Symphony Number 1, The Transcendental* are encased in grids and circles suggesting sequences, pauses, and spaces: time bound into pattern.

In the 1950s Pousette-Dart created a group of paintings that were shown at the Betty Parsons Gallery in an exhibition entitled *Predominantly White*. Works like *White Garden, Sky*, 1951 (19), exhibit a striking innovation "so beautifully realized that it would not have occurred to anyone that a shortage

of funds for paint was responsible for the departure."[102] Exploring the physical characteristics of simple materials on large-scale canvases, Pousette-Dart made pencil drawings on titanium white grounds, as also seen in *Descending Bird*, 1950–51 (20). Smooth, white surfaces are enlivened with individual pencil marks, which nonetheless create a feeling of quiescence. White paintings from this period, such as *Descending Bird* and *Path of the White Bird*, 1950–51 (21), have finely delineated compartments and spiraling biomorphic shapes that resemble birds and serpents. The bird form, a recurring image in Pousette-Dart's paintings and brasses (22, 23), is a symbol of freedom for the artist, who has written, "Out of enmesh and the ashes arises the bird pure and free."[103]

The contemplative quality of these works, produced by the calligraphy, suggests a Far Eastern influence and perhaps an exchange of ideas with Mark Tobey, who was creating paintings with delicate traceries of lines known as "white writing." Both artists exhibited at the Willard Gallery, shared an interest in mysticism and universal consciousness, and unified their compositions with allover, calligraphic imagery. Tobey's views were shaped by his Bahai beliefs; Pousette-Dart found inspiration in a number of religious sources, believing that the doctrinaire aspects of any one religion were too confining.[104] Both Pousette-Dart and Tobey use linear play to convey content. Tobey's "white writing" is composed of tightly meshed webs of white lines; Pousette-Dart's calligraphy is more freely dispersed on open fields conveying a rhythmic sense of movement around veiled biomorphic forms.

In a later series of hand-colored etchings including *Crystal Forest*, 1979–80 (24), and *Black and White Quartet*, 1979 (25), Pousette-Dart continues to create allover calligraphic fields that invite contemplation. The quality of the line varies, creating different moods; it is delicate and ethereal in *White Awakening*, 1980 (26), and bold and assertive in *Iconography*, 1979–80 (27). The fluctuating sense of depth achieved through an interweaving of white gouache and black line frees the viewer from a fixed sense of perspective. The spiritual vitality in the rhythmic linear patterns recalls the work of the great Chinese masters of calligraphy, who expressed an internal continuity of spirit by identifying brush stroke with an inner force.

17 *Symphony Number 1, The Transcendental,* ca. 1941–42
Oil on linen, 90 x 120 inches
Collection of the artist

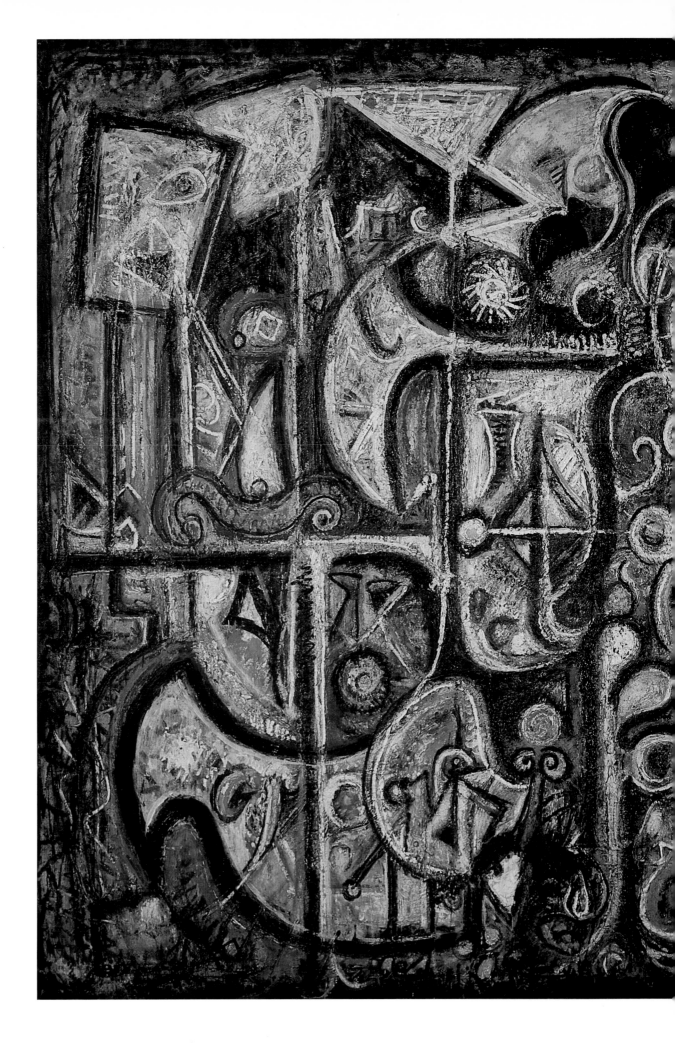

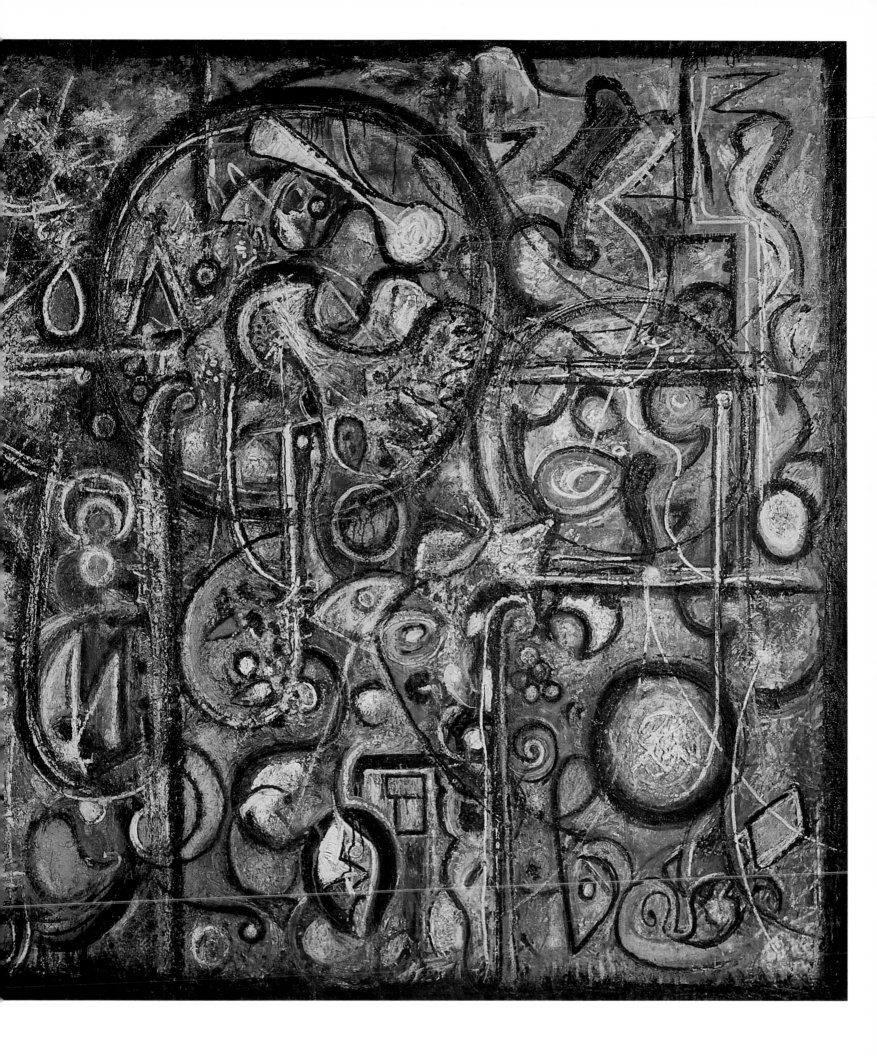

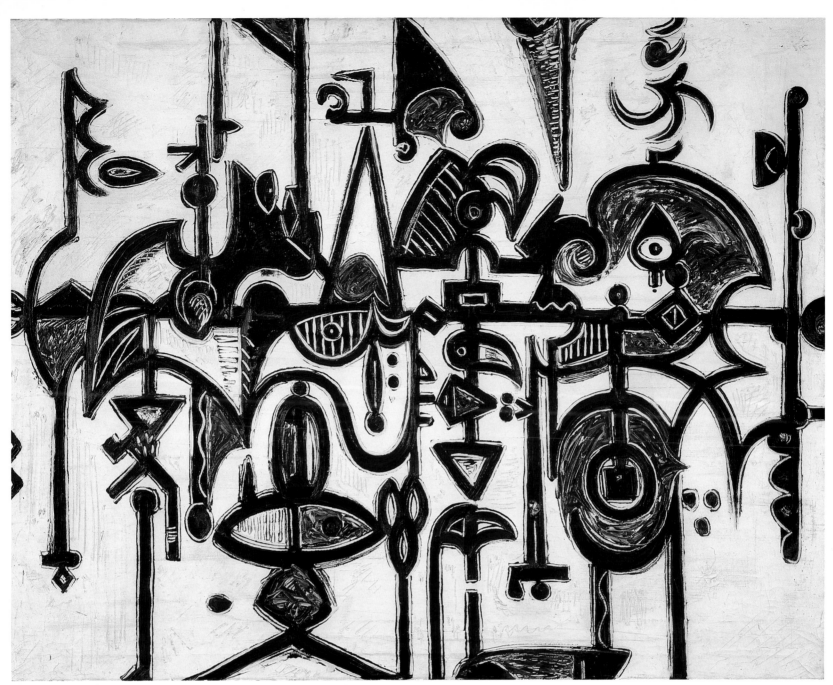

18 *Fugue*, 1940
Oil on linen, 40 x 51 inches
Collection of the artist

19 *White Garden, Sky*, 1951
Pencil and oil on linen,
53½ x 60¾ inches
Collection of the artist

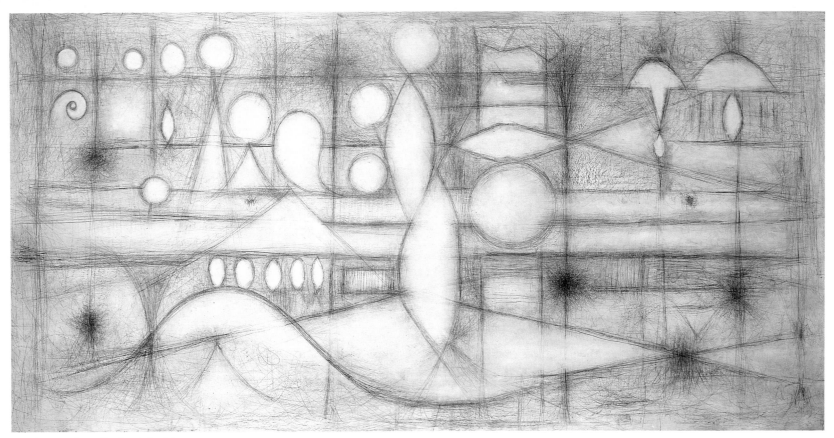

20 *Descending Bird*, 1950–51
Pencil and oil on panel,
48 x 96 inches
Collection of the artist

21 *Path of the White Bird,*
1950–51
Oil on linen, 68 x 115 inches
Private Collection

22 *Bird Forms*, 1943–44
Gouache on handmade paper,
31¼ x 22⅝ inches
Collection of the artist

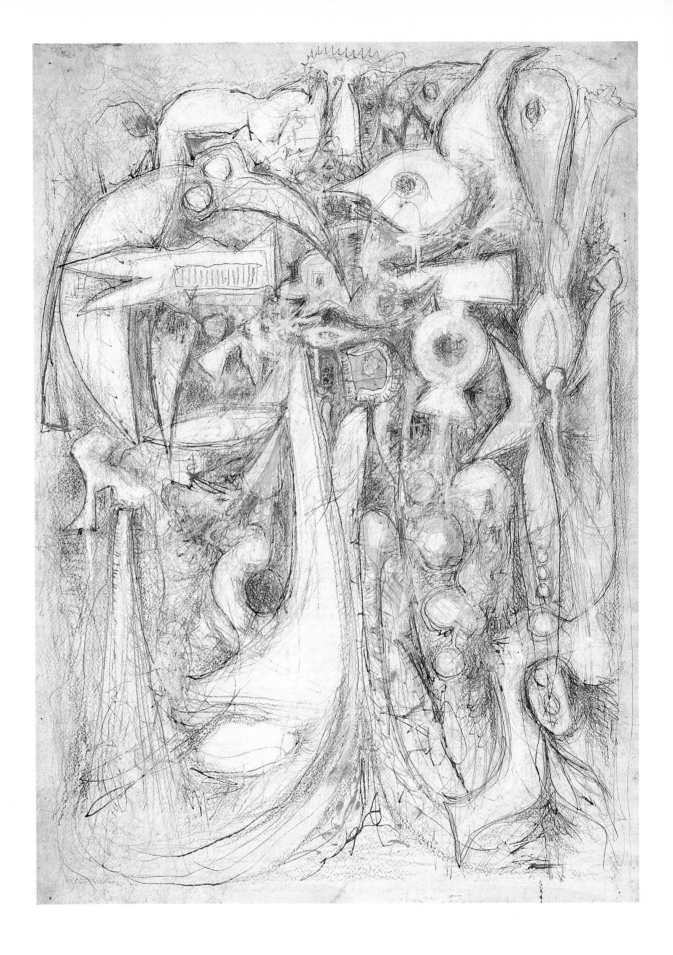

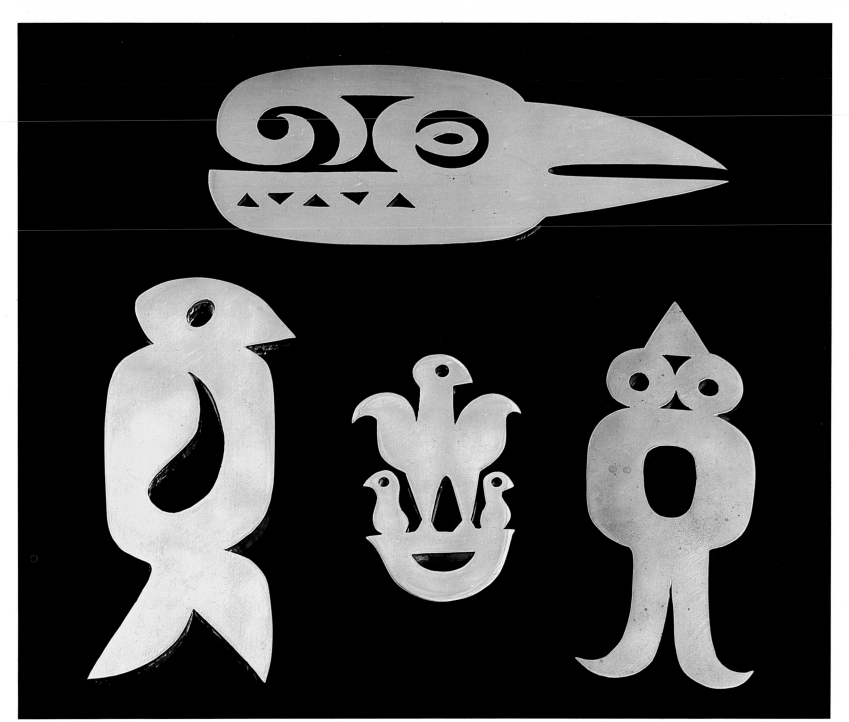

23 Untitled Brass Bird
Sculptures. *Top:* number 97,
1938, 6 inches. *Bottom:* 2, ca.
1944, 5 inches; 5, ca. 1943–50,
3 inches; 65, ca. 1946, 4½ inches

24 *Crystal Forest,* 1979–80
Hand-colored etching,
18 x 23⅞ inches
Collection of the artist

25 *Black and White Quartet*, 1979
Hand-colored etching, first state,
black carbonnet on German
etching paper, 17⅞ x 23⅞ inches
Collection of the artist

26 *White Awakening,*
June 5, 1980
Etching, second state,
on BFK Rives paper,
17⅞ x 23¾ inches
Collection of the artist

27 *Iconography*, 1979–80
Hand-colored etching, first state,
17⅞ x 23¾ inches
Collection of the artist

Nicolas de Stael, *Le Chemin Difficile*, 1948.
Oil on canvas, 39⁹/₁₆ x 32 inches.
Indianapolis Museum of Art. Gift of Mrs. F.
Robert Hensel in memory of Robert Hensel.

Later in the 1950s color became an important
expressive vehicle for Pousette-Dart. He continued
to create hieratic images, related to the biomorph-
ism of earlier works, but added brilliant colors that
suggest the luminosity of stained glass windows, as
seen in *Blood Wedding*, 1958 (84). Other paintings
from this period, like *Golden Dawn*, 1952 (74),
have delicate, golden-washed surfaces, which
suggest an underlying density. Ephemeral shapes
appear simultaneously as abstract "presences" or
allusions to figures. The delicate quality of the
paint, achieved by applying multiple thin layers,
creates a quivering light that enhances the veiled
presences. Shifting biomorphic forms emerge and
fuse with the ground, conveying a sense of meta-
morphosis. Pousette-Dart's mastery of line and
subtle compositional harmonies distance him from
the gestural painters, and his continued interest in
expanding his vocabulary of form and symbol
separates him from such Abstract Expressionist
colleagues as Rothko and Newman, who were
distilling their vocabularies and focusing on specific
imagery.

Pousette-Dart was also exploring a wide range of
surface textures. *Cascella II*, 1952 (28), has a
thickly encrusted surface that contrasts sharply with
the flatness of the pencil and oil canvases and with
the golden-washed canvases of the early 1950s. He
continued to work with heavily textured canvases
throughout the decade. The surface of *Shadow of
the Unknown Bird*, 1955–58 (81), has a raw quality;
its dense layers of paint contain primeval scratches,
biomorphic forms, and skeletal structures that
appear to have been chiseled into the surface. The
dense surface of *White Gothic Number 5*, 1961 (29),
resembles the stuccoed texture of Nicolas de Stael's
Le Chemin Difficile, 1948.

Like his Abstract Expressionist colleagues, Pousette-
Dart explores the physical characteristics of ma-
terials and techniques as a means of expanding his
formal vocabulary. His method of painting involves
an assiduous technique of applying layer upon layer
of paint. During the process forms merge, disappear,
and sometimes resurface again, and he has been
known to work on paintings for decades. A
description of the application of the paint in *White
Gothic*, 1957, suggests the complexity and
experimental nature of Pousette-Dart's technique,
which is central to his idea of fine-tuning the
surface of the canvas to achieve harmony and
balance:

*The initial paint layers were relatively thinly applied
with brush and knife as marks indicated. Sub-
sequent paint applications were [squeezed] directly
from the tube, judging by the extremely "short"
quality of the paint, building up considerable thick-
ness working with brushes, spatula or knife and the
end of the paint tube to texture. The paint was only
blended slightly in the process, not worked into a
continuous layer, leaving voids and hollows and
pulling paint into delicate peaks and strands. Some
thick buildups of paint are pressed flat from contact
with another surface.*[105]

The artist has used various combinations of oil,
pencil, sand, and acrylics in paintings and water-
color, gouache, pen and ink, and oil and graphite
in his drawings and etchings. His philosophy about
the individual nature of creativity leads him to a
personal fusion of the conceptual and technical
aspects of painting. The blend is the crucible for
creating his art, which he describes as a "reflection
of being."[106]

In the paintings of the 1960s and 1970s Pousette-
Dart uses dense fields of gestures, radically sim-
plified compositions, and a highly developed sense
of color harmonies to convey spiritual content and
meaning. The physical vitality and tension of the
paintings, which translate into a visionary quality,
come from the interplay of texture and light-
generating color fields. However, he differs from the
color-field painters—Rothko, Newman, Still, and
others—in his emphasis on the complexities and
harmonies of the textural field and in the broad
range of iconic references he has used for fifty
years. Using his own version of a pointillist tech-
nique, he creates radiant surfaces filled with a
personal vocabulary of forms. *Hieroglyph of Light*,
1966–67 (30), has a dense, allover surface texture
animated by biomorphic shapes; a calligraphic web
unifies the pictorial surface as the eye traverses the
rectangular format. The delicate calligraphy
contrasts with the raw, brash strokes of his contem-
poraries Franz Kline and Willem de Kooning;
Pousette-Dart infuses these works with a con-
templative, Far Eastern spirit that is similar to that
found in the calligraphic works of Mark Tobey.
Imploding and exploding cosmic orbs (31),
references to the planets (32), allover fields of

28 *Cascella II*, 1952
Oil on canvas, 65⅝ x 45 inches
Hirshhorn Museum and Sculpture
Garden, Smithsonian Institution
Joseph H. Hirshhorn Bequest,
1981

30 *Hieroglyph of Light*, 1966–67
Oil on canvas, 43 x 57 inches
Collection of Joanna Pousette-Dart

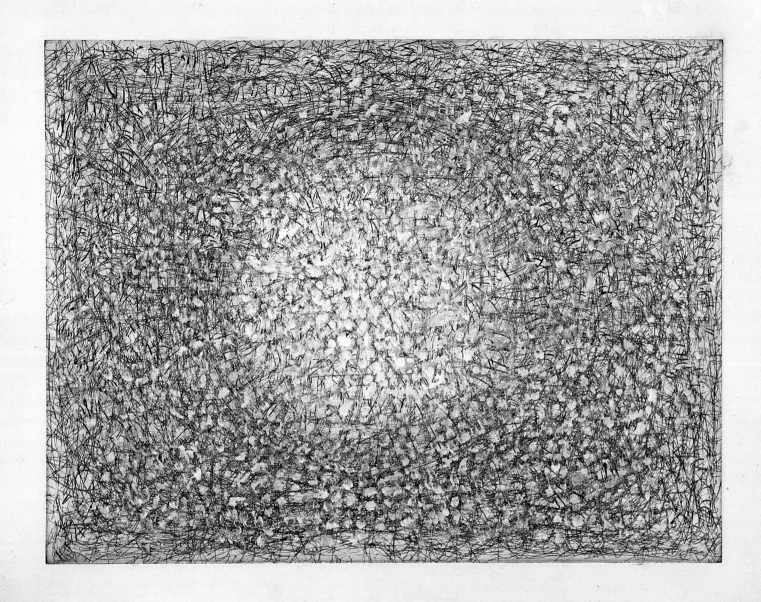

31 *Imploding Circle*, 1981
(Original etching, 1979)
Hand-colored etching,
17⅞ x 23⅞ inches
Collection of the artist

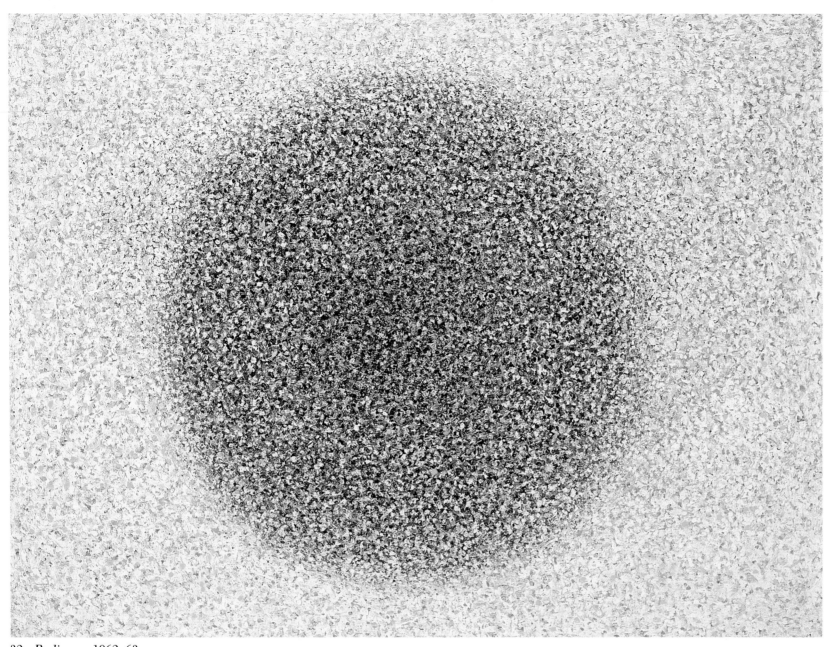

32 *Radiance*, 1962–63
Oil and metallic paint on canvas,
72⅛ x 96¼ inches
The Museum of Modern Art,
New York
Gift of Susan Morse Hilles, 1964

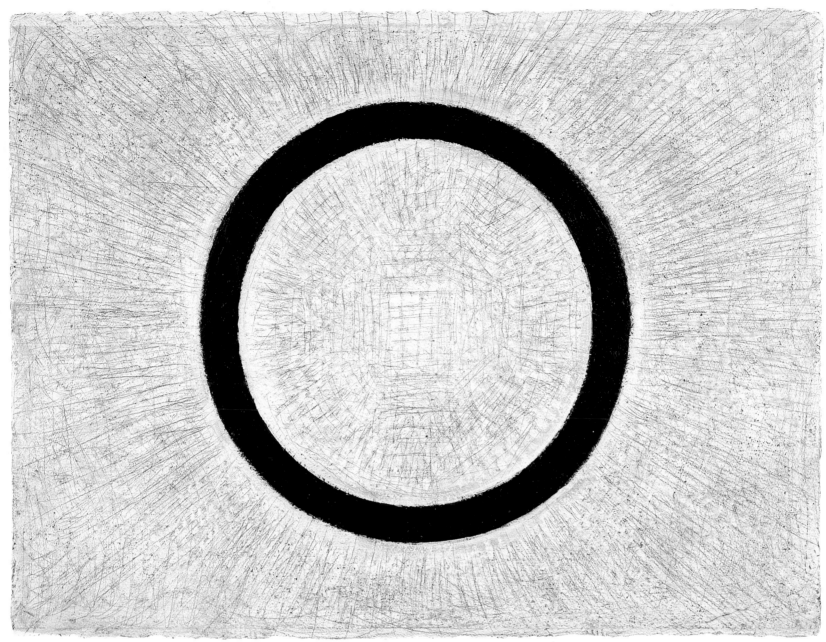

33 *Circle of Multifarious
Precisions*, 1981
Acrylic, graphite, and gesso
on handmade paper,
22⅝ x 30¼ inches
Collection of the artist

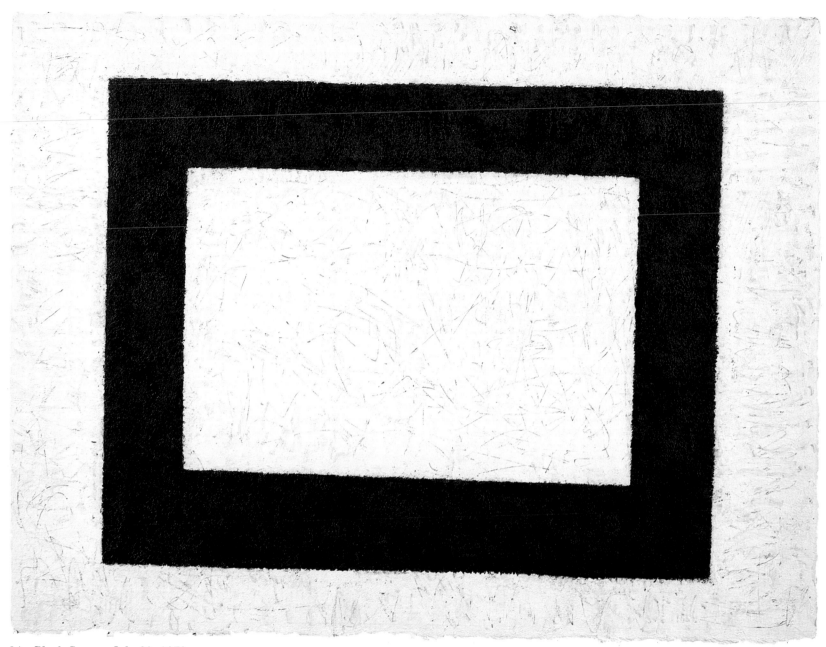

34 *Black Square*, July 30, 1978
Acrylic, graphite, and gesso
on handmade paper,
22⅝ x 30¼ inches
Collection of the artist

infinite space, and pure geometric abstractions appearing as metaphysical emblems (33, 34) take him beyond the iconic vocabulary of the color-field painters.

Other paintings from the 1960s, like *Presence Red*, 1968–69 (35), have circles and floating orbs that serve as focal points. These contemplative images were built up with minute particles of paint, creating light-filled surfaces that are visual metaphors for celestial imagery and cosmic events. *Imploding Light*, 1967 (103), has a dominant circular image in flux, composing or decomposing as the title suggests, in the center of a field of blue and gray. Works like *Radiance, White Center*, 1960 (36), and *Celebration, Birth*, 1975–76 (37), continue the exploration of cosmic imagery to evoke spirituality. The vast, luminous field of *Celebration Birth* suggests a brilliantly lit night sky, filled with quasars. In *Pulsating Center*, 1978 (38), using only graphite on paper, he created a hypnotic image that is substantive in form and yet ethereal in mood.

In works of the 1970s, such as *Radiance* (89) and *Presence, Genesis* (86), Pousette-Dart created luminous fields through small, repeated gestures of color. The allover effects create realms of potential meaning that lead one to the true intent of the paintings from this period: the evocation of universal spiritual truths through concrete perceptual experience with vast fields of light, color, and texture. The experience is heightened by the tension produced through the juxtaposition of the delicate surface quality with the powerful physical impact created when the viewer's field of vision is completely filled. The effects produced by Pousette-Dart's large-scale color-field paintings parallel two of Edmund Burke's criteria for the evocation of the sublime: simplified compositions and greatness of dimension.[107] Vague notions of the sublime were discussed by New York School artists, who used it as an inspiring myth and even held a symposium in 1948 to discuss its nature in art.[108]

Between 1978 and 1980 Pousette-Dart created a series of black and white paintings that are minimal in form but have richly textured, evocative surfaces. The hieratic, centralized black and white motifs of these paintings are a dramatic shift from the allover color fields of vibrating light. The mandala-like geometry of the black and white paintings takes form as circles within circles in *Black Circle, Time*, 1979–80 (39); spirals in *Venice, Nightspace*, 1981–82 (40); and triangles, squares, and circles in *The Square of Light*, 1978–80 (41). In *White Circle*, *Time*, 1979–80 (42), and *Beyond Space*, 1979–80 (43), hypnotic circles, embedded in squares, invite contemplation. The artist has limited his palette to white and black, and yet he has created an extraordinary range of tonalities. In these works multiple gradations of tone slowly emerge in the shades of gray that circumscribe black or white circles. These vibrating tonalities appear when the viewer intently looks at the edges of the images, which represent, as the whole work of art does, the "dynamic edge between the conscious and the unconscious."[109] The points of transition, the edges between the circles and the square of the background, set up a dynamic of metamorphosis that is central to an understanding of the contemplative qualities of this series, revealed over time.

The experience created for the viewer reflects Pousette-Dart's philosophy about the relationship between art and reality: "Art lies behind the cloth of surface things, it is always deeper than appearance and must be delved for."[110] He speaks of the necessity for significant paintings to have "the possibility of contemplation so they can draw out of people the things they have in them."[111] The spiritual connotation is reinforced through his choice of geometric icons: circles, triangles, and squares that have traditionally been used in Western and Eastern cultures to symbolize spirituality (44, 45).

The dualities of black and white and circles placed within squares represent the union of opposites and set up a paradoxical dialectic that Pousette-Dart has explored in his writings and art for six decades. In a 1939 notebook he drew diagrams of squares and circles and wrote: "Symbol of eternal relationships between man and God, heaven and earth, man and cosmos, circle of spirit, square of matter, circle of God, square of man, circle of cosmos, Square of micro[co]smos, square of the circle." Jung suggests that a circle is a traditional symbol for heaven or perfection, and the square represents the lowest of the composite and factorial numbers. Together they symbolize the pluralist state of man who has not achieved inner unity (perfection), while the circle would correspond to this ultimate state of Oneness.[112] A white circle symbolizes energy and the black square telluric forces.[113] The simplicity of this iconography, with its accretion of identities from both Western and Eastern cultures, is charged with fresh meaning through the large scale of the canvases, complex textures, and minute, shifting tonal variations.

35 *Presence Red*, 1968–69
Oil on canvas, 80 x 80 inches
Collection of the artist

36 *Radiance, White Center*, 1960
Oil on paper, 11½ x 11½ inches
Collection of the artist

37 *Celebration, Birth*, 1975–76
Acrylic on canvas,
72 x 120 inches
Collection of the artist

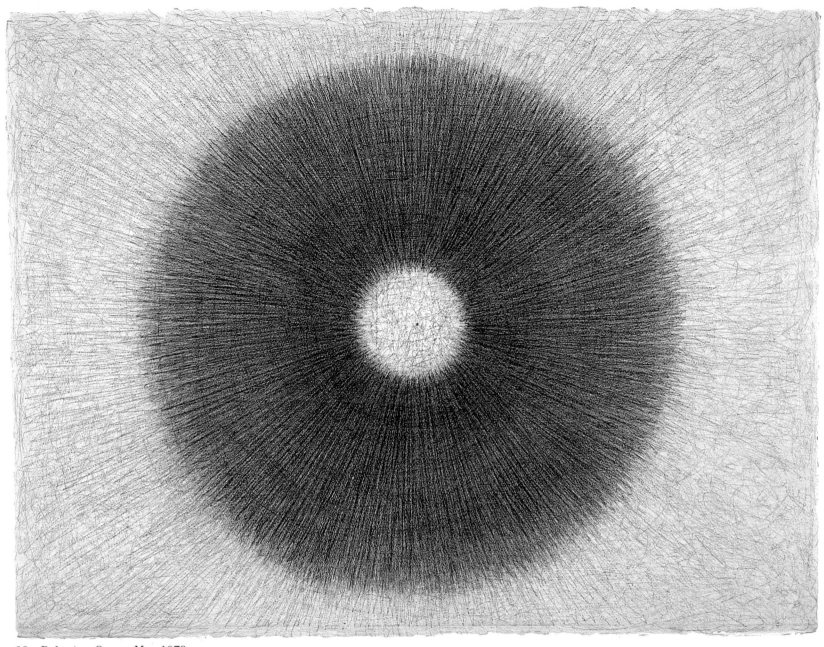

38 *Pulsating Center*, May 1978
Graphite on handmade paper,
22⅞ x 30⅜ inches
Collection of the artist

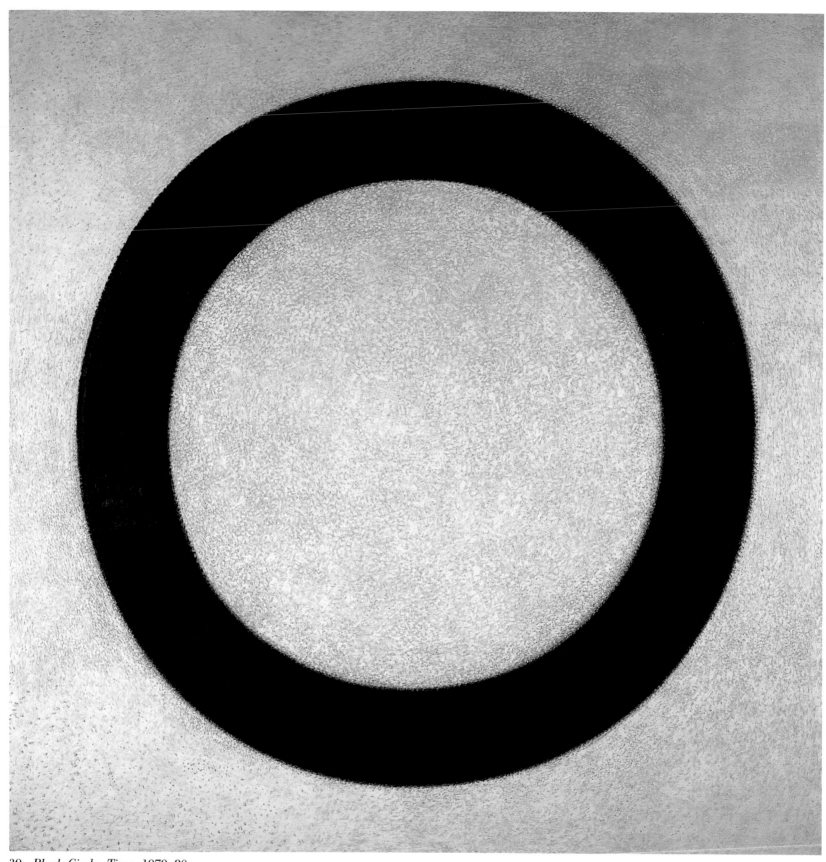

39 *Black Circle, Time*, 1979–80
Oil on linen, 90 x 90 inches
Collection of the artist

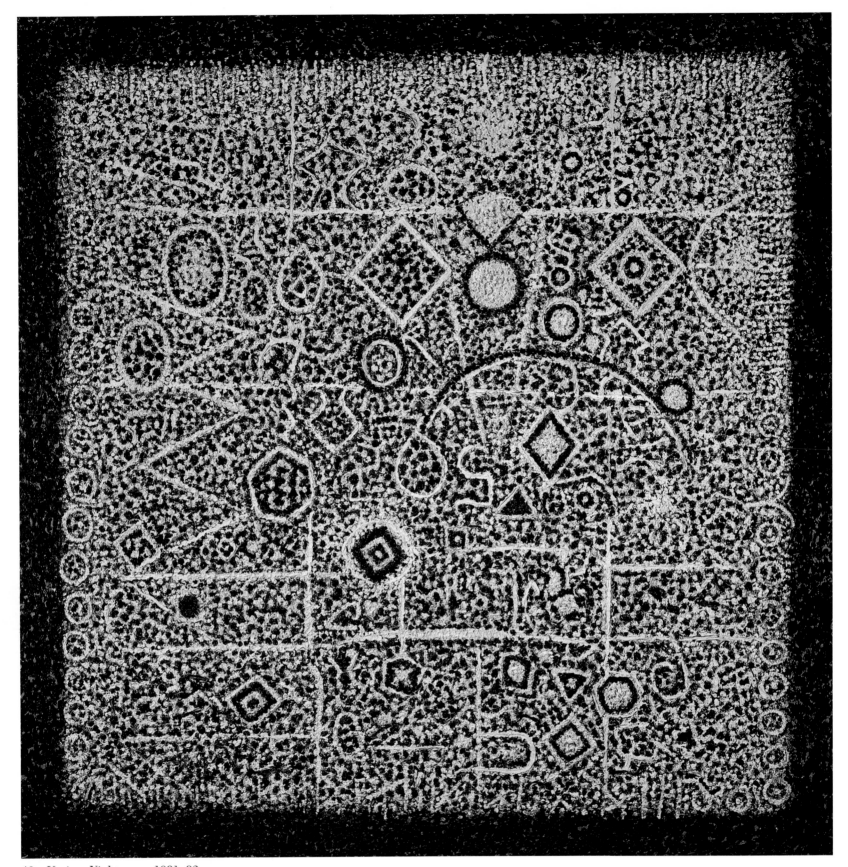

40 *Venice, Nightspace*, 1981–82
Oil on linen, 90 x 90 inches
Collection of the artist

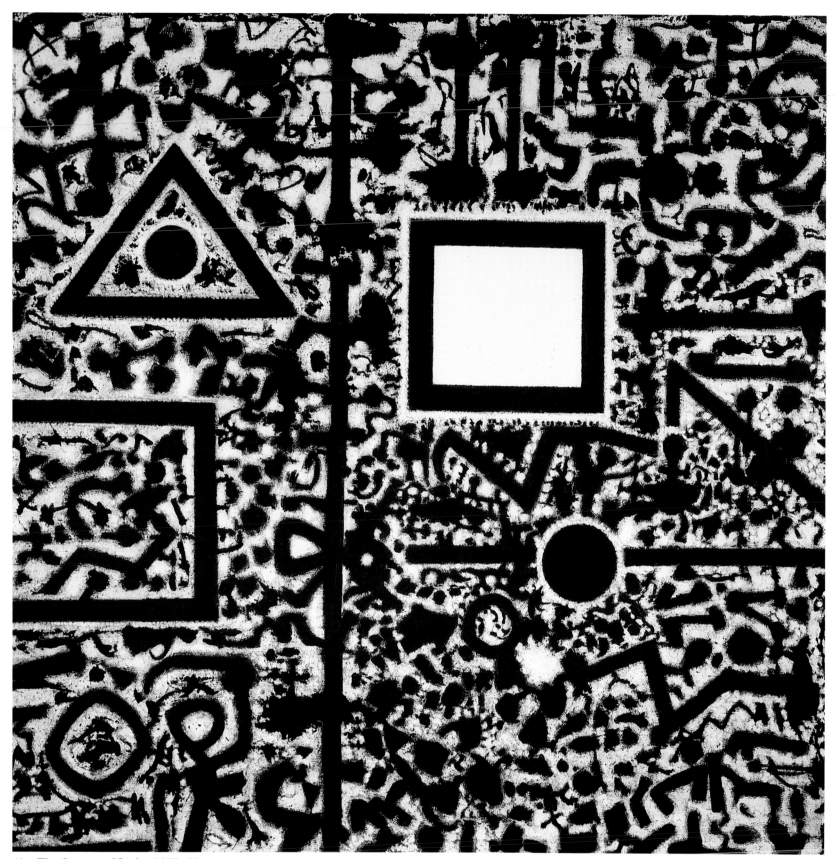

41 *The Square of Light*, 1978–80
Acrylic on linen, 90 x 90 inches
Private Collection

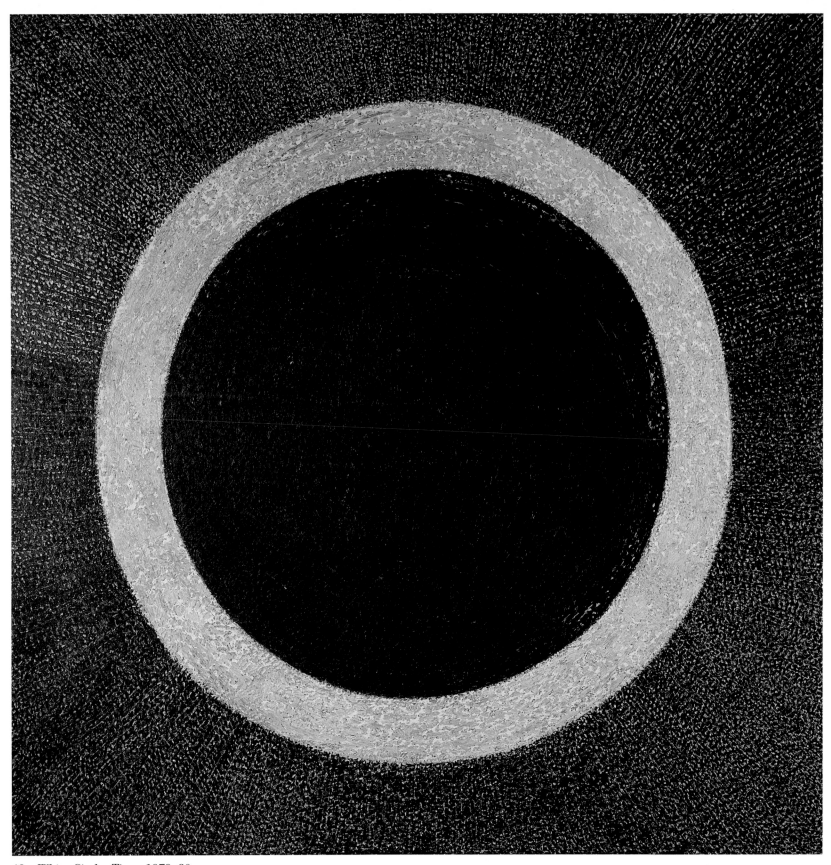

42 *White Circle, Time*, 1979–80
Oil on linen, 90 x 90 inches
Collection of the artist

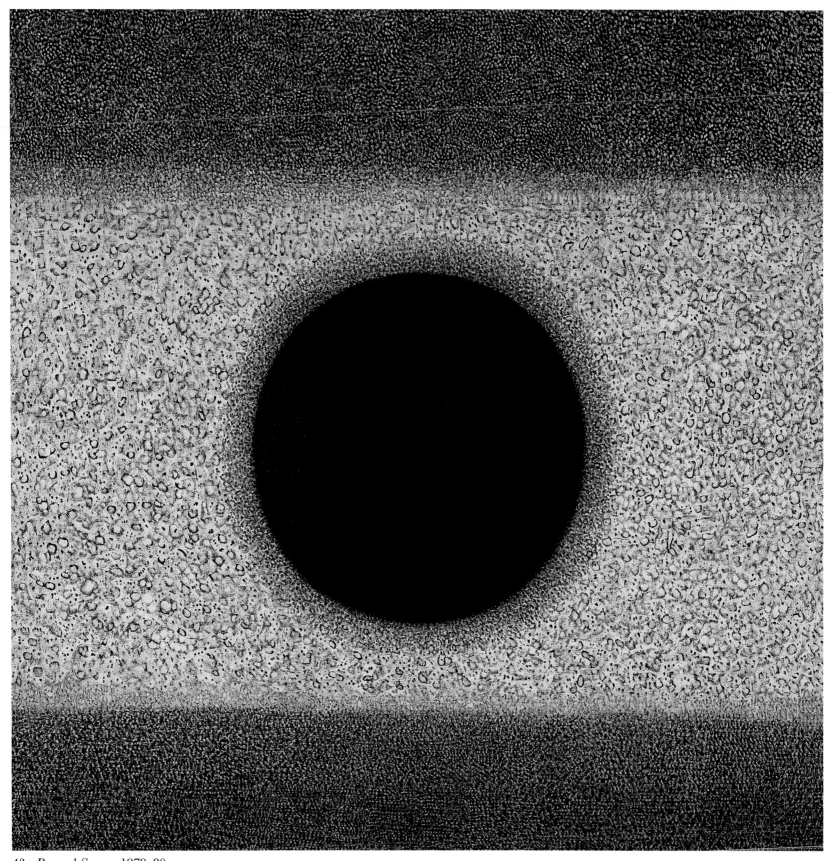

43 *Beyond Space*, 1979–80
Acrylic on linen, 90 x 90 inches
Collection of the artist

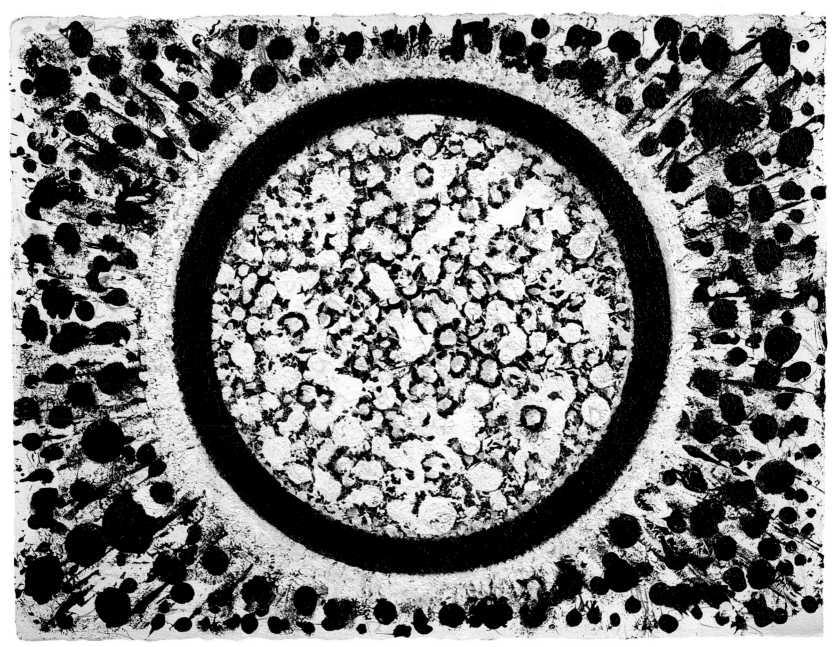

44 *White Penumbra,*
August 1978
Acrylic on handmade paper,
22¾ x 30⅜ inches
Collection of the artist

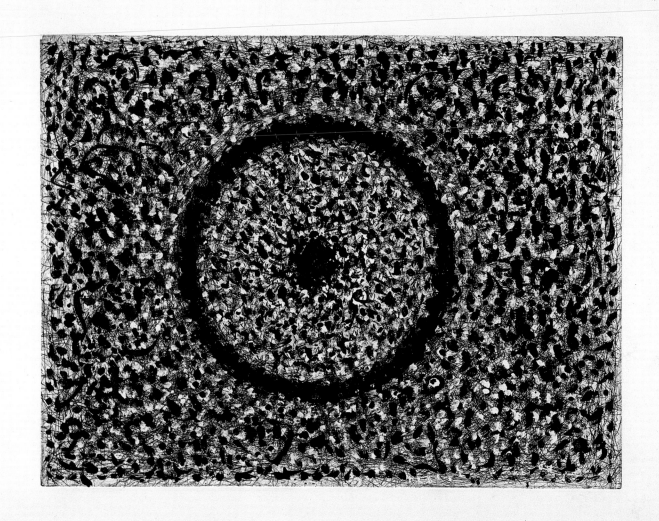

45 *Black Circle*, 1981
Hand-colored etching,
17⅞ x 23¾ inches
Collection of the artist

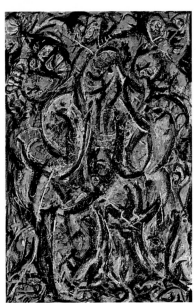

Jackson Pollock, *Gothic*, 1944. Oil on canvas, 87⅝ x 56 inches. The Museum of Modern Art, New York. Bequest of Lee Krasner.

Pousette-Dart uses abstraction to express universal experience. His art enables him to identify with a larger order of things, and he reacts strongly against the idea that aesthetic and practical activities are separate. He defines art as the essence of man's aesthetic experience, echoing John Dewey's definition of art as experience in its most articulate and adequate form: "the union of sense, mood, impulse, and action characteristic of the live creature."[114] As Pousette-Dart has written:

The only relationship of my painting to nature is simply through me as a mystical part of nature and the universe. My work and my work alone defines my relationship to nature. A work of art for me is a window, a touchstone or doorway to every other human being. It is my contact and union with the universe. Art is not a mirror reflecting nature, but is the very essence of man's aesthetic, imaginative, experience. Art transcends, transforms nature, creates a nature beyond nature, a supra nature, a thing in itself—its own nature, answering the deep need of man's imaginative and aesthetic being.[115]

Pousette-Dart maintains a fierce individualism and is interested in expressing his personal vision. His distance from his contemporaries can be measured by his interest in the dynamic balance between the conscious and the unconscious, by his lack of interest in spontaneous expression as an end in itself, and, in his later works, by his wide range of iconic references to both the material and immaterial worlds. The elaborate and highly refined surface textures of his paintings are far removed from the bold gestures of the Action painters; the emotional and poetic qualities of his canvases distance him from the cool, intellectualized surfaces of Newman and Reinhardt. Pousette-Dart's style in the mid-1940s was sometimes close to Pollock's. Compare, for example, Pousette-Dart's *Composition Number 1*, 1943 (46), with Jackson Pollock's *Gothic*, 1944. Both artists combine abstract elements with biomorphic forms to create fields of energy that allude to primordial beginnings. Energetic lines dance across both canvases, simultaneously creating and unraveling biomorphic shapes. Pousette-Dart's paintings from the 1960s to the present differ from

the shared aesthetic of mainstream Abstract Expressionism and go beyond metaphor, evoking spirituality through the materials and language of art. They are often self-referential and set up perceptual experiences rather than merely signifying experiences. In recent works, he does not rely on metaphor for natural phenomena (as Pollock did with his fields of energy), nor on intellectual constructs (Newman's references to sacred religious texts), but uses a phenomenological approach, creating spiritual experience through perceived light generated by vast, assertive color fields. The color in *Presence, Byzantium*, 1989 (47), extending twenty-four feet, fills the viewer's field of vision with a textured cadmium red expanse punctuated with bold, black abstract forms that reveal the artist's "life-long struggle with a vocabulary of the creative spirit."[116]

Pousette-Dart's broad range of expression in materials, styles, and iconic references distinguishes him from his colleagues. For over fifty years Pousette-Dart's work has consistently evolved, as he probes the temporal and spatial boundaries of human experience in his search for the transcendent. His individualism, carefully preserved by self-imposed isolation from the art world, is characterized by his belief in the importance of the artist finding his own thread of creativity. Continuity in his work can be found in the elegant surface control that is a hallmark of his canvases. His vision is sustained through his continual quest to convey spirituality through the materiality of paint and "to penetrate ever deeper into the nature of the creative and the universe."[117]

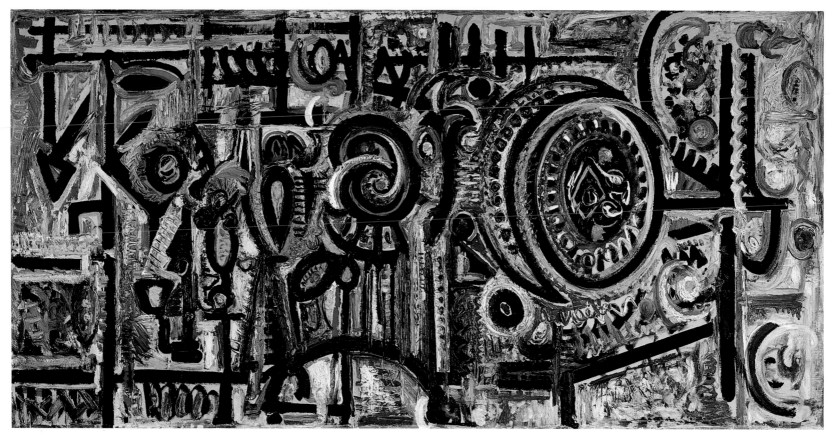

46 *Composition Number 1*, 1943
Oil on linen,
40½ x 80½ inches
Collection of the artist

47 *Presence, Byzantium,* 1989
Oil on panel, 4 panels,
each 72 x 72 inches
The Detroit Institute of Arts
Founders Society Purchase,
W. Hawkins Ferry Fund

Notes

1. Quoted in "Spontaneous Kaleidoscopes," *Look* 15:21 (October 9, 1951), p. 96.

2. The disparity in Pousette-Dart's paintings between the spiritual content and the sensual use of pigment has been noted by Carter Ratcliff in "Concerning the Spiritual in Pousette-Dart," *Art in America* 62 (November–December 1974), p. 91; by Hilton Kramer in a review for *The New York Times*, April 10, 1976; and by Paul Kruty in "Richard Pousette-Dart, Paintings, 1939–1985," in *Transcending Abstraction: Richard Pousette-Dart Paintings 1939–1985* (Fort Lauderdale: Museum of Art, 1986), p. 31.

3. Conversation with the author, Suffern, New York, August 9, 1984.

4. Telephone conversation with the author, December 23, 1989.

5. Flora Louise Pousette-Dart, *I Saw Time Open* (New York: Island Press, 1947), p. 8.

6. *Richard Pousette-Dart Drawings*, May 15–June 21, 1978 (Chicago: The Arts Club of Chicago, 1978), introduction, n.p.

7. Richard Pousette-Dart, Notebook 19, dated ca. 1946–50. Like many creative individuals, Pousette-Dart has kept a private journal in the form of random notes and dozens of notebooks. His notebooks, which chronicle more than fifty years of artistic thought, have not been systematically catalogued. For this reason, entries from his notebooks are cited as "Notebook" and are categorized according to numbers given by the artist or by specific dates noted in them (when available), or on the basis of circumstantial evidence. All notebooks are part of the artist's archives housed in his studio in Suffern, New York. Quotations are cited with the artist's approval.

8. Notebook, 1939, loose-leaf sheet.

9. Flora Pousette-Dart, *I Saw Time Open*, p. 9.

10. Ibid.

11. Ibid.

12. Notebook, ca. 1944.

13. Judith Higgins, "To the Point of Vision: Profile of Richard Pousette-Dart," in *Transcending Abstraction*, p. 15.

14. Nathaniel Pousette-Dart, ed., *Distinguished American Artists*, 6 vols. (New York: Frederick A. Stokes Co. Publishers, 1922–24).

15. "Nathaniel Pousette-Dart," *American Artist* (September 1948), p. 47.

16. These two works were among those exhibited at the Pinocatheca in New York in 1943. Reviewed by M. R., *The Art Digest* 17:9 (February 1, 1943), p. 15.

17. At least one completely abstract painting by Nathaniel Pousette-Dart, *Renaissance* of 1952 (oil on canvas, 40 x 48 in.), which has elongated abstract forms superimposed on a grid, is known through an illustration in the book he edited, *American Painting Today* (New York: Hastings House Publishers, 1956), p. 39.

18. Brochure for *Exhibition of Watercolors by Nathaniel Pousette-Dart*, at the Art Gallery of the New York School of Applied Design for Women, December 5–22, 1939, in the artist's file (NP-D), The Museum of Modern Art, New York.

19. Nathaniel Pousette-Dart, quoted in MKR, *Art Outlook* (April 28, 1947), artist's file (NP-D), The Museum of Modern Art, New York.

20. Nathaniel Pousette-Dart, *American Painting Today*, p. 34.

21. Ibid.

22. Ibid., p. 8.

23. Ibid., p. 35.

24. Notebook, loose-leaf pages with no cover and leather cord, October 1939.

25. Lecture delivered at the School of the Museum of Fine Arts, Boston, 1951, typescript, p. 2, artist's file, The Museum of Modern Art, New York. Excerpts reprinted in *New York School: The First Generation Paintings of the 1940s and 1950s*, ed. Maurice Tuchman (Los Angeles: Los Angeles County Museum of Art, 1965), p. 26.

26. Nathaniel Pousette-Dart, quoted in MKR, *Art Outlook* (April 28, 1947), artist's file (NP-D), The Museum of Modern Art, New York.

27. Richard Pousette-Dart, statement written for John I. H. Baur, *Nature in Abstraction: The Relation of Abstract Painting and Sculpture to Nature in Twentieth-Century American Art* (New York: The Macmillan Company, in association with the Whitney Museum of American Art, 1958), p. 79.

28. Flora Pousette-Dart, *I Saw Time Open*, pp. 7-8.

29. Quoted in *American Painting Today*, p. 50.

30. Quoted in Higgins, "To the Point of Vision," in *Transcending Abstraction*, p. 15.

31. Notebook, inscribed "R.P.D., Jan. 26, 1926 Valhalla, New York."

32. "Personality in Art," early 1930s, in artist's archive in Suffern.

33. John Gordon, *Richard Pousette-Dart* (New York: Praeger, in association with the Whitney Museum of American Art, 1963), p. 8.

34. Letter from Richard Pousette-Dart to his mother, May 12, 1938, in the artist's archive in Suffern. This letter is also cited by Gail Levin in "Richard Pousette-Dart's Emergence as an Abstract Expressionist," *Arts Magazine* 54 (March 1980), p. 125.

35. Telephone conversation with the author, February 22, 1990.

36. "What is the Relationship between Religion and Art?" Paper presented at a seminar at the Union Theological Seminary, New York, December 2, 1952. Typescript in the artist's archive, Suffern. Excerpts reprinted in Tuchman, *New York School*, pp. 26–27.

37. Ibid.

38. Pousette-Dart has been a vegetarian for over fifty years because of his belief in the sacredness of all living beings.

39. Lecture at the School of the Museum of Fine Arts, Boston, 1951, reprinted in Tuchman, *New York School*, p. 26.

40. Clement Greenberg, "New York Painting Only Yesterday," *Art News* 56:4 (Summer 1957), p. 84.

41. Modi's first exhibition, a one-woman show, was on view at the Artists' Gallery in May 1944. It included portraits, a self-portrait, and still lifes. See "Fifty Seventh Street in Review—Lydia Modi," *The Art Digest* 18:16 (May 15, 1944), p. 19.

42. *The Beechwood Tree* (Scarborough-on-Hudson High School Senior Magazine, New York) XVII (February 1935), p. 10.

43. Copy of letter dated August 6, 1941, in the artist's archive, Suffern.

44. Quoted in Higgins, "To the Point of Vision," in *Transcending Abstraction*, 1986, p. 19.

45. Conversation with the author, 1985.

46. Notebook, ca. 1940, p. 99.

47. The exhibition was *Abstract Painting and Sculpture in America*, curated by Andrew Carnduff Ritchie, director of the Painting and Sculpture Department at The Museum of Modern Art.

48. In a conversation with the author on August 9, 1984, Pousette-Dart said that Graham often adopted unusual poses to shock arriving guests.

49. John Graham, *System and Dialectics of Art* (Paris: l'Imprimerie Crozatier, 1937; and New York: Delphic Studios, 1937). This book was originally published in Paris in 1937 in a limited edition of only one thousand copies and published in New York that same year by Delphic Studios. Unless otherwise indicated, further citations are to the reprint edition, with introduction and notes by Marcia Epstein Allentuck (Baltimore: Johns Hopkins University Press, 1971).

50. The inscription reads: "To Richard, the Sculptor [from] Graham, the painter, XXXVII." John D. Graham, *System and Dialectics of Art* (New York: Delphic Studios #615, 1937). See Pousette-Dart's letter to his mother in Hobbs essay, "Confronting the Unknown Within," note 26.

51. Wassily Kandinsky, *Concerning the Spiritual in Art*, trans. by M. T. H. Sadler (New York: Dover Publications, 1977), introduction, p. 1. Originally published as *Uber das Geistige in der Kunst* in 1912; Russian translation, 1914.

52. Graham, *System and Dialectics of Art*, p. 95.

53. Ibid., p. 102.

54. The application of the Golden Section in this painting is described by Eleanor Green in *John Graham: Artist and Avatar* (Washington, D. C.: The Phillips Collection, 1987), p. 43. "The proportion of the height to the width of the stretched canvas is the standard, commercial 1.44. Within the painting that ratio is repeated, and several approximations of the 1.618 ratio can be found by comparing one segment of line to another."

55. In a conversation with the author on February 8, 1990, Pousette-Dart stated that the forms in *Untitled, Birds and Fish* are related to Northwest Coast American Indian forms that he had seen in the American Museum of Natural History in New York and to his own observation of nature; pigeons seen from his brownstone windows, and fish in The Fulton Fish Market.

56. Notebook, early 1940s. The rejection of the exclusive use of automatism for the creation of a fully realized work of art was reiterated to the author in a telephone conversation, May 19, 1989.

57. Notebooks, ca. 1938–44.

58. Quoted in Higgins, "To the Point of Vision," in *Transcending Abstraction*, pp. 16–17.

59. Notebook, Summer 1939, p. 16.

60. Quoted from a notebook dated ca. 1940 in Gail Levin, "Richard Pousette-Dart's Emergence as an Abstract Expressionist," *Arts Magazine* 54:6 (March 1980), p. 125.

61. Notebook, ca. 1944, loose-leaf pages.

62. William Rubin has noted that, earlier in the century, European artists' receptivity to African, South Pacific, and American Indian art forms was at least partially due to "a fundamental shift in the nature of most vanguard art from styles rooted in visual perception to others based on conceptualization." William Rubin, *"Primitivism" in 20th-Century Art* (New York: The Museum of Modern Art, 1984), vol. 1, p. 11.

63. Richard Pousette-Dart, telephone conversation with W. Jackson Rushing, March 16, 1985, cited in Rushing, "Ritual and Myth: Native American Culture and Abstract Expressionism," in *The Spiritual in Art: Abstract Painting 1890–1985* (Los Angeles: Los Angeles County Museum of Art, 1985), p. 277. Later in a conversation with the author on March 12, 1990, Pousette-Dart stated that his work came from many diverse sources, including European, African, and Asian.

64. Clive Bell, *Art* (New York: Frederick A. Stokes Company, 1913), pp. 36–37.

65. Pousette-Dart still owns a copy of Ezra Pound, *Gaudier-Brzeska: A Memoir* (London: Jones Lane and New York: The Bodley Head, 1916). Gail Levin also noted the relationship between Pousette-Dart and Gaudier-Brzeska in "Richard Pousette-Dart's Emergence as an Abstract Expressionist," pp. 125–26.

66. Alan G. Wilkinson, "Paris and London," in Rubin, *"Primitivism" in 20th-Century Art*, p. 444.

67. Robert Goldwater, *Primitivism in Modern Art* (New York: Alfred A. Knopf and Random House, Inc., 1966), p. 240.

68. Quoted by Pound in *Gaudier-Brzeska*, p. 9.

69. Pousette-Dart's sculpture was cast at the Kunstnieder foundry in New York before 1945. Comments by the artist, 1975, in the curatorial file, National Museum of American Art, Smithsonian Institution, Washington, D. C.

70. J. E. Cirlot, *A Dictionary of Symbols*, 2nd ed., trans. Jack Sage (New York: Philosophical Library, 1971), p. 28.

71. F. Kloss, *Treasures from the National Museum of American Art* (Washington, D. C.: Smithsonian Institution, 1985), p. 144.

72. Rubin, *"Primitivism" in 20th-Century Art*, p. 41.

73. Horace Brodsky, *Henri Gaudier-Brzeska 1891–1915* (London: Faber and Faber, 1931), p. 21.

74. Alan G. Wilkinson, "Paris and London," in Rubin, *"Primitivism" in 20th-Century Art*, p. 445.

75. Richard Pousette-Dart, conversation with the author, May 5, 1989.

76. Notebook, 1938, loose-leaf pages.

77. Quoted in Maude Riley, "The Tactile Approach," *Art Digest* 18:21 (November 1, 1943), p. 21.

78. Ibid.

79. The Luristan bronzes illustrated in the photographs were from the Warburg Collection and the Ackerman-Pope Collection.

80. Conversation with the author, February 26, 1990. The artist has also stated that the brasses are related to the marble statuettes from the Cycladic islands; Egyptian, Greek, and Etruscan sculpture; and Chinese bronzes.

81. These exhibitions were *Richard Pousette-Dart: Forms in Brass*, Willard Gallery, New York, October 1943; *Forms in Brass and Watercolors*, Willard Gallery, New York, 1946; and *Brasses and Photographs*, Betty Parsons, New York, 1948. See "The Passing Shows," *Art News* 42:12 (November 1–14, 1943).

82. Conversation with the author, May 5, 1989.

83. The work was exhibited at the Betty Parsons Gallery in *Exhibition of Works So Far Completed on Guggenheim Fellowship*. See "The Betty Parsons Gallery," *Vogue* 118 (October 1951), pp. 150–51, 194–97.

84. Rosemary Cohane, "Richard Pousette-Dart: Artistic Sources of an Abstract Expressionist Style" (MA thesis, Tufts University, 1982), p. 107.

85. Barnett Newman, in conversation with Thomas B. Hess in a public program at the Solomon R. Guggenheim Museum, New York, May 1, 1966, cited in Brenda Richardson, *Barnett Newman: The Complete Drawings 1944–1969* (Baltimore: The Baltimore Museum of Art, 1979), p. 15.

86. Robert Rosenblum, *Modern Painting and the Northern Romantic Tradition: Friedrich to Rothko* (New York: Harper and Row, 1975), p. 167.

87. Grünewald as a source of inspiration for Max Ernst is suggested by Rosenblum, ibid.

88. This painting was on view in New York in 1939 in Alfred H. Barr's exhibition *Picasso: Forty Years of His Art*, The Museum of Modern Art, 1939. Barr refers to the parallels between Grünewald's *Isenheim Altarpiece* and this painting in *Picasso: Fifty Years of His Art* (New York: The Museum of Modern Art, 1974), p. 167.

89. Graham, *System and Dialectics of Art*, p. 135.

90. This idea, as it relates to the Abstract Expressionists in general, is put forth by Philip Leider in "Surrealist and Not Surrealist in the Art of Jackson Pollock and His Contemporaries," *The Interpretive Link: Abstract Surrealism into Abstract Expressionism, Works on Paper, 1938–1948* (Newport Beach, CA: Newport Harbor Art Museum, 1986), p. 44. Works by Pousette-Dart were included in this exhibition.

91. Notebook, 1939.

92. Notebook, 1986.

93. Pencil notes on last page of Graham's *System and Dialectics of Art*, inscribed copy from the author to Pousette-Dart.

94. *Seven Paintings*, Willard Gallery, January 1945.

95. See Paul Schimmel, "Images of Metamorphosis," in *The Interpretive Link*, p. 25.

96. Quoted in Gordon, *Richard Pousette-Dart*, p. 11.

97. Pousette-Dart's interest in mechanical objects dates from early childhood, when he was fascinated by the steam engines that passed through Valhalla. Throughout his life he has experimented with old mechanical equipment of all kinds and has extensive collections of cameras, hi-fi equipment, ham radio sets, telescopes and old clocks, which he repairs himself. The studio is a visual mélange of paintings, sculpture, and mechanical objects: American Indian artifacts, old machines, a tractor seat hung on the wall suggesting a totemic presence, a portable radio painted in a richly variegated pattern, and a model airplane hanging from the ceiling.

98. Quoted in Higgins, "To the Point of Vision," in *Transcending Abstraction*, p. 15.

99. Graham, *System and Dialectics of Art*, p. 196.

100. Ibid., p. 103.

101. Lecture at the School of the Museum of Fine Arts, Boston, 1951, reprinted in John I.H. Baur, ed., *The New Decade: 35 American Painters and Sculptors* (New York: The Macmillan Company, in association with the Whitney Museum of American Art, 1955), p. 70.

102. Martica Sawin, "Richard Pousette-Dart" *Arts Yearbook 3, Paris/New York* (New York: The Art Digest, Inc., 1959), p. 146.

103. Notebook, ca. 1945.

104. Conversation with the author, August 6, 1986.

105. Letter from Suzanne Penn, Associate Conservator of Paintings, Philadelphia Museum of Art, to David A. Miller, Senior Conservator of Paintings, Indianapolis Museum of Art, June 12, 1989, on file at the Indianapolis Museum of Art.

106. Quoted in Jack Kroll, "Richard Pousette-Dart: Transcendental Expressionist," *Art News* 60 (April 1961), p. 34.

107. Edmund Burke, *A Philosophical Enquiry into the Origin of Our Ideas of the Sublime and the Beautiful* (1757); New York: Columbia University Press, 1958).

108. See "The Sublime Is Now," *Tiger's Eye* 6 (December 15, 1948).

109. Richard Pousette-Dart, quoted in "Abstract Impressions," *Detroit Free Press*, Sunday, November 6, 1983, p. 8B.

110. Lecture at the School of the Museum of Fine Arts, Boston, 1951.

111. Richard Pousette-Dart, quoted in "Abstract Impressions," p. 8B.

112. Carl Jung, quoted in Cirlot, *A Dictionary of Symbols*, p. 47.

113. Ibid.

114. John Dewey, *Art as Experience* (New York: Capricorn Books, 1959). Originally published in 1934.

115. Quoted in Baur, *Nature in Abstraction*, p. 79.

116. Conversation with the author, March 13, 1990.

117. Quoted in Higgins in "To the Point of Vision," in *Transcending Abstraction*, p. 24.

Confronting the Unknown Within

Robert Hobbs

Richard Pousette-Dart's art testifies to the fecundity of the unconscious mind. A founding member of the New York School that came into being in the 1940s and was generally known as Abstract Expressionism in the 1950s, Pousette-Dart has evolved a complex imagery of unicellular life, religious symbols, and overlapping skeins of color to suggest the dense interconnected web of forms and ideas that lie beyond the threshold of consciousness. While he shares with his fellow Abstract Expressionists an interest in human values and spiritual truths, he goes far beyond most other painters of his generation in emphasizing creation as a primal act of self-definition. For over half a century he has worked to "express the spiritual nature of the universe"[1] by getting people "onto the thread of their own creative being."[2]

For Pousette-Dart creation is being; it is an active process of acknowledging the power of preformulative thought, the seemingly chaotic images appearing in dreams, and the shadows lurking in the recesses of the mind. His idea of creation differs from the standard Western definition, which has received its most cogent treatment in Michelangelo's *The Creation of Adam*, part of the Old Testament cycle decorating the Sistine Ceiling. In this work Michelangelo painted the creation of the human soul as the divine spark of inspiration given to an existing Adam. This Renaissance conception develops out of Michelangelo's early association with Florentine neoplatonists. His characterization of Adam, consequently, indicates a belief in a timeless realm of universal ideas that antedates even the God of the Old Testament, as is evidenced by Adam's heroic, classically-inspired anatomy, which pre-exists the gift of the soul. Michelangelo's view of creation has been highly regarded in Western culture for its clarity and for the significant role given to his monumental, idealized image of the first man; however, it does not concern itself with the aspect of creativity important to Pousette-Dart, who wishes people to confront the unknown within. Only the scene in Michelangelo's ceiling depicting the separation of light from darkness approaches Pousette-Dart's interest in exploring darkness and finding in it the relationship that unites all elements making up the life forces. In his art, then, the ideal state is to "go far enough to come into the universe of everything where nothing is separable."[3]

In his largely abstract paintings Pousette-Dart presents an image of creative growth that involves relinquishing a secure and static identity in order to enter a preformulative realm full of possibilities but without a predictable outcome. In 1937–38 he defined painting as "that which cannot be preconceived,"[4] and in subsequent notes and lectures he referred to the potential of chaos as a necessary route to creation. Early in his career he marveled that "out of the rich enmesh of chaos unfolds great order and beauty, suggesting utter simplicity is this labyrinth of all possible truths."[5] He repeatedly questioned the wisdom of bracketing aspects of life by imprisoning them in static artistic forms. "The frames are all futile," he wrote, "to close any life away from the inevitable change and dissolve of going ceaselessly on in new birth."[6] His subject is the potential to change, and change is communicated in his art by overlapping and fragmented forms. "Come disarrange things," he wrote, "so things may more properly rearrange, let nothing be fixed . . . for all insists upon movement and change even death yes even death to the living and living to the dead."[7] Although this reference to life and death might seem at first melodramatic, it actually refers to the symbolic death and rebirth of creation: one must die to old forms and cast off the constraints of ego in order to be immersed in the chaos that leads to new discoveries. In a talk at The School of the Museum of Fine Arts, Boston, in 1951, Pousette-Dart described this process of discovery in ecstatic terms:

Art for me is the heavens forever opening up, like asymmetrical, unpredictable spontaneous kaleidoscopes. It is magic, it is joy, it is gardens of surprise and miracle. It is energy, impulse. It is question and answer. It is transcendental reason. It is total in its spirit. . . . It is a doorway to liberation. It is a spark from an invisible central fire. . . . Painting must have form but not necessarily in any preconceived or set known way.[8]

Recently he confirmed the importance that a completely open-ended attitude still has for his art when he said, "the highest knowing is unknowing."[9]

Pousette-Dart's understanding of creation, although compatible with Genesis, relies on Eastern and tribal concepts of creation, which the newly developed fields of psychology and comparative mythology began to examine early in this century. According to the comparative mythologist Mircea Eliade, who describes this concept in both the East and the South Pacific in his essay "The Symbolism

Pousette-Dart seeds his paintings and brasses with cultural symbols from ancient art, tribal culture, and religion to connote a universal realm.

Whorl or swirl
Radiance, 1973–74

Spiral
Composition Number 1, 1943

Letters
Untitled (Ricardo), 1946–48

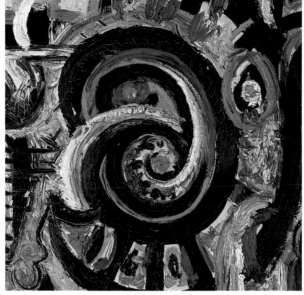

Hieroglyphs
The Magnificent, 1950–51

Abstract calligraphy
Figure, 1944–45

of Shadows in Archaic Religions," the initiation into the unformed world of chaos or shadows is recognized as a necessary prelude to growth:

Shadows symbolize the Cosmic Night, the undifferentiated totality, the unformed, the secret. From one perspective, shadows are homologizable with Chaos, since no form is discernible, no structure is disengaged; this is the modality of the pre-formed. Shadows symbolize at the same time that which is before manifestation of forms and after their disappearance, when the forms are reintegrated into the primordial mass. This is why the cosmological symbolism of shadows approximates that of the Waters. The Waters also express the undifferentiated, the preformed, the unmanifested. The act of manifestation is signified by the emergence from the Waters, the exemplary image of Creation is the island or the lotus which rises about the waves. [10]

Although Eliade accepts the image of "the emergence of Light out of Shadows" as symbolic of "the creation of the Universe as well as the beginnings of History," he also emphasizes the positive value of Shadows, the potential latent in "the totality, the fusion of all forms." [11] Initiations may be viewed as a symbolic death, a descent into Hell, a merging with the cosmic night, and enclosure in the proverbial monster's belly. The release from this frightening, albeit fecund, situation signals a "passage from 'chaos' to 'creation.'" [12] Eliade concludes his summary of this mythological descent into the unformed by reminding readers of its pervasiveness:

But we know that, for archaic and traditional cultures, the symbolic return to Chaos is indispensable to all new creation, whatever the level of manifestation, every new sowing, or every new harvest is preceded by a collective orgy which symbolizes the reintegration of "precosmogonic Night," of total "confusion"; every New Year is comprised of a series of ceremonies which signify the reiteration of the primordial Chaos and of the cosmogony. But the same symbolism can be deciphered in the "madness" of future shamans, in their "psychic chaos," in shadows where they have strayed: this is the sign that profane man is in the process of "dissolution" and that a new personality is being born. [13]

According to Eliade, creation goes far beyond artistic spheres to embrace the everyday lives of individuals coping with new seasons, years, stages of life, and spiritual attitudes. And, although it is not negative, entering the primordial broth of chaos can be an intimidating and perhaps even harrowing experience for someone who is not prepared to sacrifice ego in the interests of growth.

In his art Pousette-Dart presents a realm of shadows, heavily seeded with cultural and biological fragments, to encourage viewers to begin their own initiations, to confront the "psychic chaos," and finally to understand its special beauties. "Everyman," this artist has observed, "finds himself, in parts composes his real self, in little symbols, over the period of his allotted time, he is the sum of these bright absolutes." [14] Writing in May 1940, Pousette-Dart proclaims the need for observers to complete the work of art by using it as a route to personal discoveries:

*Great art leaves half of the
Creation to the onlooker—Gives
the key to a creative experience
Draws the spectator into infinite mysteries.* [15]

That same year he substantiated this idea when he proposed that "painting is not what the eye sees but what the second and inner light of feeling knows." [16] And a decade later he concluded that "to see paintings we must recreate them." [17]

While viewers must recreate Pousette-Dart's works by making them relevant to their own lives, this artist must continually reenact the initial steps of creation. He must constantly challenge himself by pushing his art and symbolically himself to the brink of unrecognizability, and he must never allow painting to become static, because stasis cuts off the challenges of creation and becomes mere artistic production: the replication and manufacturing of art. Pousette-Dart imposed on himself this heroic and difficult goal when he announced early in his career: "Let me flow, affect things, and dissolve, to be, and be no more, and be forever. For such is to be one, in accord, with nature. For nature, is that which I am, I shall be." [18] He has continued to subscribe to this understanding of the creative process, which in a notebook of the 1970s he viewed as "forever growing/forever being reborn/ no one can ever truly tell about this concept except by being it." [19]

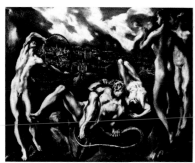

El Greco (Domenikos Theotokopoulis), *Laocoon*, 1610–14. Oil on canvas, 54⅛ x 67⅞ inches. National Gallery of Art, Washington, D. C. Samuel H. Kress Collection.

Self-portrait with cameras

This necessity to enact the formative stage of creation by confronting chaos and the unknown anticipates by more than a decade Harold Rosenberg's famous article "The American Action Painters,"[20] which joins the French existential imperative to make personal commitments in an absurd, meaningless world to the gestural branch of Abstract Expressionism. In contrast to Rosenberg's desire for resolution through commitment, an understandable attitude for a politically engaged critic during the Cold War, Pousette-Dart's interest in action is a necessary consequence of his philosophical and spiritual understanding of life as the ceaseless ebb and flow of time:

> *I do not speak of that which means today not tomorrow but only that which means always everything means change eternity & ceaseless infinite change*
> *everything means everything else*[21]

In his quest for a higher reality, the artist condemns himself to almost endless creation: he paints images which he then covers up, and he evolves compositions which are then cancelled out.[22]

Pousette-Dart recognized the need to confirm, repeat, and then reassert again and again the ritual of ceaseless flux and eternal chaos in his paintings. He anticipated his own artistic advances as well as those of his fellow Abstract Expressionists when he wrote in "Painting the Nothingness" (ca. 1940):

everything must be painted over and then over endlessly there is no finish to realization the only completion means renewal in greater unknowns eternal beginning again as the morning all over things are as false shape, they must be put back into flow, zeroing everything must die toward the river Rivering all life into its flow to the sea things do not mean it is we who mean we must see and we must go through it beyond all forever.[23]

Here, in essence, is the basis of his drive to create and then create again, thus evoking images of a primordial chaos and an almost endless possibility. The result is works that sometimes contain as many as twenty or thirty layers and have surfaces so thick that they become painted relief sculptures. And here also is a basis for Abstract Expressionism's continued exploration of the richness and allusiveness of the subconscious or unconscious mind.

Pousette-Dart invokes the idea of chaos and the unknown in a series of veiled images that provoke and tantalize viewers while frustrating their attempts to make all the forms in a particular work completely intelligible. This artist complicates his imagery by conflating a number of sign systems referring to aspects of biology, geometry, religion, and writing. His paintings frequently join fragments of birds and fish with the unicellular creatures amoeba, flagella, and paramecia. These forms in turn interact with whorls, spirals, Greek and Latin crosses, Stars of David, letters, hieroglyphs, abstract calligraphy, and shapes resembling ancient blades to communicate the far-ranging types of images that exist beyond the threshold of consciousness. In addition, Pousette-Dart alludes to a range of spiritually encoded artistic forms that include stained glass, mosaics, and the expressive painterliness of El Greco, Vincent van Gogh, Albert Pinkham Ryder, and Wassily Kandinsky. He, for example, transformed the cataclysmic qualities of van Gogh's *Starry Night*, 1889, into struggling biomorphic forms in *Untitled*, ca. 1945 (48).

This multiplicity in part reflects a lifelong interest in collecting mechanical gadgets, natural objects, tribal art, and antiques. As a teenager, Pousette-Dart was fascinated with the steam engine in Valhalla, New York, where he grew up, as well as with automobiles and such gadgets as radios, telescopes, lenses, and old cameras; he even made a pin-hole camera capable of taking half-day exposures. His visits during those years to the American Museum of Natural History inspired him to collect rocks and shells, make bows and arrows, study American Indian art, and speculate about the magic of life. This range of interests is still apparent today in his home and studio. He shares with his wife Evelyn a penchant for collecting a broad assortment of materials. Their house in Suffern, New York, is a virtual treasure trove of collections that include African, South Pacific, and North American Indian art, tobacco tins, adding machines, beaded pin cushions, putti, bird decoys, European seventeenth- and eighteenth-century furniture, old clocks and cameras, lenses, candlesticks, plants, blue-and-white earthenware, dolls, old tools, books, postcards, and works of art created by several generations of Richard's family. In its density and layers of objects, its inclusion of different cultures, and its combination of profound works of art with flea-market trinkets, the house extols the kind of free cultural association which in the art is intended to prompt viewers to explore their own creative darkness.

48 *Untitled*, ca. 1945
Mixed media and gouache on
parchment, 22 x 18 inches
Private Collection

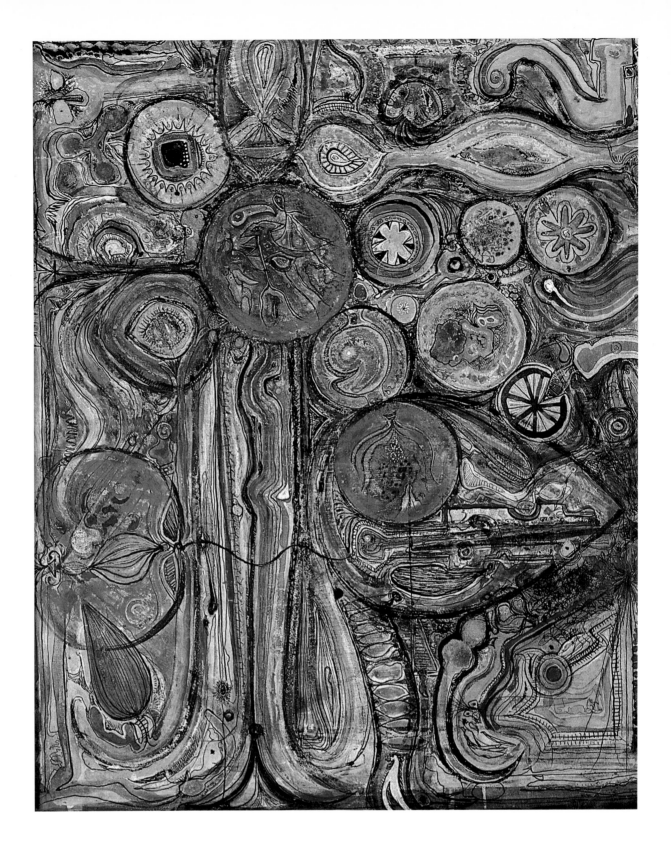

Richard Pousette-Dart, *Untitled (Flora)*, late 1930s. Collection of the artist.

Richard Pousette-Dart, *Portrait of Lydia*, 1939–40. Collection of the artist.

In the art, however, unlike the house, different cultures and forms are only suggested and not completely described because Pousette-Dart is convinced that ultimate meaning is always veiled. For him, mystery is a necessary part of in-depth understanding because it requires reliance on belief or trust, as opposed to mere thinking: "again and again I approach to unwrap the veils but with all unwrapping I find the form huddled in a formless darkness telling me infinite light is infinite belief."[24] Also, because Pousette-Dart wishes to veil recognizable forms in order to use them as signs of the ultimate mystery of reality, which can only be understood as mystery and therefore is unrepresentable, an assessment of his art has to consider ambiguity and conflation as aesthetic strategies for communicating meaning. He recognized this important aspect of his art when he wrote:

> whatever the subject matter—it is
> not the subject matter
> whatever the theme or shape it
> is not the theme or shape
> whatever idea or motivating beginning
> it is not the idea or motivation
> it is always something within and
> all pervading . . .
> transcendental being it is this
> but this is not describable not
> definite[25]

These allusions to unrepresentable aspects of spiritual reality are apparent in Pousette-Dart's paintings dating from the late 1930s. One group of works develops out of African sculpture. Among its goals, this group represents an attempt to distance the painter from his one-time friend, the artist and theorist John Graham. Like Pousette-Dart, Graham found inspiration in tribal art; he may in fact have encouraged Pousette-Dart, as he had Adolph Gottlieb, Jackson Pollock, and David Smith, to look at tribal artifacts as significant works of art. But the younger artist found Graham too dogmatic and wished instead "to strive for an impersonal truth and . . . [a] philosophy of balance between abstraction and nature."[26] In his early paintings of heads Pousette-Dart attempted such a balance, and he used African art as a way of transforming heads of women into abstract icons. In his notes Pousette-Dart extols African art as equal to or surpassing the work of Michelangelo[27] because it allowed him to take liberties with the human form and to realize his goal of picturing a higher reality.

One of the first heads in this group even anticipates Graham's pictures of cross-eyed women who are accompanied by mystical signs and numbers. This head is an abstract portrait of the artist's mother, Flora, who is presented as frontal, static, and hieratic. Divided by a series of bilaterally symmetrical signs, her face is united by the crescent-shaped moon formed by her cheekbones and by the fish overlapping the white key shape forming her forehead and nose. The artist keeps bilateral symmetry from becoming too dominant, however, when he creates round and square pupils in the right and left eyes, respectively, and when he differentiates earrings, symbols on the shoulders, and colors underneath the arms. In the portrait Flora is essentially a shadow figure with certain features picked out in white, and the image bespeaks the esoteric beliefs important not only to Graham and Pousette-Dart, but also to Flora herself, who had published several volumes of poetry dealing with theosophy, the fourth dimension, and the subconscious. In the foreword to *I Saw Time Open*, she describes art as "ecstatic revelation . . . [when] the secret of life is revealed, the riddle of the universe is solved. Such moments . . . constitute a mystic communion with all mankind; they convey an overwhelming realization of human brotherhood, and imperatively demand expression."[28] Richard's strange hieratic image of Flora suggests her connection with mythic realms, which are indicated by the moon and by the visual rhyming of the fish with the key making up her forehead and nose. As woman/mother/mystic creator par excellence, she serves as a symbol of intuitive understanding.

From a mystical image of his mother, Pousette-Dart moves to abstracted portraits of his second wife Lydia, who was an aspiring painter. In his first abstract painting of Lydia, the artist transforms her into the type of African-inspired image that Picasso might have created (49). Her hair and ear are joined into a large spiral that holds elaborate ornaments. In his notes of this period Pousette-Dart combined a drawing of an ear with the statement "to hear sight/to see sound."[29] He then followed this passage with a spiral and a reference to "the window upon good," no doubt to indicate that the ear and spiral are connected synaesthetically to achieve heightened awareness. His second abstract image of Lydia (50) is a slightly different African mask seen in profile rather than three-quarter's view. Her elaborately

49 *Head of a Woman*, 1938–39
Oil on linen, 40 x 24 inches
Private Collection

Central Africa (Angola), Chokwe people, *Figure of Chief*, 19th century. Wood, 19 inches high. Indianapolis Museum of Art. Gift of Mr. and Mrs. Harrison Eiteljorg. Pousette-Dart used figures similar to this Chokwe piece as the basis for his meditation on the female head.

Arshile Gorky, *Garden in Sochi*, 1941. Oil on canvas, 44¼ x 62¼ inches. The Museum of Modern Art, New York. Purchase Fund and Gift of Mr. and Mrs. Wolfgang S. Schwabacher (by exchange).

coiffed hair centers on a spiral which might represent an ear; but in the spiral's center is a disconcerting eye that stares directly at the viewer, perhaps signifying a level of consciousness far deeper than that suggested by the disembodied mask constituting the face of this figure. This eye resembles those in ancient Egyptian paintings, which are seen from the front even though the face is in profile. In this second version Lydia's head is broken into even more discrete parts. This fragmentation into individual and autonomous forms represents an important aspect of Pousette-Dart's art, and it parallels his developing interest in multiple foci, overlapping images, and allover compositions.

In addition to these stylistic devices, Pousette-Dart explores the poetic resonance of conflation. In *African Head*, ca. 1938–39 (51) he presents on the right a mask seen in profile, placed against a large leaf. This mask is balanced on the left by a bunch of grapes, indicating nature's bounty, an idea also embodied by the huge leaf. The leaf's severed stem, in turn, serves as the snout of a powerful head that resembles a Senufo helmet mask. Pousette-Dart's ingenious conflation of forms enriches his painting by aligning the individual elements into an overall whole that suggests their common role as evocations of the powerful and mysterious spirit of nature.

The stylistic approach used in these abstract heads becomes increasingly complex in a concurrent series of imaginary landscapes. *River Metamorphosis*, 1938–39 (52), provides a view of the enigmatic realm that awaits anyone prepared to leave the conscious world, signified by the girders of a bridge in the upper right. The artist then offers viewers a plunge into the mythic waters of the "unconscious." The unconscious is populated in this painting by birds, fish, and a strange monster on the left, whose body is equivalent to the hundred eyes of the Greek mythological giant Argus, an image of personal importance to Pousette-Dart since his aunt Olga Pousette had made a watercolor of Argus that is now in his collection. The eyes of this monster also resemble those seen in Northwest Coast American Indian art, where they are used to decorate boxes, chests, and blankets. Here these tribal eyes suggest the atavistic and symbolic ways of seeing that modern people still retain in their unconscious minds. Covered as it is with these eyes, the beast of the unconscious apprehends the world with its whole being and thus multiplies its ability to understand.

This painting comes before Arshile Gorky's *Garden in Sochi* series of ca. 1940–43, in which mysterious eyes peer out of a vaguely Surrealistic world. It also anticipates the symbolic importance of Adolph Gottlieb's *Oedipus* series of 1941, which is concerned with the Greek figure's tragic unwillingness to look at his own guilt and to recognize his role in an incestuous psychological drama so universal that Freud used Oedipus's name to describe it. A similar emphasis on eyes occurs in the paintings of William Baziotes, who, in the second half of the 1940s, found the inner eye both a poignant and macabre element that he could use in *Cyclops*, *Dwarf*, *Night Mirror*, and *Mirror Figure*. The conjunction of underwater imagery with archaic eyes fascinated Pousette-Dart, who created such works in the 1940s as *Nightflower* (53), *Blue Fantasy* (54), and *Sea World* (55).

Pousette-Dart's *Primordial Moment*, 1939 (56), presents a slightly different variation on the theme of the conscious/unconscious mind. In this painting a prominently placed white head is seen lying in profile. The head may represent a fragment of a classical sculpture, a reading substantiated by the Greek fretwork on the left and its similarity to the broken sculpted head in Picasso's *Guernica*. As a sculpture fragment, this head is symbolically separated from classical rationality, and it is used to emphasize a spiritual state, which is indicated by the singing bird emanating from its throat. Radiating from this head in a manner akin to stylized Art Deco beams of light is a cluster of tribal forms that includes eyes and heads of birds derived from Northwest Coast Indian art. As in *River Metamorphosis*, these eyes suggest the primordial seeing/knowing/feeling unconscious that connects modern people with their tribal counterparts. In *Primordial Moment*, then, Pousette-Dart encourages viewers to open themselves to their tribal unconscious, to the intuitive side symbolized by the Indian art forms.

In *East River*, 1939 (57), a third imaginary landscape of this period, Pousette-Dart uses absurdity to shock people into an awareness of the mystery, richness, and delight that the irrational world of dreams and myths offers. In this work he creates two hybrid images that move in opposite directions: one is a flying rabbit/bird; the other is a swimming

50 *Head*, 1938–39
Oil on linen, 30 x 24 inches
Collection of the artist

51 *African Head*, ca. 1938–39
Oil on linen, 30 x 40 inches
Collection of the artist

52 *River Metamorphosis,*
1938–39
Oil on linen, 36 x 45 inches
Private Collection

53 *Nightflower,* 1940
Mixed media; watercolor,
gouache, pen and ink on paper,
8⅝ x 11¼ inches
Collection of the artist

54 *Blue Fantasy*, 1941–43
Watercolor on paper, 6 x 9 inches
Collection of the artist

55 *Sea World*, 1943–44
Gouache and ink on handmade
paper, 31¾ x 23 inches
Collection of the artist

56 *Primordial Moment*, 1939
Oil on linen, 36 x 48 inches
Collection of the artist

57 *East River*, 1939
Oil on masonite panel,
36½ x 48¼ inches
Collection of the artist

Pablo Picasso, *Girl Before a Mirror*, 1932. Oil on canvas, 64 x 51¼ inches. The Museum of Modern Art, New York. Gift of Mrs. Simon Guggenheim.

Giuseppe Arcimboldo, *Autumn*, 16th century. Pinacoteca, Brescia. (Scala/Art Resource)

bird/fish. The artist has included in this painting a section of the Queensborough Bridge, over the East River, which situates this painting in a definite place in Manhattan—outside the brownstone in which he was then living—and emphasizes, in addition, the modernity and relevance of his mythic figures. The bird/fish hybrid represents an iconographic refinement of a mythological reality that is symbolized by the Chinese flying dragon and the Native American duality of underwater panther and thunderbird. In all three myths sky is joined with earth or water to indicate transcendence from prosaic reality. Balanced between these two mythic animals in Pousette-Dart's painting are a number of ovoid shapes that resemble pebbles, eggs, and eyes: symbols, perhaps, of unrevealed secrets, fertility, and insight—just rewards for crossing the bridge (the pun is evidently intended or else is a trick of the subconscious) from the rational to the intuitive mind, for leaving, in other words, the everyday and entering the mythic. The river in this painting merges with the dark sky of night to suggest the extent of the mythic realm and to indicate the total immersion in the unconscious that is necessary for true understanding.

Like *Primordial Moment* and *River Metamorphosis*, *East River* is executed in a technique suggesting stained glass. Its jewel-like intensity may well have been inspired by Picasso's *Girl Before a Mirror* (1932), which is similarly concerned with a journey inward to discover one's true image. Pousette-Dart, however, differs from Picasso by using stained glass to recall church windows and by alluding to the spiritual kinship between radically different mythic forms. He establishes zones of brilliant color which are compelling in their own right and which cluster together to create images evocative of the unconscious.

Pousette-Dart's researches into the mythic dimension of the modern psyche culminated in his life-size *Bird Woman*, 1939–40 (58), a painting that inaugurates the increasingly complex imagery and large-scale of his work of the 1940s. A precedent for *Bird Woman* is this artist's *Woman Bird Group* (5), a bronze sculpture of 1939 depicting a mechanized female form, with a bird's head, holding a fledgling. This armored bird figure constitutes a critical view of a machine-oriented world and its impact on the human spirit, which begins to look as mechanical and rapacious as this bird mother. In contrast to this sculpture, *Bird Woman* is affirmative, as an examination of its complex iconography of birds, fish, eggs, a female prophet, and a swimming figure will reveal.

The Bird Woman is a modern-day Arcimboldo, consisting of a crescent moon for a headdress, a mask-like face, a fish for a mouth, a bird-shaped right ear, and a horn in place of the left ear. She holds in her hand a bird that becomes the wings of another creature, which holds in its mouth a reddish-brown form constituting still another bird. Her body is composed of birds, fishes, and egg shapes that serve respectively as symbols of the spirit, the unconscious, and fecundity. Her heart looks like both an enameled brooch and an artist's palette. A complex grouping of forms in the lower section of the painting might well represent an abstract white wave with a white snail and a swimmer whose torso becomes a shield emblazoned with a face pointing in the opposite direction from the rest of his body. This warrior's head consists of a series of ideograms, including a white cloud shape that resembles a Jean Arp concretion, a golden tower, and a steel girder. Many of these images might well suggest the fragments of the unconscious mind, which are sometimes trapped when the conscious mind free-associates about clouds, while the tower in the painting may connote the isolation of the self, and the girder may indicate the rationality and force of the conscious mind. The different attitudes expressed by this swimmer, who moves in one direction while his shield faces the opposite direction, suggest the multiple challenges facing an adventurer on a mythic journey. His shield and helmet reinforce the idea that he is the proverbial hero exploring uncharted territory in order to discover his real self. On either side of this swimming figure are egg shapes: one is whole, the other is segmented, and both contain nuclei that are symbols of fecundity and are also similar to eyes in Northwest Coast American Indian art. The conjunction of Bird Woman with water, fish, and a swimmer indicates the artist's concern with the mythic waters of the unconscious, where spiritual insight equals depth and a retreat inward.

Bird Woman can be compared to Jackson Pollock's works of the same period, particularly his *Man, Bull, Bird*, his *Birth*, and his *Bird*, which all date from ca. 1938–41. The similarity is all the more noteworthy because Pollock did not exhibit his early Abstract Expressionist works until January 1942, when John Graham invited him to show *Birth* in the exhibition *American and French Paintings* at the McMillen Gallery. A few months before the McMillen exhibition in October–November 1941 Pousette-Dart had a one-person show at the Artists' Gallery. Since the gallery was sponsored by influen-

58 *Bird Woman*, 1939–40
Oil on linen, 72 x 40 inches
Collection of the artist

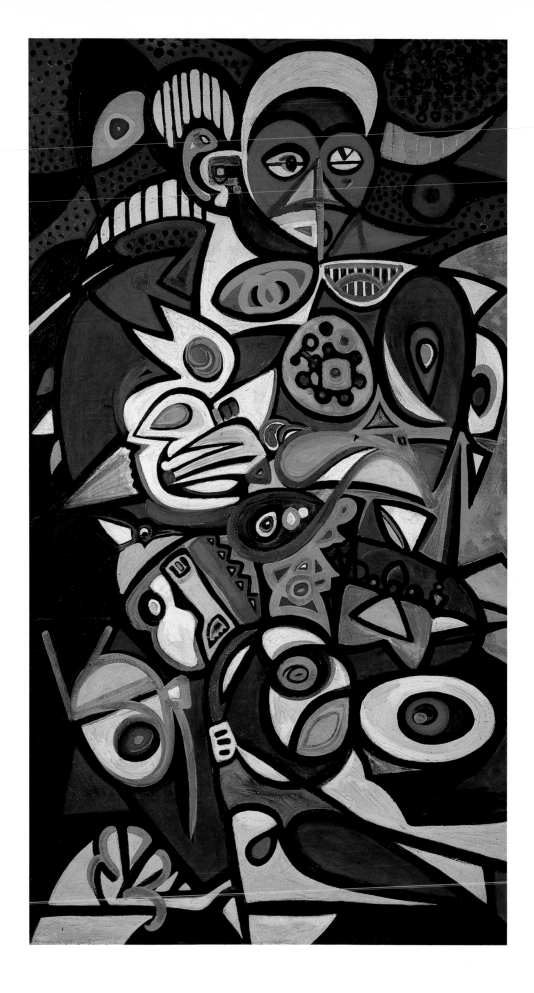

Ivory Coast, Western Sudan, Senufo people, *Face Mask (Kpeli-Yëhë)*. Wood, 14 inches high. The University of Iowa Museum of Art. The Stanley Collection. The overall configuration of Pegeen's face bears an astonishing resemblance to Senufo face masks.

tial critics and art historians, including Clive Bell, Frank Jewett Mather, Jr., Walter Pach, Meyer Schapiro, and James Johnson Sweeney, his show would have been noticed by other artists. Like Pousette-Dart, Pollock was involved in his early work with mythic dimensions of the self that can be understood in terms of ancient and tribal art. While Pollock shares with Pousette-Dart an interest in Jungian psychology, Picasso's art, and the theories of Graham, Pousette-Dart develops out of still other traditions that are tied to his childhood and sense of spirituality. Although Graham had suggested to Pousette-Dart, as he had to Pollock, the connections between tribal art, modern French painting, and psychology, he cannot serve as the sole source for Pousette-Dart's interest in the spiritual dimensions of modern humanity.

The paintings of this period reflect Pousette-Dart's intense concern with spiritual matters. This is particularly evident in the sweeping rhythms of *The Boundless Atom*, 1941–43 (59), a work on paper that reflects his understanding of the very similar, spiritually-motivated expressionistic art of Wassily Kandinsky, which was amply represented in the collection of the Museum of Non-Objective Painting in New York. A confirmed pacifist who was willing to go to jail rather than join the army, the artist immersed himself in the late 1930s and early 1940s in the religious thought of both the East and the West. His notebooks are full of ecstatic insights, such as the statement, "I say everything is connected and is one, transmutes, transcends, is immediate eternal life with you and me."[30] This belief in unity accounts for the complexity of interpenetrating forms making up *Bird Woman*, who is at once primordial mask; Diana, goddess of the moon; and the embodiment of spiritual wisdom. Pousette-Dart confirms his belief in totality by writing, "Only with the fabric of all as one . . . does the eye truly see, not of this eye is sight but of belief darkly knowing."[31] Furthermore, he spells out the implications of this for his own work: "art is only significant as it takes us to the whole man and gives us new insights and opens secrets toward the unknown heart of our total mystic awareness."[32]

Unlike Pollock, who turned Jungian psychology into a new religion, Pousette-Dart finds aspects of the old religions useful as universal routes to human understanding and fulfillment. Although Pollock and Pousette-Dart discovered different ways of approaching the same truth about the universal self in its mythic dimension, their art manifests a common interest in ambiguity as a clue to the ultimate mystery of being; in conflation as an artistic means

for manifesting the chaos of the unconscious mind, which leads to true creativity; in African and Native American images as a way to signal basic feelings of modern humanity; and in personal and inherited mythology as a condensed vocabulary for expressing spiritual and/or psychological growth. One of Pousette-Dart's most complex works of the early 1940s, *Bird in the Wind* (60) parallels the conflation and ambiguity of Jackson Pollock's psychoanalytic drawings.

Connections between inner and outer worlds fascinate Pousette-Dart. In 1943 he painted a psychological portrait of Peggy Guggenheim's daughter Pegeen, which is his most Surrealist work. The presence of the European Surrealists in New York during World War II clearly affected the American art scene. Peggy Guggenheim, who was married to Max Ernst, had opened the important commercial art gallery Art of This Century. Ernst's concept of Surrealism as a type of hyper-realism that served to pry open the surface of things and reveal their inner contents was intriguing to a number of American artists. These Americans hoped to rid themselves of Art Deco aspects and come to terms with their own feelings—a path that led to Abstract Expressionism.

Portrait of Pegeen (61) amplifies Pousette-Dart's belief in the unitary nature of reality by showing a symbolic portrait of a young girl who confronts her inner self by looking in a mirror. The painting serves as a critique of Picasso's *Girl Before a Mirror* by suggesting greater connections between inner and outer worlds. Pegeen, the child on the left who can be identified by a ponytail, looks at a more mature version of herself, suggested by the seductive blond wave on the right. Her face bears no resemblance to the masks of Pousette-Dart's earlier heads, even though it develops out of an interest in African sculpture and is closely connected to Senufo masks. In *Portrait of Pegeen*, unlike his earlier heads, the artist has employed an x-ray vision similar to that in the art of a number of prehistoric cultures as well as in the art of the Chumash, Zuni, and Australian Aborigines. More complex than its tribal prototypes, the x-ray style of Pegeen's face uncovers a teeming biomorphic realm of unicellular life, abstracted eyes, and tribal implements to indicate the richness of her inner world. Although jumbled, these forms are dominated by a large central eye. From the young Pegeen another eye reaches out to inspect closely the image in the mirror, and in the process it becomes part of its vision. The painting not only

59 *The Boundless Atom*,
1941–43
Mixed media; watercolor,
pen and ink on paper,
22⅝ x 31¼ inches
Collection of the artist

60 *Bird in the Wind*, 1942
Oil on linen, 26¼ x 44¼ inches
Collection of the artist

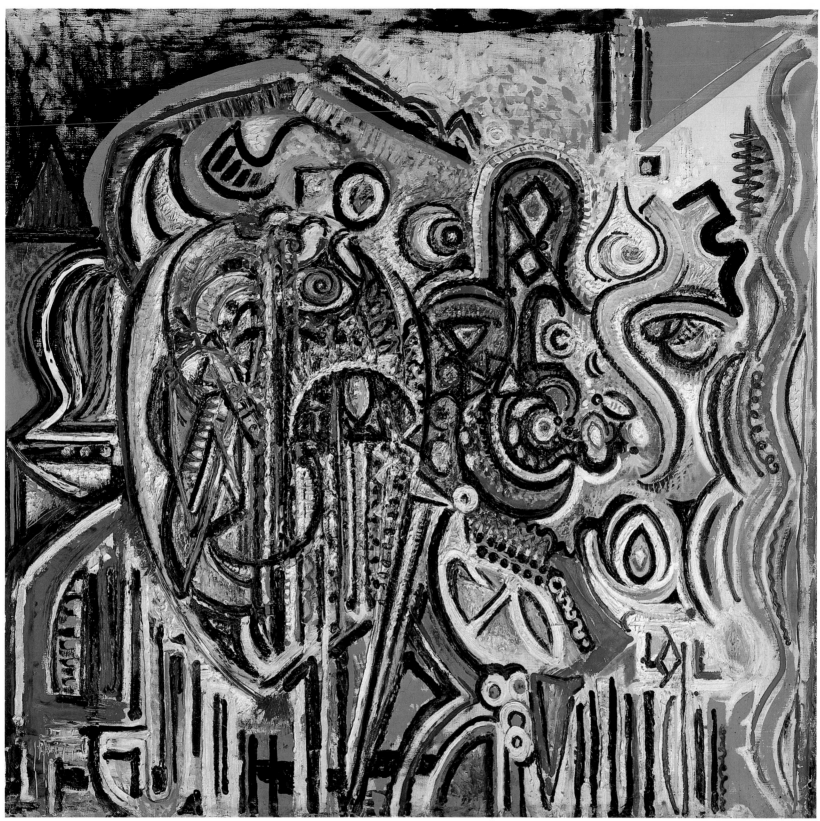

61 *Portrait of Pegeen*, 1943
Oil on linen, 50 x 52 inches
The Detroit Institute of Arts
Founders Society Purchase,
W. Hawkins Ferry Fund

Wassily Kandinsky, *Verdichtung (Compression)*, 1929. Oil on canvas, 39½ x 31½ inches. The University of Iowa Museum of Art. Gift of Owen and Leone Elliott. Late works by Kandinsky, like *Verdichtung*, that rely increasingly on geometric grids served as a basis for *The Edge*.

Richard Pousette-Dart, *Crucifixion, Comprehension of the Atom*, 1944. Oil on linen, 77½ x 49 inches. Collection of the artist.

develops from Picasso but also depends on the advances of Joan Miró's Surrealist paintings of the 1920s and 1930s to reach the core beneath the surface. *Portrait of Pegeen* is a positive symbolic image of a young girl who grapples with a more self-possessed image of herself.

Pousette-Dart continues his interest in inner and outer worlds in *The Edge* (62) of the following year, a painting clearly anticipated in the watercolor *Opaque Harmony*, 1941–43 (63). This interest is also apparent in *Abstract Eye*, 1941–43 (64). *The Edge* presents a Rube Goldberg apparatus consisting of turning blades, gears, fan belts, and spirals that connect various parts and suggest movement. On the lower right, abstract cloud forms imply that this machine is not a simple mechanical apparatus but instead is the great cosmic machine that Eastern mystics describe as ordering the universe. The more one studies this machine, the more it appears cosmic and four-dimensional, with its planets and astral forms seen in conjunction with a large, orderly grid. On the lower right, the artist plays with an illusory world by depicting a nail and its reflection, a reference no doubt to the nail and shadow appearing in Georges Braque's Cubist painting *The Portuguese* of 1911. The nail in Pousette-Dart's painting, however, is suspended in space; its only purpose is to show the impossibility of fixing anything in this colliding, expanding, and changing universe. The artist uses scumbled paint, layered forms, pentimenti, and transparency to give this machine a depth and resonance impossible for any simple mechanical instrument. And the work's similarity to the spiritual art of Kandinsky strongly supports the claim that his machine is intended to be cosmic rather than prosaic.

The title of this work refers to Pousette-Dart's use of the edge as a metaphysical concept to convey the power of the subconscious. The edge is the indecipherable line separating the conscious from the unconscious mind and the particular from the universal:

I want to keep a balance just on the edge of awareness, the narrow rim between the conscious and subconscious, a balance between expanding and contracting, silence and sound.[33]

The closer one gets to the edge, the less distinct it is; at a certain point the edge, which is analogous to a line in art, ceases to be distinct and absolute and becomes a symbol for tremulous being. Pousette-Dart has equated the edge with universal oneness or God:

*The edge is anonymous and contains
All personalities without personality
All individual difference without signature.
Or inequality. The edge IS equality of
Difference, love AS truth, darkly light being.*[34]

He admits that "every painter has an edge to himself and this is his anonymity," or his unconscious, for "the edge is inside within me I am the edge."[35] Given the edge's value as a conduit to the God within, it is reasonable to assume that a painting entitled *The Edge* would attempt to bridge the gap between the conscious and the unconscious through the analogy of bridging the gap between realism and abstraction. It is not surprising, then, that except for a few watercolors such as *Ascending* (65) and *City Dream* (66), which both date from 1945, *The Edge* served as a watershed work, marking the last traces of an illusionism that was to become increasingly obscured by myriad brush strokes, drips, and deliberately inchoate passages of paint, which signaled the triumph of experimentation over clearly achieved results and the importance of being as a vital changing force over stasis, or death.

In the painting *Abstract Eye* (65), the artist maintains some feeling for both the grid and the cosmic machine that appeared in *The Edge*, but he reorients his subject matter to make it accord with the work's reduced scale. Instead of the cosmos, *Abstract Eye* calls to mind a microscopic world of unicellular forms that share their space with a fish and an abstract eye. The entire composition pulsates with life, and the sweeping lines in this painting have at their center a black spider who has spun a web to capture this teeming, fecund world. The painting thus contains positive and negative elements; like the images in dreams, it is both inviting and disconcerting.

Focusing on the positive and negative aspects of creation is a central concern of *Crucifixion, Comprehension of the Atom*, 1944 (11), a painting that alludes to the destructive force that nuclear fission is capable of unleashing on the world. Although the word "Crucifixion" in the title might refer to the punishment of Jesus of Nazareth, the painting, according to the artist, is intended to be more generally concerned with the crossroads facing someone on a mythic journey. A crucifixion is a symbolic testing, a separation of the material from the spiritual; and it stands for the tragedy of humanity, which has rejected its divinity, its Christ-

62 *The Edge*, 1943
Oil on canvas, 81 x 47½ inches
Collection of the artist

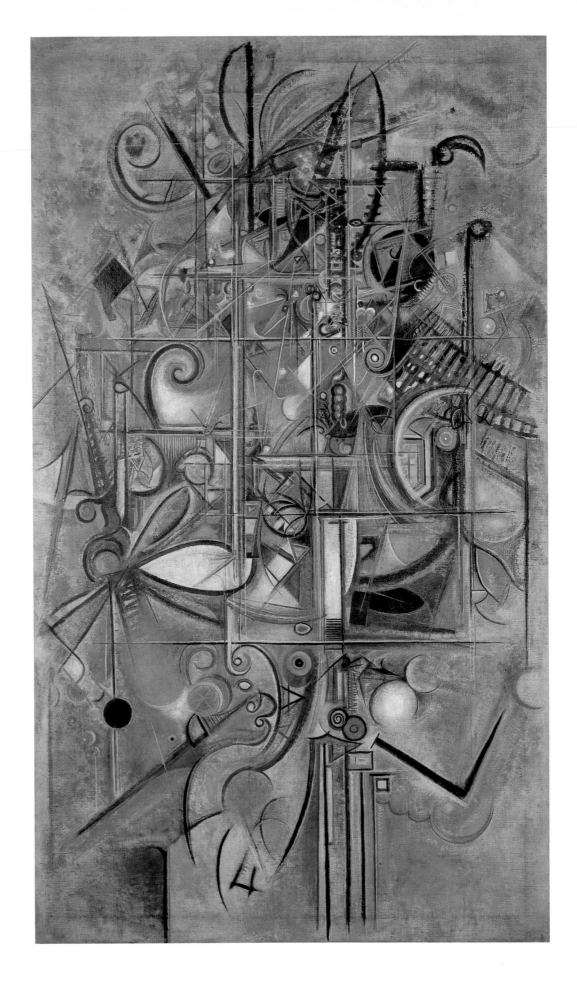

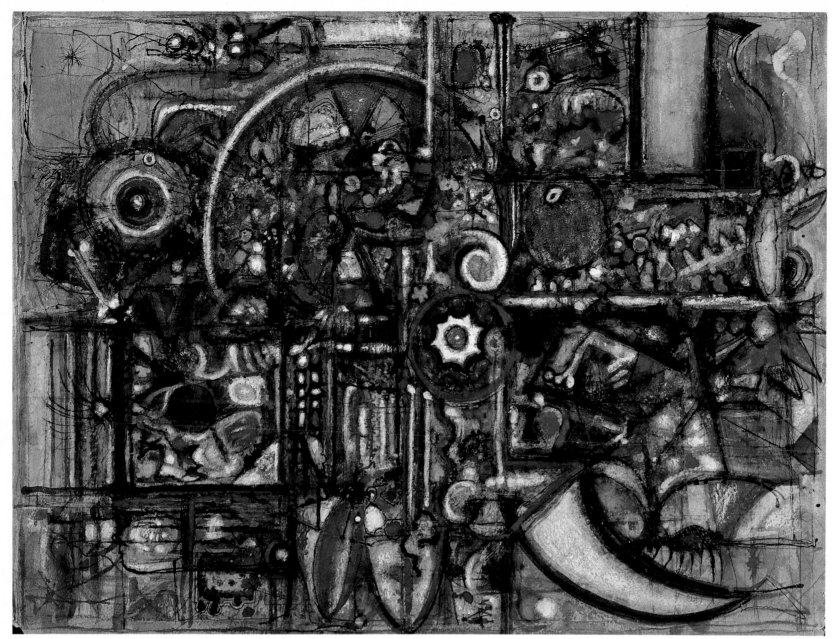

63 *Opaque Harmony*, 1941–43
Mixed media; gouache,
watercolor, pen and ink on paper,
22⅞ x 30⅝ inches
Collection of the artist

64 *Abstract Eye*, 1941–43
Oil on linen, 21 x 16½ inches
Collection of the artist

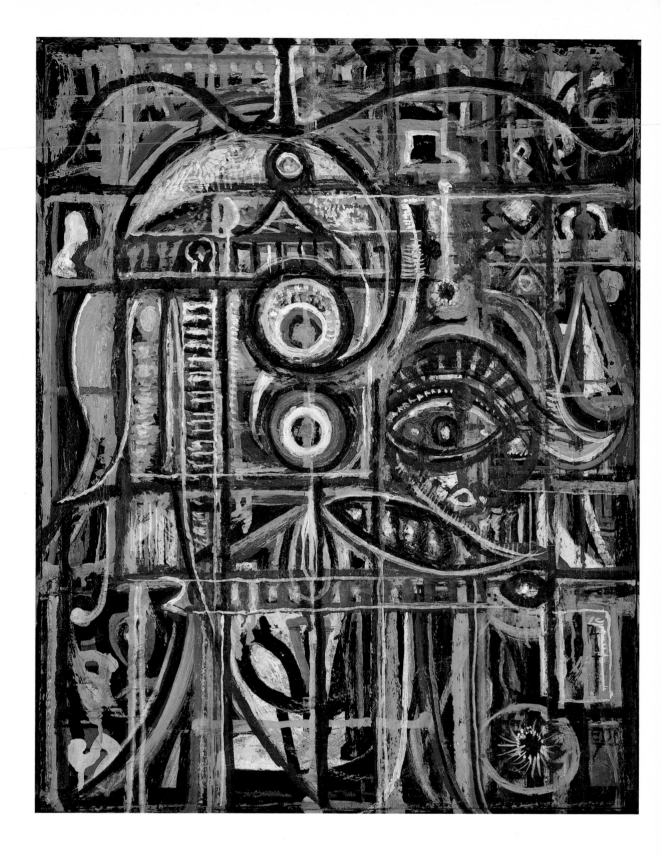

65 *Ascending*, 1945
Watercolor on paper,
18 x 11⅞ inches
Collection of the artist

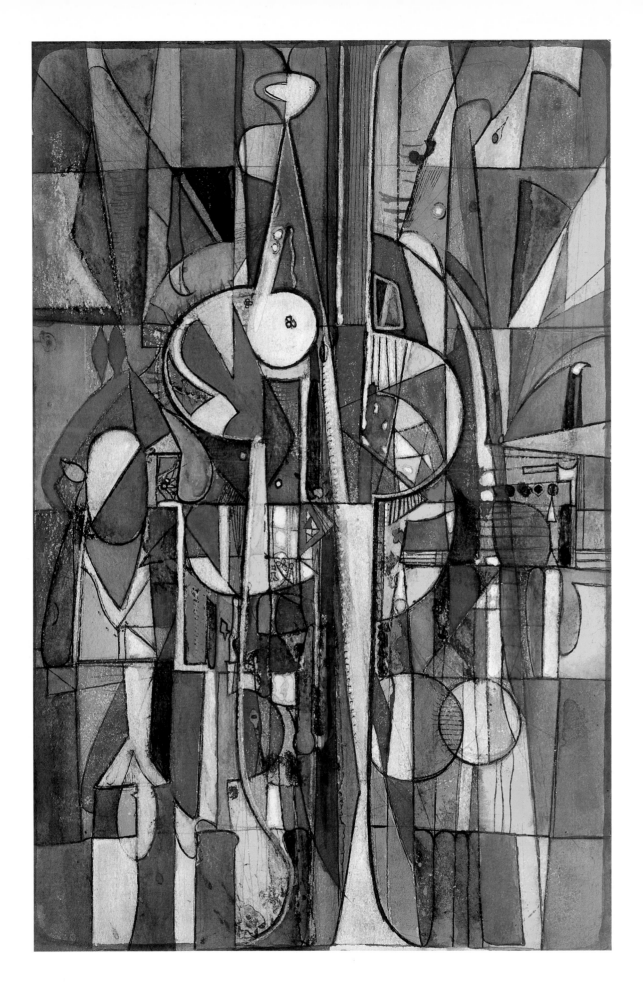

66 *City Dream*, 1945
Watercolor on paper,
18 x 12 inches
Collection of the artist

67 *The Atom, One World,*
1947–48
Oil on linen, 50 x 53½ inches
Private Collection

68　*Figure*, 1944–45
Oil on linen, 79⅞ x 50 inches
Collection of the artist

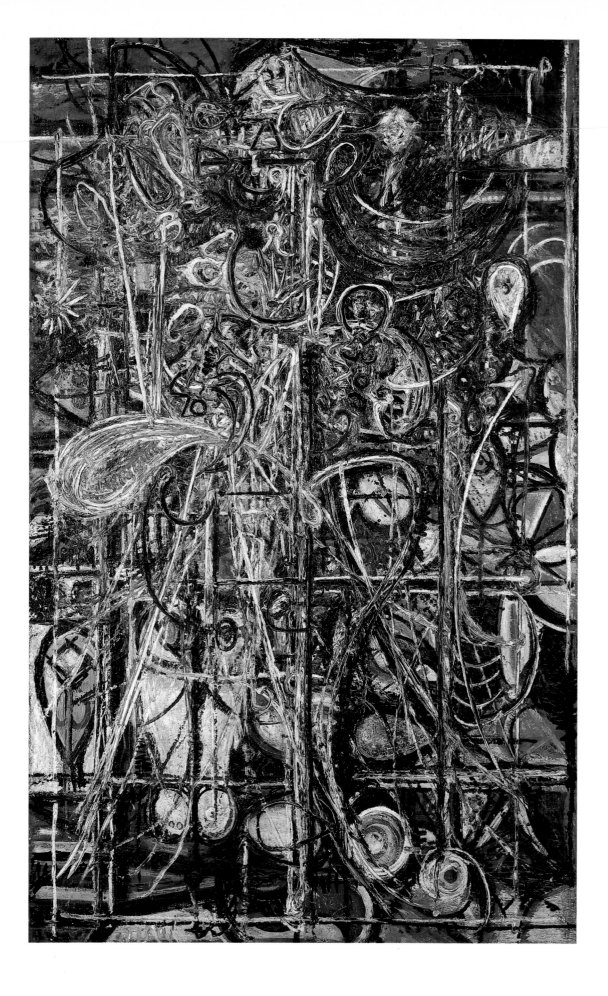

Jackson Pollock, *Portrait of H. M.*, 1945.
Oil on canvas, 36 x 43 inches.
The University of Iowa Museum of Art.
Gift of Peggy Guggenheim.

Tree of Jesse window, Royal Portal, Chartres
Cathedral, early 13th century (Giraudon/Art
Resource). In *Figure* Pousette-Dart relies on
stained glass as an established vocabulary for
the sacred. His *Figure* is conceived in black
forms similar to the leading of stained glass
and is surrounded by rich colors recalling its
luminosity. But instead of representing the
sacred, his spectral and enigmatic figure
inverts it, creating a horrific image of the
denizens of the unconscious.

likeness. In this work Pousette-Dart suggests that the divinity of the atom, its integrity of spirit/body and energy/form, is likewise being crucified. The glowing egg at the center anticipates by a year the phosphorescent light of the first atom bomb, dubbed "Trinity" and tested by the Los Alamos Group on July 16, 1945, which led in a few weeks to the bombing of both Hiroshima and Nagasaki. In the painting the glowing egg symbolizes the destruction of the unity of the universe as well as the disintegration of the personal truth of the unified man/god symbolized by the crucified Christ. The head of the figure in the painting is a dark ovoid. Separated from the luminous colored background, the blackened figure has been destroyed. Submerged beneath the lower part of this figure is a fish, a symbol of Christ and perhaps also the unconscious. In this painting Pousette-Dart regards the destruction of the atom as a metaphor for the potential destruction of humankind. Later in *The Atom, One World*, 1947–48 (67), he is less poetic and indirect as he presents an image of the ominous mushroom cloud of a nuclear blast. The "One World" of the title is intended to be disturbingly ironic, since it refers to the fact that world unity is attained through the common threat of nuclear destruction.

The spectral and dark forces of the unconscious loom large in *Figure*, 1944–45 (68). In this painting a black-and-white grid blocks the foreground figure from the colorful background shapes that recall fish, masks, simple geometric forms, and unicellular life. The grid in this painting thus serves a function analogous to the constraining prison-like grids found in sculptures that Seymour Lipton, Ibram Lassaw, and Herbert Ferber, among others, created in the 1940s and the heavy black lines in early Pollocks such as *Portrait of H. M.* From Pousette-Dart's grid emerges a black-and-white wraith with a grinning skull and possibly wings, which would indicate that it is an angel of death. The exuberant paint obscures this form, making its head appear to be a skull as well as a New Guinea mask with an arrow piercing its nose. Overlapping this wraith is a complex group of intertwined signs in the form of white letters, flowers, fish, geometric shapes, and sprawling whiplashes of paint that turn the figure into a spectral Rorschach, thus forcing viewers to participate in the interpretation of the painting by transforming it into a personal experience. *Figure* employs a number of culturally encoded forms relating to biomorphism, primitivism, stained glass, and grids to allude to the fact that its penumbral realm is the unconscious. (His implicit reference to stained glass became explicit a decade later when he

titled a watercolor *Presence, Cathedral Window* (69).) In addition, in *Figure*, Pousette-Dart uses paint as an automatic gestural overlay to suggest a mystically inspired sign system. It is similar to the mystical "white writing" of Mark Tobey, who exhibited in the same gallery. Although Pousette-Dart's gestural use of paint achieves an entirely different meaning from Tobey's delicate skeins, it might be considered part of a dialogue that Tobey's work elicited.

In 1941 Pousette-Dart selected a piece of stretched canvas 90 by 120 inches and then spent several years working on it to find a way of manifesting his personal vision on a large scale. He first exhibited the painting at Peggy Guggenheim's Art of This Century in 1947. Entitled *Symphony Number 1, The Transcendental* (17), this work is composed of the same complex system of signs that the artist used in a number of paintings of the early 1940s: spiraling nebulae, birds, eggs, grids, white writing, x-ray vision, and allusions to a cosmic machine. Like his other works, *Symphony Number 1, The Transcendental* is heavily encoded and deliberately ambiguous. It is a visual metaphor for the spirit or unconscious that joins elements of the microcosm such as flagella with cosmic forms to attest to the fecundity of chaos and the cosmic rhythms of the life force. The painting calls to mind Freud's comparison of the subconscious mind to a child's magic writing tablet, particularly the complex impressions left in wax.

The scale of *Symphony Number 1, The Transcendental* recalls the great history paintings that the French academy once favored. But in place of their commonly understood subject matter relating to historical, mythological, or literary events, Pousette-Dart has presented a personally intuited vision, thus making a Romantic statement about the nature of reality. He believes that he must begin with the personal and pursue it until it becomes universal and anonymous. He is convinced that a work of art will begin to establish its own significance when it transcends the limited individuality of the artist: "All things in themselves exalt, of themselves are exalted, to transcend themselves, to break all boundaries, to leap past limitations, to permeate into Everywhere."[36] As a way of affirming this interest in going beyond the personal, Pousette-Dart has for decades refused to sign his art. In his lecture in 1951 at the School of the Museum of Fine Arts, Boston, he explained his refusal: "Real painting is

69 *Presence, Cathedral Window,*
1955
Mixed media; watercolor, pen and
ink on paper, 14 x 10⅞ inches
Collection of the artist

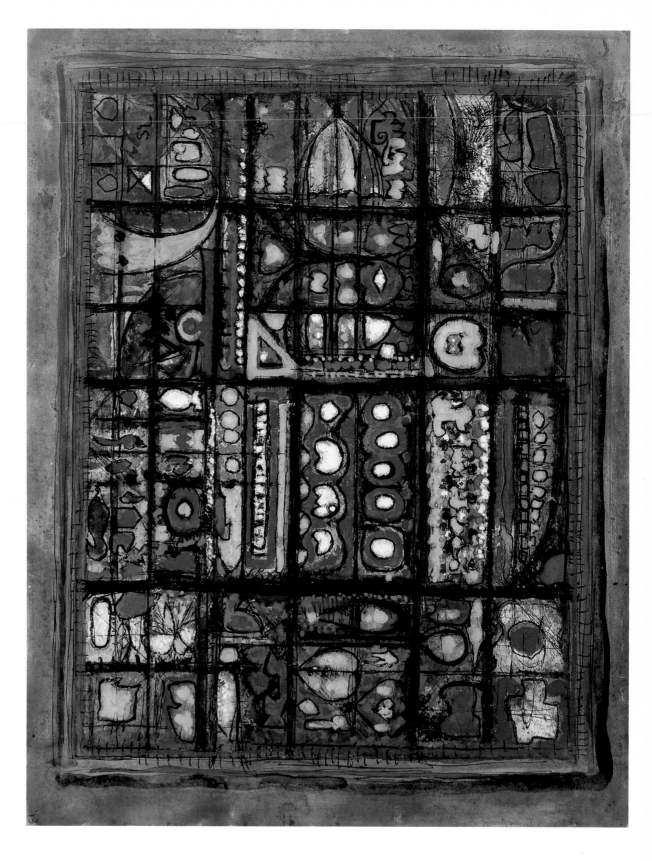

untitled and unsigned, it is a flower of its own self, its self *is* its own signature and its own name."[37] Although he has since decided that titles are more convenient ways of remembering specific works of art than numbers, he has maintained to this day a belief in art's autonomy and in the comparative insignificance of the artist's ego. His disdain for the ego separates him from many of his fellow Abstract Expressionists, who followed the French philosopher Jean-Paul Sartre in believing that their concerns and experiences are symptomatic of humankind and therefore universally valid. Unlike many members of this group, Pousette-Dart believes that the ego is limited and must be transcended if one is ever to approach the kind of universal music that he hopes to convey in *Symphony Number 1, The Transcendental*.

The monumental painting also reflects the importance of music to abstract painters in the first half of this century, who believed it to be the highest and most abstract art form. In *Symphony Number 1, The Transcendental* and the several *Fugues* (70) he created during the years he was working on this painting, Pousette-Dart was developing a special, poetic, and nontranslatable pictorial language:

> *Here are some words*
> *form of the inner language*
> *the feeling delved deep hieroglyph*
> *not meant to mean, still*
> *meaning, meaning more*
> *the gleaning of the spirits' mind*
> *leaps past frail literality*
> *where cosmic cords are sound fugues*
> *not records to be writ with words*
> *the elements record their own*
> *eloquent potent signatures*[38]

Since a fugue is a musical composition designed for a specific number of instruments or voices in which a theme is first presented in one voice before being developed by others, it is an apt title for paintings that play on the culturally encoded voices of stained glass, primitivism, Surrealism, mystical languages, and biomorphism.

At times Pousette-Dart has felt the need to reflect on his abstract images by making collages with materials from the real world. In them he overlaps realistic equivalents of the abstract signs that are layered in the paintings to the point of unrecognizability. The collage *Untitled (Ricardo)*, 1946–48 (71), is apposite, since "Ricardo" is Spanish for "Richard," and the collage is an emblem of the

artist. A notable image in the collage is the photograph of the artist's daughter Joanna decorating a Christmas tree. Seen in connection with a number of traditional religious symbols, including European churches, the photograph becomes a personal way of viewing the sacred. The conjunction of a Gothic nave with a snake calls to mind Pousette-Dart's interest in chaos. A traditional image of chaos, the snake symbolizes the uncreated form at the core of the creative experience, and its place in the nave of a church suggests the spiritual growth which transforms chaos into order. The Greek marble Venus in this collage could represent traditional beauty and also the rational approach of the Greeks, while the shield with a backward "5"—reminiscent of Leonardo's mirror writing—and a schematic figure point to the private languages artists have frequently used. A drawn fish with an eye or an egg, which also occurs in a number of the artist's paintings, may refer to seeing as both understanding and a means of rebirth and regeneration. The German word "heute" ("today"), written in red, could signify the end of the war, which came just as Pousette-Dart was beginning this collage, and the need then to forget the past and begin anew. Certainly "heute," in conjunction with Joanna, who represents the next generation, and the Christmas tree, which symbolizes rebirth in the midst of winter, is a provocative challenge. In addition, the Spanish "Ricardo," German "heute," and the many different European churches and cultures represented in this collage suggest the importance of different ways of viewing the world and convey the artist's ecumenical approach to religion and life.

In the 1930s and early 1940s Pousette-Dart further discovered and developed his style, and in the 1950s he grew more comfortable with it, learning, so to speak, to play it in different keys and with increasingly varied tempos, even though his overall orientation remained essentially unchanged. Pousette-Dart still explored the mystery, process, and creative force of the spirit/unconscious mind. While he continued in such works as *Number 1, 1951* (72) to make references to eyes, eggs, and amoebic forms and to use these elements as basic building blocks of his compositions, his palette became richer and his colors grew more luminous. In addition, he veered away from the dark and sometimes even threatening tonalities of his paintings of the war years and began to create works that were exuberant and even joyous. In place of the wraith of *Figure* or

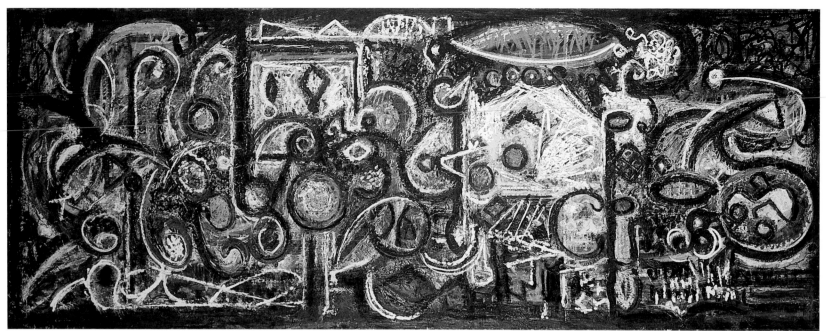

70 *Fugue Number 2*, 1943
Oil and sand on canvas,
41⅛ x 106½ inches
The Museum of Modern Art,
New York
Given Anonymously, 1969

71 *Untitled (Ricardo),* 1946–48
Collage, 20 x 16 inches
Private Collection

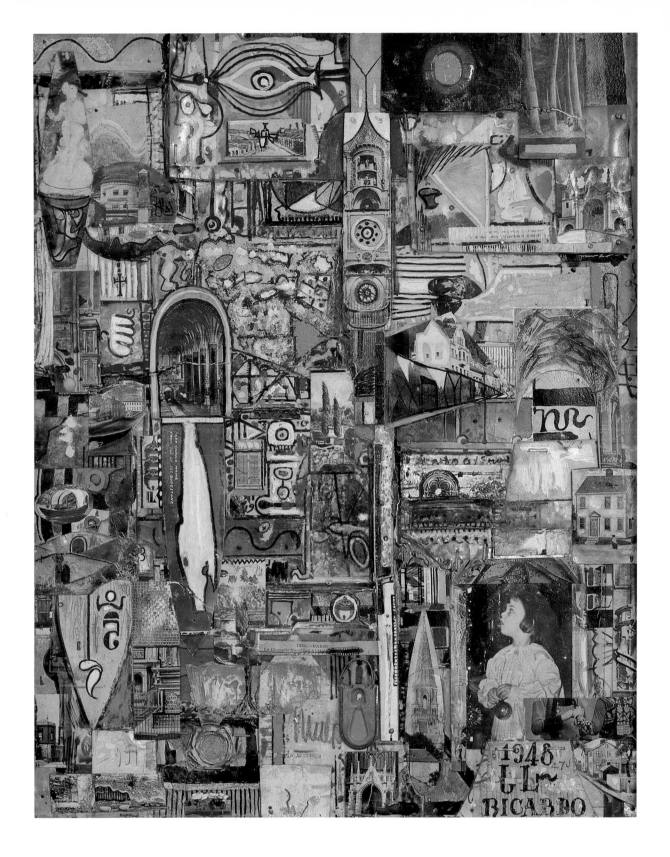

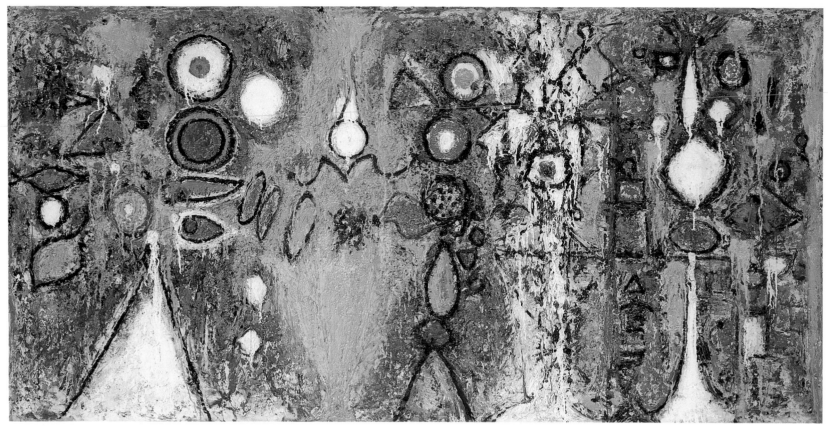

72 *Number 1, 1951*, 1950–51
Oil on linen, 42½ x 85 inches
Collection Marisa del Re Gallery,
New York

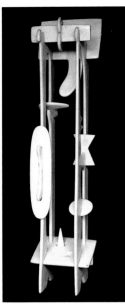

Isamu Noguchi, *Metamorphosis*, 1946. White Italian marble, 68½ inches high. Yale University Art Gallery, New Haven. Henry Heinz II, B.A. 1931, Fund.

the dying abstract figure of *Crucifixion, Comprehension of the Atom*, postwar paintings contain groups of totemic figures that signify ecstatic revelations rather than dire premonitions. The totemic figures of *Number 1, 1951* and other paintings of the period accord with a growing trend among the Abstract Expressionists to populate their canvases with enigmatic personages whose source is both the subconscious and the art of Metaphysical painters and Surrealists, particularly Giorgio de Chirico's jerry-built mannequins and Alberto Giacometti's tremulous postwar figures, which go beyond Surrealism to achieve a personal and intuitive sense of reality. Although some personages, such as Willem de Kooning's women, Jackson Pollock's black-and-white figures, and William Baziotes's hybrids, continue to be troubling denizens, others emerge from the darkness to be seen in new revelatory light. Both Barnett Newman and Mark Rothko find ways of transmuting the personages stemming from their unconscious by making them embodiments of light in "zips" and "multiforms," respectively. And David Smith uses humor in the form of found objects welded together in his Tank Totems as a way of lightening the burden of his World War II despair and proclaiming a new and more optimistic postwar era. These last three Abstract Expressionists share with Pousette-Dart an interest in befriending the unconscious mind while still paying homage to its mystery and autonomy.

The enigmatic figures of Pousette-Dart's *Number 1, 1951* convey an almost Byzantine quality. Both familiar and strange, they are grand abstract equivalents of the famous Ravenna mosaics of Emperor Justinian and Empress Theodora, who are each pictured with their attendants. Significantly, Pousette-Dart's figures neither emerge totally out of a background nor stand completely isolated on a shallow stage. Instead they oscillate between foreground and background, becoming part of one overall fluctuant surface that is marked at times by dissolving white personages and at other times by emergent gold ones.

The Magnificent, 1950–51 (73), proclaims this newly befriended realm in all its splendor. Picturing a refined, inviting, and thoroughly radiant chaos, *The Magnificent* is notable for its joyous, majestic colors and its quivering indecisiveness, as if it consisted of unicellular life being viewed through a microscope. It is possible to get lost in certain passages of this painting, which look as if the colors of Impressionism have been released from the servitude of describing the world and now are free to reveal

themselves as the opulence of heavily encrusted paint. The layered surface reflects the time spent carefully working out the artistic solutions making up this painting. Like Pousette-Dart's pictures of the 1940s, *The Magnificent* is culturally encoded with allusions to stained glass (spirituality), amoebas (gestating life), grids (rationality), drawing (the artist's initial thoughts), and layered forms (the complexity and unity of the unconscious mind).

Transmuting the past and finding a way of invoking a positive new beginning is the subject of *Golden Dawn*, 1952 (74), a thinly painted work that combines areas of primed canvas with passages of drawing to suggest radiant images. The personages in *Golden Dawn* consist of a collection of bones assembled in such a way as to make them overlap and mirror one another. The reference to bones recalls the Surrealist sculptures of Herbert Ferber, David Hare, Isamu Noguchi, and David Smith, and it was anticipated in Pousette-Dart's own gouache *White Undulation* of 1941–43 (75). But instead of memorializing death and destruction, Pousette-Dart imbues his collection of skeletal parts with the power of regeneration and revelation. They awaken to the gold, silver, and white light of a new day, the "golden dawn" of the title. Luminous, unearthly, and radiant, the bones conjure up an image of life's numinous core, becoming emblems of resurrection and important symbols of postwar resolution for the conflict that many people, including the Abstract Expressionists and in particular Pousette-Dart, internalized in the 1940s.

Golden Dawn belongs to a group of postwar works emphasizing a pared-down formal approach. Pousette-Dart created a number of white paintings during this period that use the primed canvas together with delicate webs of graphite lines to suggest the unconscious as a fragile realm capable of registering the subtlest feelings and the most evanescent revelations. Even in *Chavade*, 1951 (76), in which white paint is worked into a dense relief, the artist abandons the heavy layers and dark tonalities of his art of the previous decade and creates luminous atmospheres by enveloping the painted surface in delicate drawing. The delicacy of white on white later serves as the basis for an entire body of graphite and acrylic works on paper, including *Silent Streams*, 1978 (77), *The White Spiral*, 1978 (78), and *White Arabesque*, 1977–78 (79). A late pastel variation on this theme is *Pale Garden*, 1980–81 (80).

73 *The Magnificent*, 1950–51
Oil on canvas, 86¼ x 44 inches
Whitney Museum of American Art,
New York
Gift of Mrs. Ethel K. Schwabacher

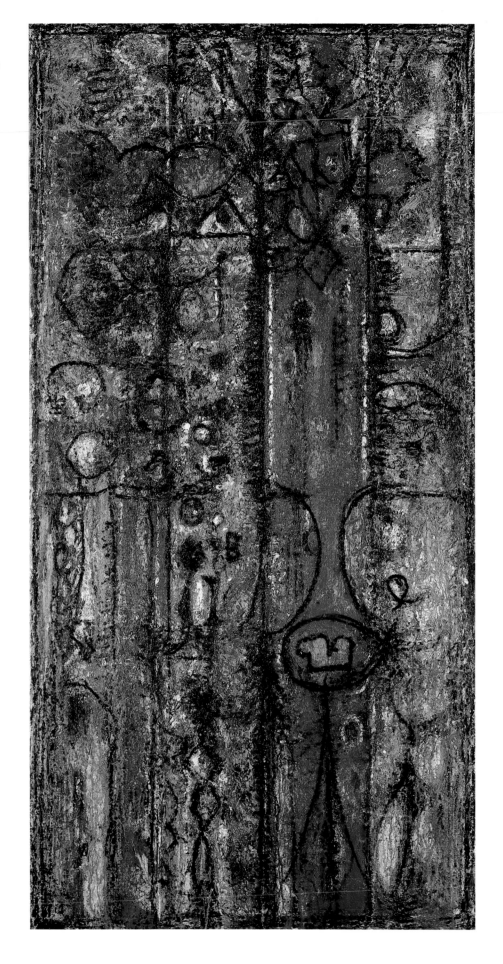

74 *Golden Dawn*, 1952
Oil on linen,
93½ x 51½ inches
Collection of the artist

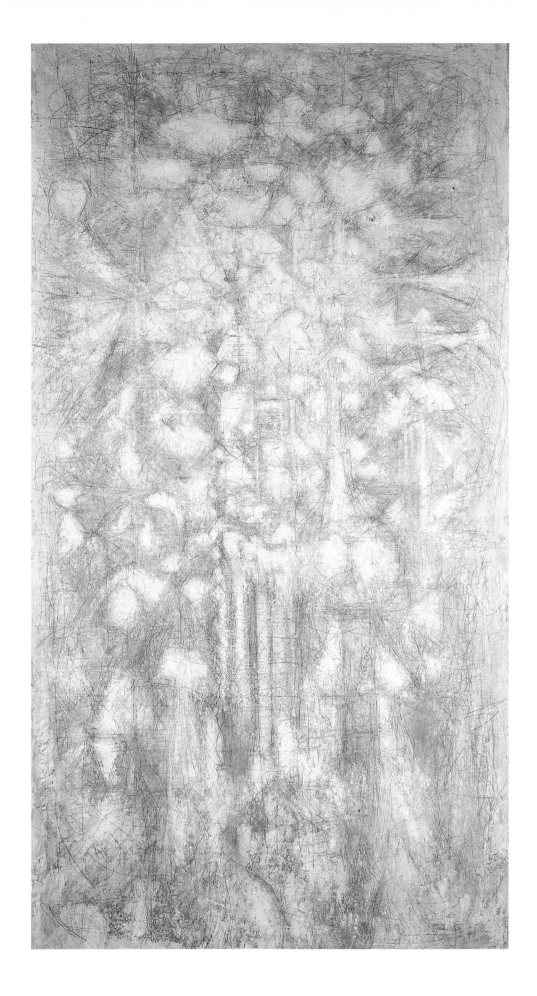

75 *White Undulation*, 1941–43
Gouache on handmade paper,
31½ x 23 inches
Collection of the artist

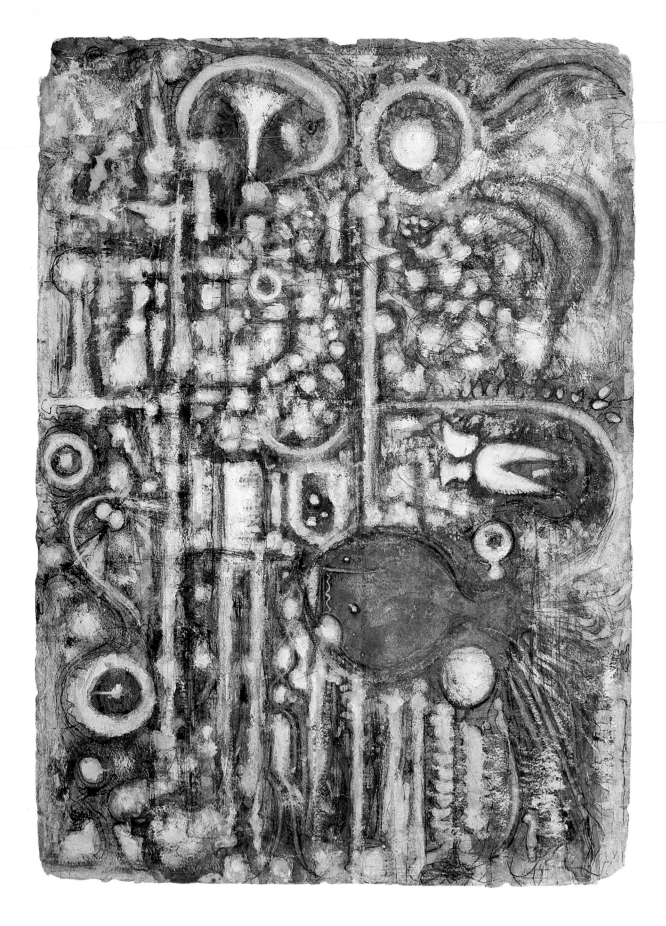

76 *Chavade*, 1951
Oil and pencil on canvas,
53⅜ x 96½ inches
The Museum of Modern Art,
New York
Philip Johnson Fund

77 *Silent Streams*, July 10, 1978
Acrylic and graphite on
handmade paper,
23 x 30¼ inches
Collection of the artist

A number of paintings from the 1950s tantalize viewers with the impossibility of ever understanding them through rational analysis. They serve as Rorschachs for individual interpretation and present a key to their solution while still remaining ineluctable and chimerical. Plato described art as the mere shadow of objects that themselves are only reflections of an ultimate reality. If the illusions of art are only shadows of imitations of reality, Pousette-Dart seems to ask in *Shadow of the Unknown Bird*, 1955–58 (81), what will happen if people are presented with a shadow of something that is beyond the grasp of the conscious mind: the unknown bird, a symbol of the spirit which casts a shadow that is impossible to comprehend through rational means. Given the title as a guide, observers might be able to detect a bird's shadow in this painting; but if this strange creature—an upended triangle topped by a circle and two ovoids—is in fact the shadow of a bird, it belongs to a new order of being. Furthermore, there are hints of other birdlike creatures elsewhere in the painting. In this manner the work guides viewers into a richly ambiguous realm that awaits their imprimatur before it can begin to assume any reasonable order. The work thus demands observers' interpretations, which become self-fulfilling prophecies and which lead to the artist's professed goal of getting viewers to come to terms with themselves through art. "A painting is successful when I no longer know anything about it," Pousette-Dart has stated. "People must find their own experience in it. A significant painting must be pregnant with the possibility of contemplation so it can draw out of people the things they have in them."[39]

Illumination Gothic, 1958 (82), epitomizes Pousette-Dart's fascination with sacred traditions and spirituality in modern life. Gothic illuminated manuscripts serve as a subtext for this and other works such as *White Gothic Number 4*, 1959 (83). The viewers' understanding of *Illumination Gothic* is enhanced if they consider it in relation to the intricate designs of elaborate initials used to introduce Gothic manuscripts. Conceived in rich colors with a lavish amount of gold leaf, the trailing vinelike patterns that encircle charming vignettes of biblical figures in medieval manuscripts attest to the beauty, intimacy, formality, and humanity of the sacred. Gothic illumination is found in Bibles and psalters that were carried to religious services. Although they were not always used by pious individuals, and frequently became sumptuous objects of conspicuous display for members of the nobility, they were intended to shed light on the meaning of

sacred texts. This idea of illuminating the sacred is important for Pousette-Dart's painting, which presents five hieratic figures against a radiating gold background. The symbolic role of these abstract totemic figures is indicated by their lack of solidity: at their base they dissolve into rivulets of Abstract Expressionist drips. The five figures serve as a spiritual scaffolding for a richly encrusted and elaborately worked surface with jewel-like ovoids, circles, and diamonds. They serve much the same function as elaborate Gothic initials, which introduce and designate a page of text as special and sacred. The Gothic decoration announces the privileged point of view of the religious devotee in much the same manner as *Illumination Gothic* announces the sacred work of creative self-discovery that the artist intends people to enact in the process of comprehending his abstract composition.

Not content to deal with the sacred in positive terms, Pousette-Dart created an inversion of *Illumination Gothic* in *Blood Wedding* (84), a brutal work in which the red paint looks like blood and the personages specters. The painting was given its title by the artist's wife, Evelyn, a poet who frequently collaborates with him on titling his works. Although Pousette-Dart believes that the title, which refers to the Federico Garcia Lorca play, may have more meaning for Evelyn than for him, he accepted it because it conjures up the idea of dark, brooding primordial forces that have their origins in the unconscious mind and that affect people in disturbing and surprising ways.

The transition from the 1950s to the 1960s is attended by a greater reliance on abstraction and an interest in allover compositions that veer away from the fluctuant stage settings populated with figures that characterize many earlier works. The changes occurring in Pousette-Dart's art in the 1960s reflect his reevaluation of Impressionism, which had important personal associations since his father had worked in an Impressionist manner. As recently as the 1940s Impressionism was considered a period style that was outside the bounds of modernism. In the 1950s when The Museum of Modern Art acquired several Impressionist works for its permanent collection, the critic Clement Greenberg began to laud its formal advances, and vanguard artists as different as Sam Francis, Philip Guston, Morris Louis, and Barnett Newman found its formal devices worth borrowing. Although he employed an almost Impressionist sense of color in *The Magnificent*,

Page from *The Windmill Psalter*, 13th century. The Pierpont Morgan Library, New York. M102 f. lv. © The Pierpont Morgan Library 1990. Gothic manuscript illumination serves as a subtext for Pousette-Dart's meditations on the Gothic theme in such works as *Illumination Gothic* and *White Gothic Number 4*.

78 *The White Spiral*, 1978
Acrylic and graphite on
handmade paper,
22⅞ x 30⅛ inches
Collection of the artist

79 *White Arabesque*, May 1977
(reworked 1978)
Acrylic, graphite, and gesso on
handmade paper,
22⅝ x 30 inches
Collection of the artist

80 *Pale Garden*, 1980–81
Mixed media on paper;
hand-colored etching,
17⅞ x 23¾ inches
Collection of the artist

81 *Shadow of the Unknown
Bird*, 1955–58
Oil on linen,
95½ x 52½ inches
Collection of the artist

82 *Illumination Gothic*, 1958
Oil on linen, 72 x 53½ inches
Private Collection

83 *White Gothic Number 4*, 1959
Oil on linen, 75⅛ x 57⅞ inches
Private Collection

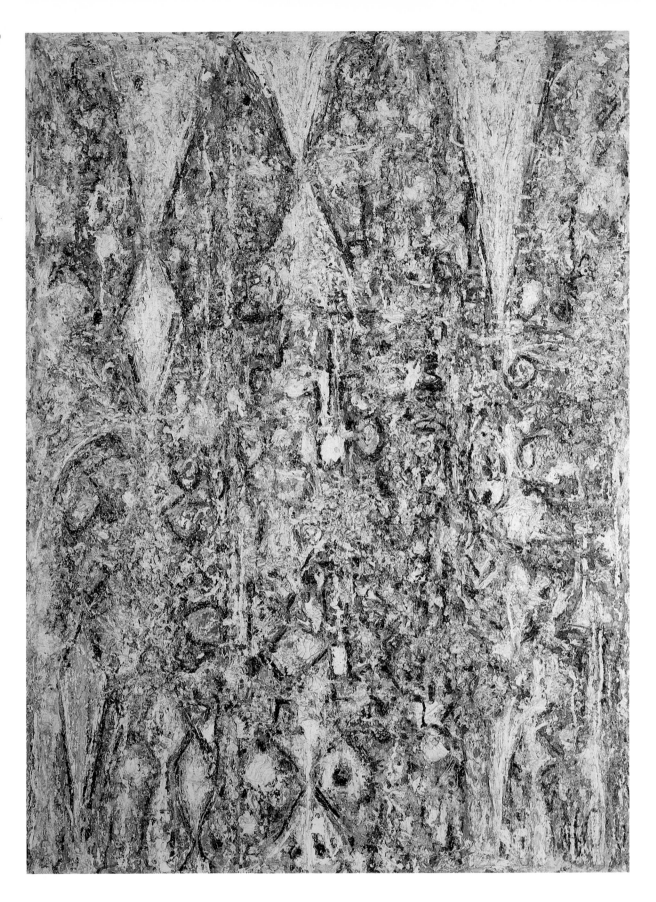

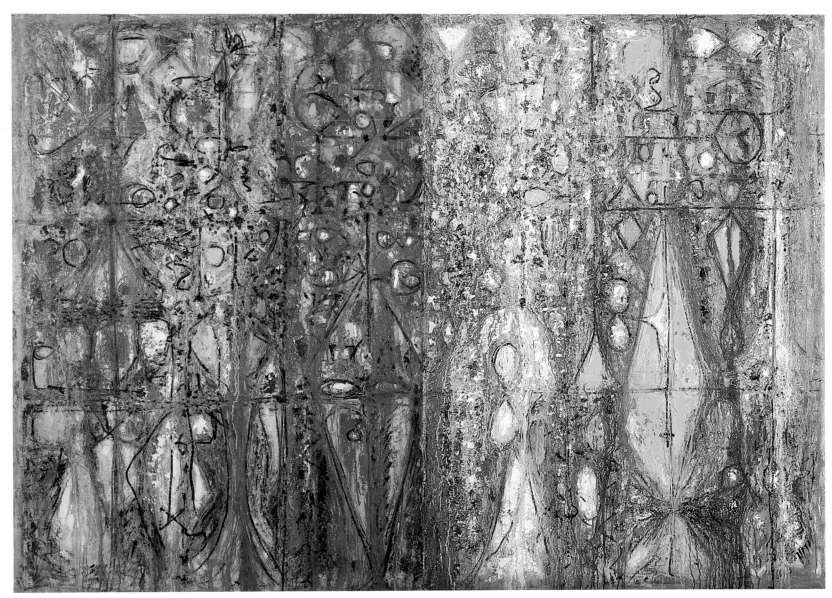

84 *Blood Wedding*, 1958
Oil on linen, 72 x 112 inches
Collection of Dr. and Mrs. Arthur
E. Kahn, New York

Richard Pousette-Dart, *In the Garden*, 1960. Oil on linen, 75½ x 56 inches. Collection of the artist.

Pousette-Dart waited for a number of years until he had thoroughly investigated the idea of abstract personages, together with the formal vocabulary of drips and gestural drawing with paint, before he began using Impressionist elements in his art to evoke an expanded sense of spirituality. From the claustrophobic interior spaces of the 1940s to the fluctuant stage settings of the 1950s, he moved to atmospheric spaces that begin to embrace the cosmos. As soon as he recognized that broken color and fractured brush strokes atomize reality, Pousette-Dart had to relinquish the quasi-figurative elements that had populated his canvases since the 1930s and to accept increased abstraction in his work.

Although he acquainted himself with the formal advantages of Impressionism, he did not use them in a traditional manner to depict landscapes. Like other Abstract Expressionists, he created an inscape rather than a landscape, a work of art that turns in on itself and presents a viewer with an essential identity rather than a mere transcription of visual appearance.[40] The inscape of a landscape would take into consideration an artist's feelings about the scene as well as the available formal means for manifesting these feelings. While a landscape might serve as a catalyst for a painting, the feelings manifested within the limits of the chosen medium would be the subject of an inscape. Pousette-Dart was careful to note the differences between external nature and the reality of his work, or the differences between landscape and inscape. In 1954 he wrote, "Art is not a mirror reflecting other life as was much artifice of the past but is the very being of nature itself we are not watching the water nor describing it we are in it."[41] When John I. H. Baur, then director of the Whitney Museum of American Art, organized the exhibition *Nature in Abstraction*, he asked a number of artists, including Pousette-Dart, to comment on their attitudes toward nature. Because Pousette-Dart's response clearly articulates his position on the type of nature germane to his art, it is worth quoting in its entirety:

The only relationship of my painting to nature is simply through me as a mystical part of nature and the universe. My work and my work alone defines my relationship to nature.

A work of art for me is a window, a touchstone or doorway to every other human being. It is my contact and union with the universe.

Art is not a mirror reflecting nature, but is the very essence of man's aesthetic, imaginative experience.

Art transcends, transforms nature, creates a nature beyond nature, a supra nature, a thing in itself— its own nature, answering the deep need of man's imaginative and aesthetic being.

Nature does not satisfy art, but art satisfies nature. Nature is dumb, while art is conscious, articulate, and triumphant.[42]

The nature Pousette-Dart depicts is his own; his reality depends on his feelings about the world.

Some of Pousette-Dart's first experiments with an Impressionist technique confound everyday experience of space as they appear to be both open and closed at the same time. *In the Garden*, 1960, might refer to an actual garden; however, the work hovers between external, atmospheric space and a protected internal realm. Both soothing and puzzling, the painting comes closest to Claude Monet's expressionist works of the 1880s in its thick coruscations of paint and to his late waterlily paintings in its abstraction. *In the Garden* has dissolved form into both light and paint, and the former is as ephemeral as the latter is dense and impenetrable. Both serve to express the artist's inscape by manifesting his feelings in paint, light, and color rather than imitating the appearances of the external world.

A similar interest in an inscape is apparent in *Sky Presence (Morning)*, 1962–63 (101), in which outer space becomes a metaphor for the artist's interior space. Changing morning light in the form of aureoles of violet, red, and yellow enliven this all-over composition that seems to engulf observers. Because the work is conceived without a dominant focal point, it encourages viewers to emphasize their peripheral vision. Rather than focusing on individual elements, they tend to treat the canvas as an allover embracing environment. Whereas focused scrutiny requires observers' conscious attention, peripheral vision is more closely aligned to a subconscious apprehension of the world, in which objects and forms are not subjected to the critical inquiry of the conscious mind. By inducing viewers to relax and be surrounded by forms, Pousette-Dart sets up a meditative situation whereby people begin to be aware of a less restrictive field of vision than that to which they are normally accustomed. In this manner he entices viewers to come to terms with a visual field that is a metaphor for the subconscious mind, and thus he creates a perceptual equivalent to chaos.[43]

In *Awakening Earth*, 1962–63 (85), Pousette-Dart similarly invokes nature without limiting himself to describing it. He may have been thinking of this work when he reflected:

If you continue [working] long enough, you start to see things, and then you bring them out. But you don't necessarily have to. It's like taking a piece of earth and dancing on it so long that it starts to live under your feet. You find there are subtle things that you keep repeating and that start to beat forms or that start to make an iconography or start to make a structure—or you can bring it out.[44]

The painting serves as a mandala of becoming since it oscillates between a centered and an allover composition. The brush strokes and individual daubs of paint in *Awakening Earth* never coalesce; they continue to vibrate, endowing this work with enormous energy. These pulsating rhythms suggest more than the dawn of the new season, spring; they create an image of new birth, a metaphor of being. This image of new birth assumed even more cosmic associations in *Presence, Genesis*, 1975 (86). Paralleling the brushwork of *Awakening Earth* but much more centered is a group of small studies exemplified by *Radiance, Blue Circle*, 1960 (87).

The transition from references to gardens and earth to analogies of cosmic realms is effortless and natural for Pousette-Dart, who had suggested aspects of both the microcosm and the macrocosm in such paintings of the 1940s as *The Edge*, in which machines, clouds, and planets collide in a grand and mysterious metaphysical realm. The critic Hilton Kramer was among the first to note Pousette-Dart's interest in the cosmos in the 1960s in his review "Art: Spirit and Substance" for the November 18, 1967, *New York Times*:

The artist's imagery has changed over the years, where in the past it was more earthbound, it has now become almost literally focused on the heavens, with a hint of sensuous, celestial light as its principal concern. But his essential purposes have remained the same—to make of painting a highly personal record of a spiritual state.

The impetus to employ an iconography of outer space no doubt derived from the emerging space program of the United States. The exploration of outer space soon became an important way of gauging the country's scientific lead over its Cold War opponent the Soviet Union. It also captured the imagination of the shrinking world, which Marshall McLuhan was appropriately calling a "global village."

Just as the atom had its artistic equivalents in George Nelson's clocks, Pollock's drip paintings, and Pousette-Dart's own works of the 1940s, so the space age spawned such forms as the Hoover Constellation vacuum cleaner, Robert Smithson's Nonsites, Robert Rosenquist's *F-111*, and Pousette-Dart's *Imploding Light Number 2*, 1968–69 (104), *Presence Number 3, Black*, 1969 (88), and *Radiance*, 1973–74 (89). *Imploding Light Number 2* and *Presence Number 3, Black* might well refer to a black hole in space, but given Pousette-Dart's history and interests, black holes could also be space-age mandalas of the unconscious mind. *Hieroglyph Number 2, Black*, 1973–74 (105), appears to picture the universe as an infinity of galaxies and suggests that the self is the last frontier, as unlimited as the cosmos. *Radiance* joins together the poetry of late-nineteenth-century French Neo-Impressionism with the traditional religious imagery of a triptych and the imagery of outer space. This work also presents an almost myopic look at individual brush strokes that separate and atomize forms, causing them to be seen against light or dark backgrounds that heighten their intensity. In *Radiance* Pousette-Dart complements his cosmic imagery with spirals, foliate shapes, and forms that resemble some of the birds, eyes, eggs, and unicellular creatures of the 1940s. In this way he reverses the use of his earlier imagery: here he embeds elements of the microcosm in the macrocosm to suggest that a living spirit encompasses infinity as well as minuscule forms. His attitude is apparent in the richly textured, multidimensional *Celebration, Birth*, 1975–76 (37), with its festive display of fireworks and streamers made up of whirling cosmic forms liberally mixed with quivering microscopic life. In this work chaos is described most positively as part of the celebration of the new self that will emerge out of the dissolution of the old and the immersion in the new free-flowing realm of limitless possibilities.

At the time he created *Radiance*, Pousette-Dart was working on a triptych for the North Central Bronx Hospital. *Presence, Healing Circles*, 1973–74 (90), consists of three almost identical spheres that look as if they are being seen either under a microscope or through a powerful telescope. The microcosm becomes equivalent to the macrocosm, and the double perspective invites the viewer's close scrutiny of the relationship between inner and outer space. *Presence, Healing Circles* joins the cosmic image of a planet with teeming life seen through the microscope to suggest the life force pervading the

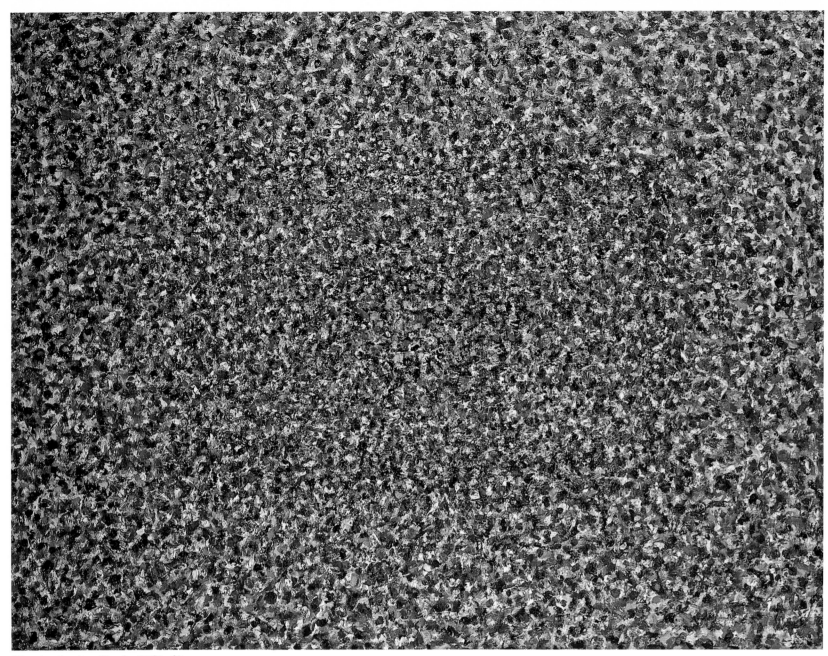

85 *Awakening Earth*, 1962–63
Oil on canvas, 43¾ x 57½ inches
Private Collection

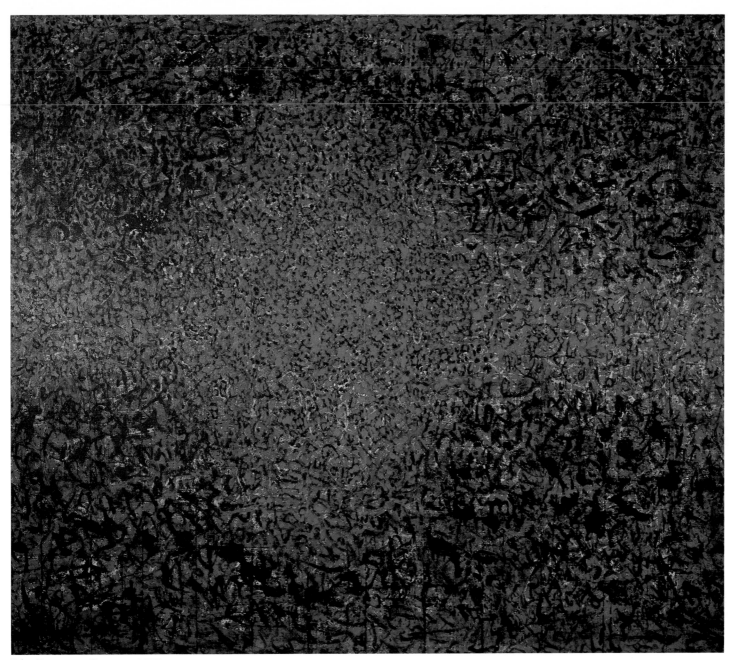

86 *Presence, Genesis*, 1975
Acrylic on canvas, 96 x 111 inches
Collection of the artist

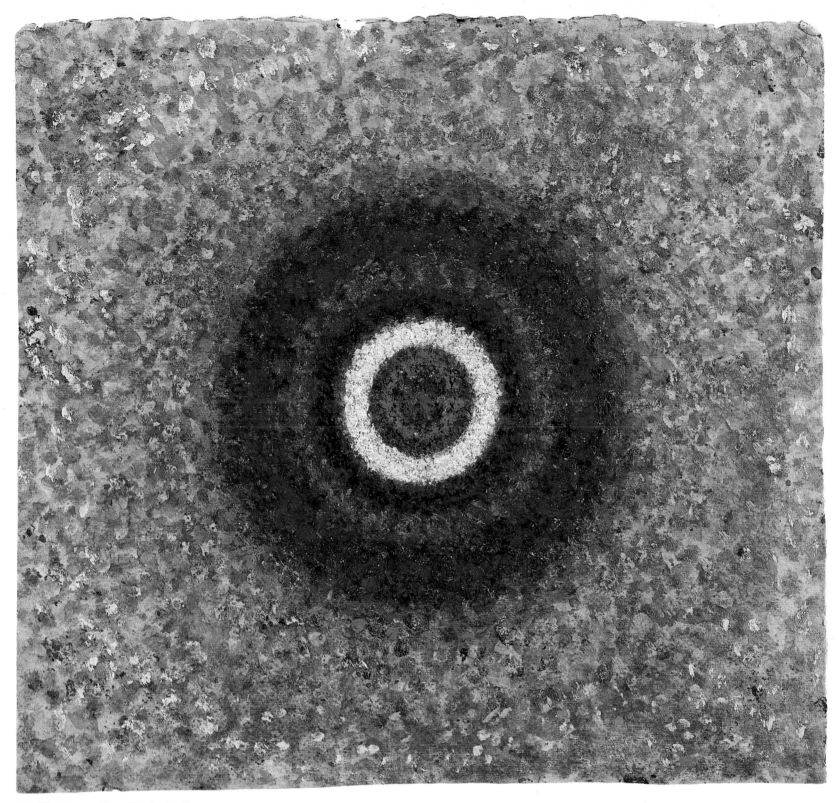

87 *Radiance, Blue Circle*, 1960
Oil on paper, 11¼ x 12¼ inches
Collection of the artist

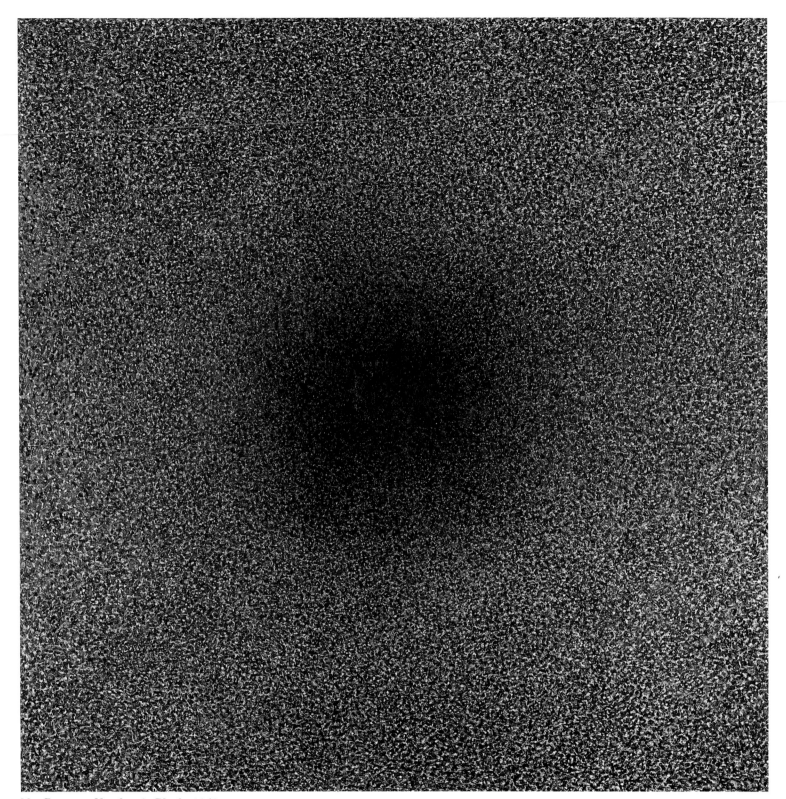

88 *Presence Number 3, Black*, 1969
Acrylic on canvas, 80 x 80 inches
Collection of the artist

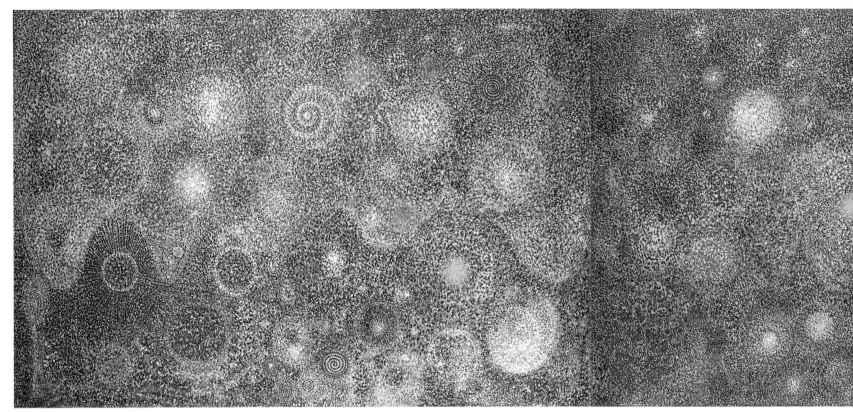

89 *Radiance*, 1973–74
Acrylic on linen, 3 panels,
each 72 x 108 inches
Collection of the artist

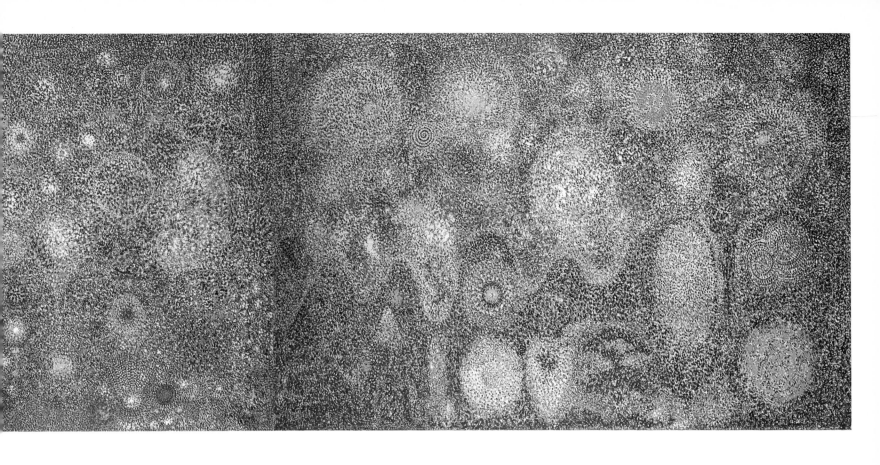

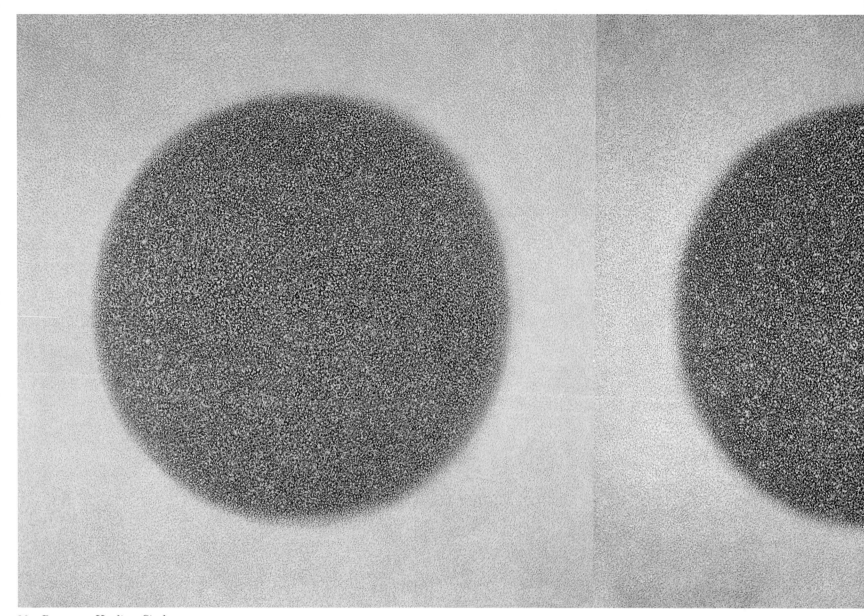

90 *Presence, Healing Circles,*
1973–74
Acrylic on canvas, 3 panels,
each 84 x 84 inches
Collection of North Central
Bronx Hospital, in cooperation
with New York State Facilities
and Development Corporation

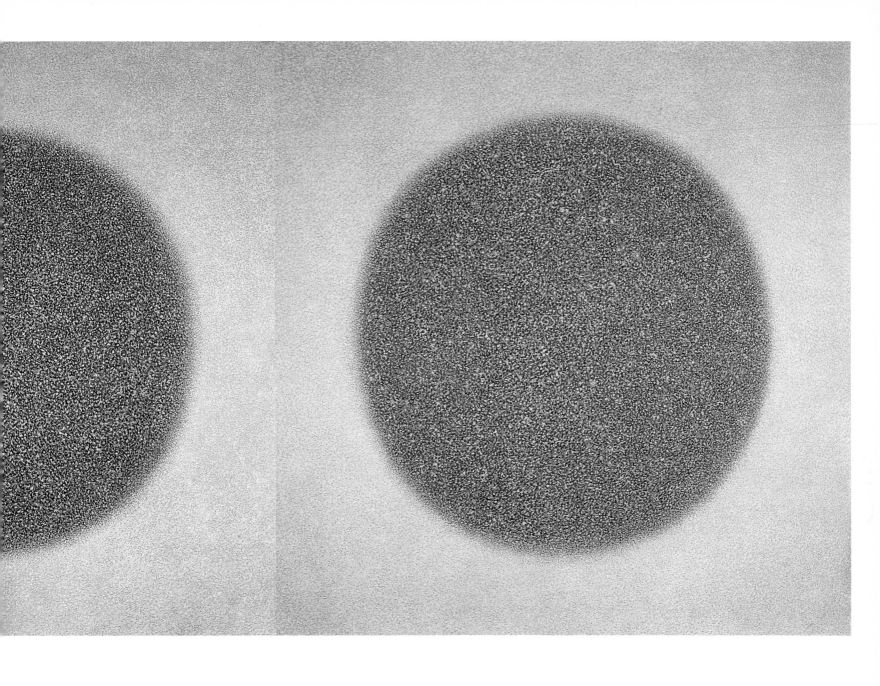

universe. The critic Lucy Lippard, who in the 1960s organized a traveling exhibition of Pousette-Dart's art, recognized the confluence of outer and inner spaces in such works as *Presence, Healing Circles*. "Images recalling outer space," she wrote, "refer each to inner space. Vastness is implied not only by visual association but by the time element transmitted by the painstaking technique."[45]

Pousette-Dart has lived since the early 1950s within view of the Ramapo Mountains and only a half-hour drive from the Hudson River landscapes that were important to such nineteenth-century painters as Thomas Cole and Asher B. Durand, so it is not surprising that traces of landscape linger in his inscapes. After his first full-fledged investigation of cosmic images in the late 1960s and early 1970s, he began to mix metaphors, so to speak, and allow elements of landscape to invade cosmic realms. Among his most poetic insights is *Presence, Ramapo Horizon*, 1975 (106), which refers to abstract aspects of the mountains as well as a transparent moon. The small daubs of paint that compose the mountains and moon suggest that a unitary life force constitutes nature. The subtle, diffused light of this painting is particularly haunting, and it recurs in a slightly different form in *Sky Presence, Circle* of the same year (91).

Like a number of artists of this period who felt a need to reduce their art to its barest essentials, Pousette-Dart began to think of ways his ideas could be conceived in black and white. "I've gone to black and white," he later recounted to critic Martica Sawin, "because of my need for a kind of intensity, the most intense light and the most intense darkness and the instantaneous balance between opposites. We can't have wholeness without both. There is nothing there and everything."[46] Starting with *Imploding Light Number 2* and *Presence Number 3, Black*, this current in his work gained momentum in the late 1970s and resulted in the exhibition *Presences: Black and White, 1978–1980*, which was installed at the Marisa del Re Gallery in New York. Among the most forceful and enigmatic pieces in the exhibition were *White Circle, Time* (42) and *Black Circle, Time* (39), which represent a further development of the transparent moon shape in *Presence, Ramapo Horizon*. The works are remarkable for the ways in which texture helps to create illusions of color. In *Black Circle, Time* roughly textured whites which reflect light contrast with the soft, velvety blacks of the circle, which absorbs light and appears as a magical hovering form. Here white and black cease to be opposites and become distinct modes of feeling. A similar though less dramatic illusion is operative in *White Circle,*

Time, in which a white ring appears to glow. (In addition to these large-scale works, the artist made a number of powerful black and white studies on paper, such as *Black and White Landscape*, 1979 (92), *Night Voyage*, 1979 (93), and *Black Quartet*, 1978 (94), which were not shown to the public.)

These black and white paintings depend on ideas formed in the late 1930s and 1940s when the artist was confronting for the first time the contradictions inherent in life and the need to affirm positive aspects of reality. In the years 1938–39 he described his disenchantment with the streamlined, industrial look that characterized late Art Deco and early Moderne, as well as with the geometric abstraction practiced by members of the American Abstract Artists group. His outline of the creative forms of interest to him could serve as a description of *White Circle, Time* and *Black Circle, Time*:

> I do not like what are called
> machine forms
> I like creative forms
> which realize
> a certain geometric quality
> whose ideal is the sphere
> forms with the eternal
> meaning
> movements of
> the circle
> the pyramid
> the sphere[47]

In other words, the artist goes beyond the decorative appeal of Art Deco and Moderne and creates majestic geometric icons that transcend any one orthodoxy as they come to represent a general belief in harmony, radiance, fullness, and completion.

After the exhibition of black and white paintings, Pousette-Dart took a different turn in his art. He began to synthesize a number of currents in his work by relying on his early interest in sculpture and creating heavily impastoed pieces that are essentially painted reliefs. In these paintings he combines his highly complex imagery of the 1940s, brighter palette of the 1950s, and Impressionistic brush strokes of the late 1960s and early 1970s, and he synthesizes images important to each of these three periods. Christian symbols seen in the early *Crucifixion, Comprehension of the Atom*, 1944 (11), for example, recur in *Illumination Cross*, 1982–83, which was originally part of a four-part series (95, 96). In both works biomorphic images in conjunc-

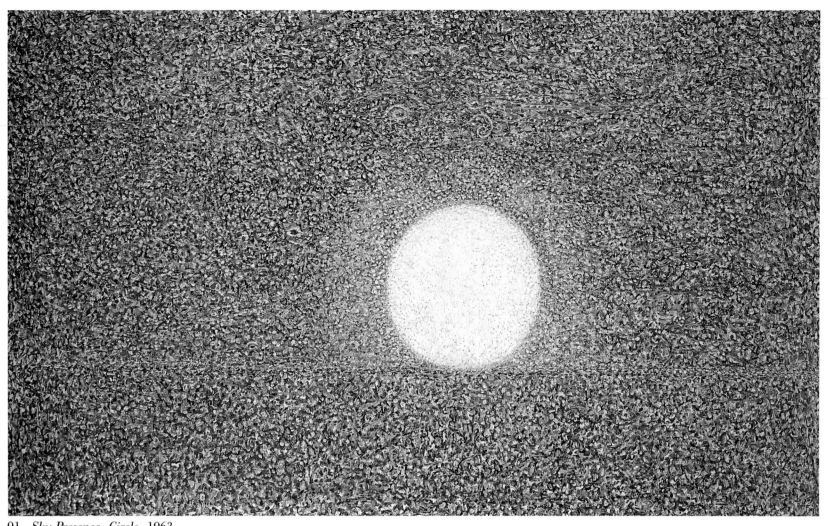

91 *Sky Presence, Circle*, 1963
Oil on canvas, 43 x 71 inches
Collection of the artist

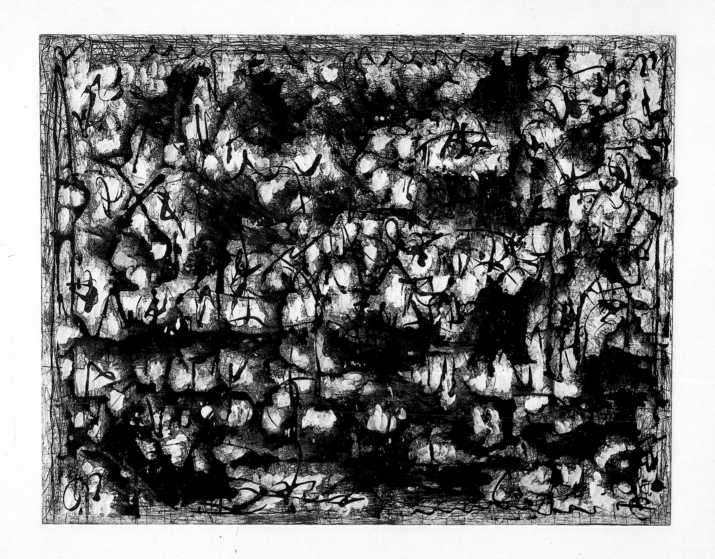

92 *Black and White Landscape,*
October 1979
Etching, third-state proof,
charbriquette and acrylic on
German etching paper,
18 x 23⅞ inches
Collection of the artist

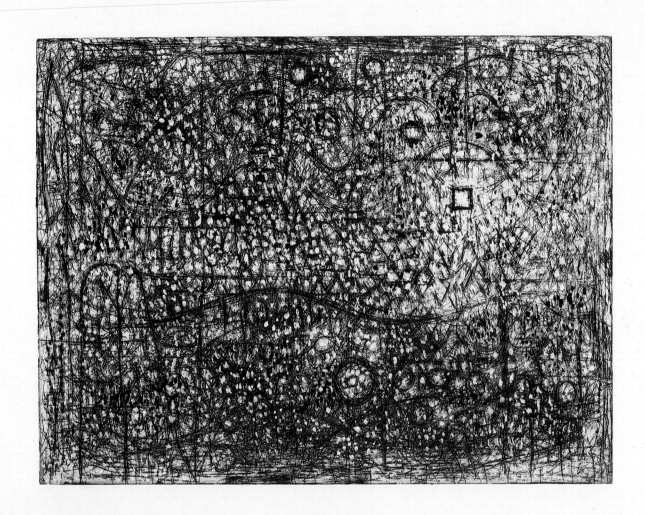

93 *Night Voyage*, July 1979
Etching, first-state proof, black
charcoal on German etching
paper, 17⅞ x 23½ inches
Collection of the artist

94 *Black Quartet*, August 1978
Acrylic on handmade paper,
30⅜ x 22¾ inches
Collection of the artist

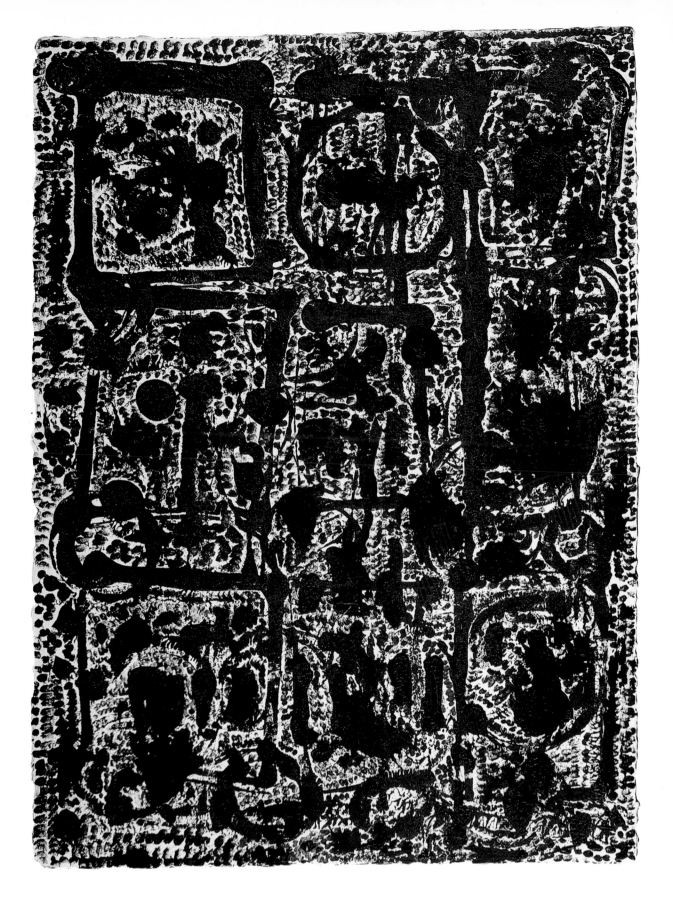

tion with religious symbols point to the fecundity of the unconscious, the modern font of wisdom and seat of the soul. But in *Illumination Cross* there is a greater reliance on abstraction, notable particularly in the cross, which serves as an emblem and also a means to organize the composition as a spiritually derived set of mullions.

Among the most complex of these recent works is the highly symbolic triptych *Time is the Mind of Space, Space is the Body of Time*, 1979–82 (95), which joins biomorphic shapes and astral forms to a boldly geometric diamond, circle, and triangle. This group is executed, as is *Illumination Cross*, in daubs of paint that resemble the small bits of colored stones making up Early Christian and Byzantine mosaics. In recent years Pousette-Dart has continued to investigate the aesthetic possibilities of this synthesis of more than fifty years of creativity in works that vary from *A Child's Room I*, 1986 (97), which contains plastic children's toys embedded in paint, to *Alizarin Time, River*, 1988 (98), a tonalist work incorporating a range of radiating symbols and images that go back to the 1940s.

This essay began with a comparison between the neoplatonic universals that are readily understood in Michelangelo's Adam and the more difficult veiled images of Pousette-Dart's work. If, on close inspection, Pousette-Dart's conflated images can be categorized as fecund signs of the unknown within, one might wonder if he is truly creating images of the void or simply approximating it. The answer of course is that he approximates the void in his art in order to make it intelligible to people. At some level art must always be an intelligible form of symbolic discourse, even if the discourse is raised from simple illusionism to a categorical confrontation with the unknown.

In recent years scientists and mathematicians have begun to reevaluate their attempts to find an underlying set of rules ordering the universe and to look at how the world defies simple categories and consistently verifiable laws. They have begun to accept the idea that chaos or unpredictable deviance is part of nature. While their ideas do not exactly dovetail with Pousette-Dart's understanding of the shadows troubling individuals undergoing emotional and intellectual growth, the two attitudes do serve to revise the once generally accepted notion of a simple, easily understood, and rational universe. Both the scientific and artistic attitudes toward unpredictable deviance are important theories that can help people accommodate themselves to a largely indeterminate world of accelerating change. Pousette-Dart's art serves the important function of abstracting disorder in terms of the metaphorical void within, giving it an aesthetic and provocative conformation, and providing a way for viewers to come to terms with segments of it. His art represents an effort to get back to basics, or as he has succinctly stated, it is an attempt to "express the spiritual nature of the universe."

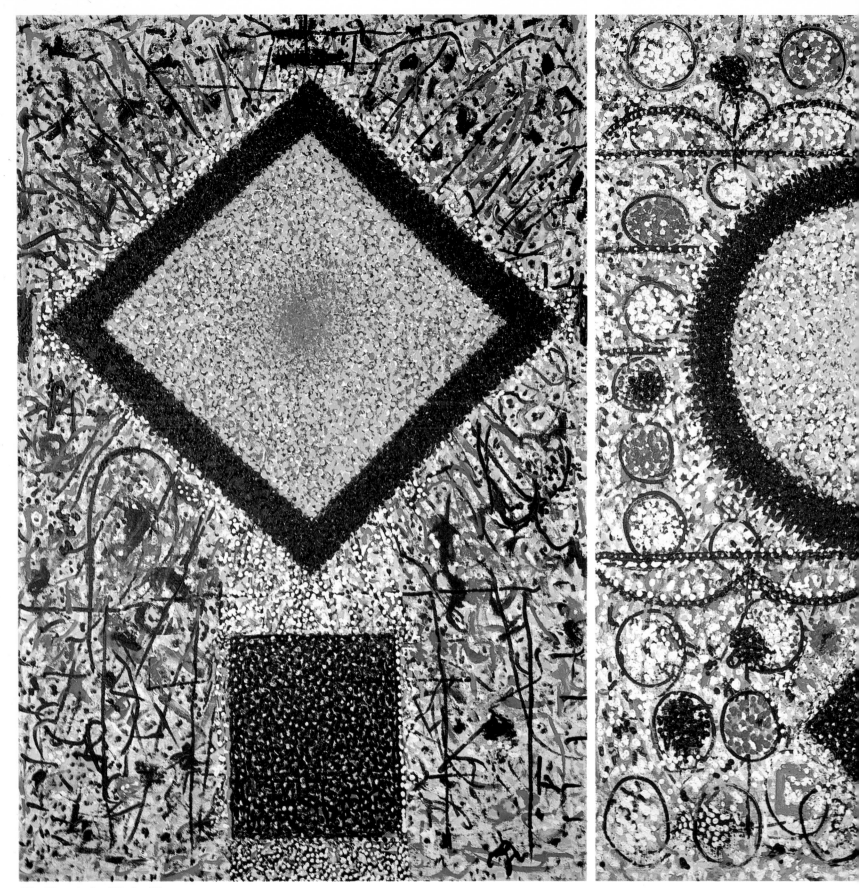

95 *Time is the Mind of Space,*
Space is the Body of Time,
1979–82
Acrylic on linen, 3 panels, each
89½ x 62½ inches
Collection of the artist

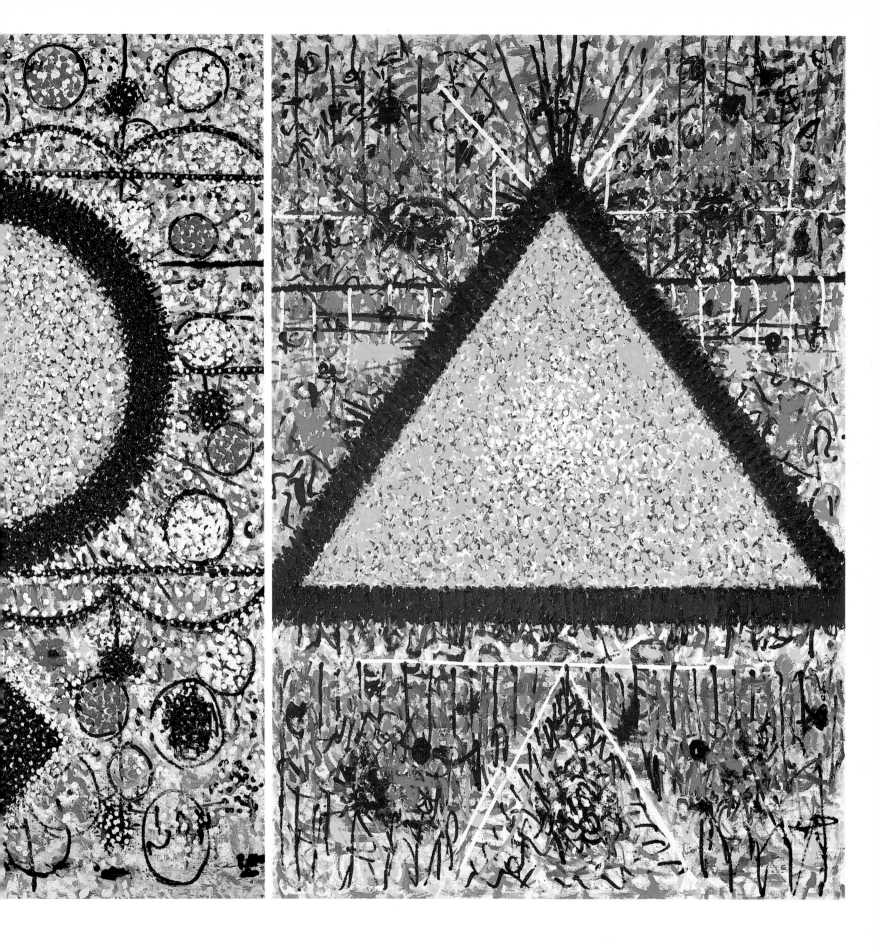

96 *Illumination Cross*, 1982–83
Acrylic on linen,
89½ x 62½ inches
Collection of the artist

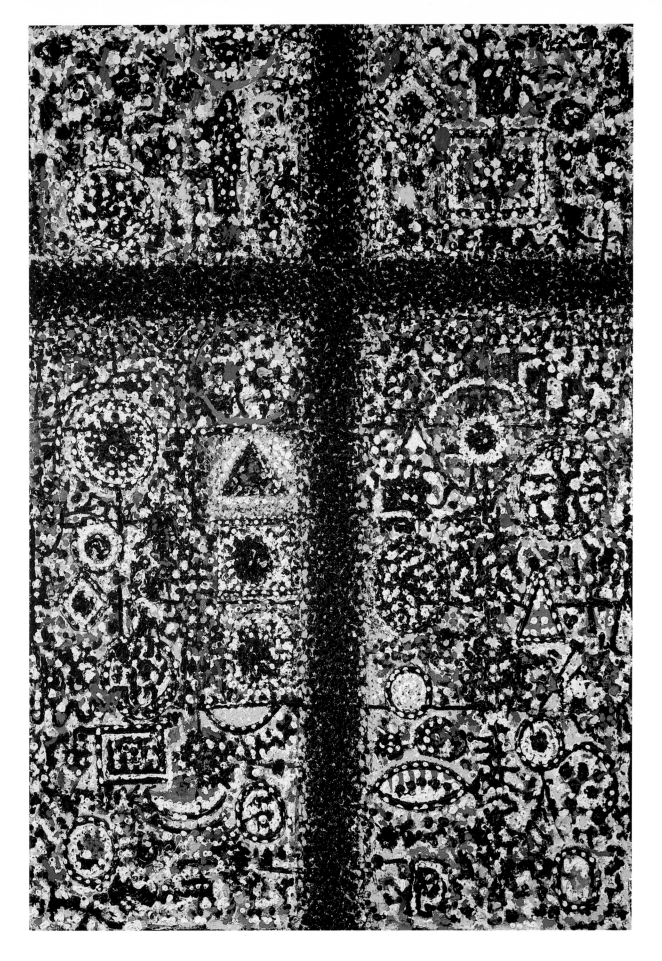

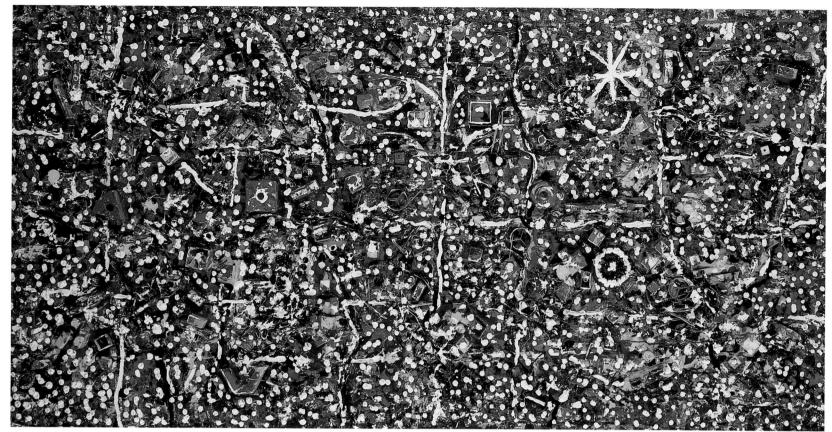

97 *A Child's Room I*, 1986
Acrylic and mixed media on
linen, 40 x 80 inches
Private Collection

98 *Alizarin Time, River*, 1988
Acrylic on canvas, 2 panels,
each 72 x 72 inches
Collection of the artist

Notes

1. Quoted in Judith Higgins, "Pousette-Dart's Windows into the Unknowing," *Art News* (January 1987), p. 112. This article is adapted from Higgins's essay "To the Point of Vision: Profile of Richard Pousette-Dart" in *Transcending Abstraction: Richard Pousette-Dart Paintings 1939–85* (Fort Lauderdale: Museum of Art, 1986).

2. Quoted in Martica Sawin, "Transcending Shape: Richard Pousette-Dart," *Arts Magazine* 49 (November 1974), p. 59. Sawin has written several important articles and reviews of Pousette-Dart's work. Her works are excellent sources of quotations by the artist, as is Gail Levin's essay "Pousette-Dart's Emergence as an Abstract Expressionist," *Arts Magazine* (March 1980), pp. 125–29, which succinctly summarizes a vast amount of information.

3. Notebook, 1988.

4. Notebook, 1937–38.

5. Notebook, ca. 1946–50.

6. Notebook LA-8, ca. 1940.

7. Notebook 19, ca. 1946–50.

8. Lecture given at the School of the Museum of Fine Arts, Boston, 1951, p. 2. The typescript of this talk is located in the artist's archives. A copy of the typescript is also on deposit in the library of The Museum of Modern Art, New York.

9. Quoted in Higgins, "Pousette-Dart's Windows," p. 115.

10. Mircea Eliade, *Symbolism, the Sacred, and the Arts*, ed. Diane Apostolos-Cappadona (New York: Crossroad, 1985), p. 6.

11. Ibid., p. 7.

12. Ibid., p. 8.

13. Ibid.

14. Notebook, ca. late 1930s–early 1940s.

15. Notebook, May 1940.

16. Notebook LA-10, 1940.

17. Lecture given at the School of the Museum of Fine Arts, Boston, p. 4.

18. Notebook, ca. late 1930s–early 1940s.

19. Notebook 11, ca. 1970s.

20. Harold Rosenberg, "The American Action Painters," *Art News* (December 1952), pp. 34–36, 55–56.

21. Notebook 18, ca. 1946–56. Many of the sections in this notebook reveal an interest in Walt Whitman's *Leaves of Grass*, such as the following:

> of myself I sing, yes, but not
> of myself myself
> of myself I sing what everywhere
> else I find
> of what in myself I find within
> every other one.

This connection with Whitman's poetry is only part of this artist's intense involvement with literary and artistic traditions, which are usually invoked and not directly cited in his writings or in his art.

22. Pousette-Dart's attitude toward creation has affinities with the philosophy of the American pragmatist John Dewey, whose well-known book *Art as Experience* emphasizes the type of knowledge to be gained from the process of making art. His ideas were important to many Abstract Expressionists, and they were significant as well for Richard's father, Nathaniel, an expert in many fields, including painting, advertising, and editing. Nathaniel refers to Dewey's ideas a number of times in his journal *Art and Artists of Today*, which was published from March 1937 to June–July 1938. In the February–March 1938 issue, in an essay entitled "The Editor Looks at Art and Artists" and under the subheading "Life as Experience," Nathaniel writes (p.3):

Our policy is based on John Dewey's philosophy—that art must spring from experience, that the artist must abstract the wisdom of the past and of the present and amalgamate them in the white heat of his individual creativeness. The subconscious is the fountain head from which inspiration wells up to create an art that is alive, rich and mysterious. The false mystery of the esoteric, with its only one-of-this-ness, is the sign of aesthetic snobbery.

While the father cannot speak for the son, Nathaniel's interest in Dewey and the subconscious appears to be more characteristic of Richard's art than his own. He may well have been influenced at this time by Richard's investigations, particularly since he was close to his son. It is worth noting also that the conjunction of process and the subconscious were important for Flora Pousette-Dart's poetry, even though she slowed the process to the point of patiently waiting for inspiration.

23. Richard Pousette-Dart's layering of images may have also had a source in the many versions of Picasso's *Guernica* (1937), which were documented in a series of photographs published in Christian Zervos's *Cahiers d'Art* (12:4–5, 1937), a publication read by many American artists. Studies for *Guernica* were also on view at the Valentine Gallery, New York, May 1939.

24. Notebook, ca. 1946.

25. Notebook, 1969.

26. Richard Pousette-Dart, letter to Flora Pousette-Dart regarding John Graham's *System and Dialectics of Art*, ca. late 1930s. Letter is in the artist's archives. Because Pousette-Dart declares his independence from Graham in this letter, it is worth citing in its entirety:

I admire Graham's book—but I am so aware of the destructive play of any dogmatism— yet perhaps one must be near that firm to approach a concrete achievement—

I do think there has been much done in art but am not sure there is as much yet to do

I think it must always be so

*I see Graham talks a good bit to justify his
own particular and personal circumstance in
life—I have done the same—always I have
been aware of this fact when doing it—I
have no wish for that kind of thing—I shall
truly strive for an impersonal truth—but how
we all are tempted to justify our easy desires
of one thing I am sure
there is no certainty—only a momentary
conviction and any too rational artistic
philosophy will breed
 no true art
the greatest creators will not be those to
understand
 most thoroughly their creations—
innovators and inventors are not of this true
 breath of creation
analysis has more to do with invention than
 with creation
there is no such thing in art!
a pure form—
and my philosophy of balance
between abstraction & nature
is superior to Graham's dogmatism
 & denunciation
my philosophy places the significance of
art according to its balance of nature and
abstraction & intensity
there by placing every work in a just position
while Graham denounced all but one faction*

27. Notebook, LA-12, Book of GOD, ca. 1940.

28. Flora Pousette-Dart, *I Saw Time Open* (New York: Island Press, 1947), p. 7.

29. Notebook 22, ca. late 1930s–early 1940s.

30. Notebook 21, ca. 1946–50.

31. Ibid. This quotation is a transposition of 1 Corinthians 13:12:
"For now we see as through thus a simply (or darkly) lit glass, but then face to face—I shall then know even as I am known."

32. Notebook LA-8, ca. 1940.

33. Quoted in Sawin, "Transcending Shape," p. 58.

34. Notebook 22, ca. late 1930s–early 1940s.

35. Notebook LA-8, ca. 1940.

36. Notebook, ca. 1937–38.

37. Lecture at the School of the Museum of Fine Arts, Boston, 1951, p. 4.

38. Notebook, ca. early 1940s.

39. Quoted in Martica Sawin, "Pousette-Dart's New Work in Black and White," *Arts Magazine* 56 (October 1981), p. 156.

40. The term "inscape," coined by the poet Gerald Manley Hopkins in his journals, was used by Roberto Matta Echaurren in the 1940s when he was living in New York. Robert Motherwell, conversation with the author, Greenwich, Connecticut, November 14, 1975.

41. Notebook, ca. 1954.

42. Statement in John I. H. Baur, *Nature in Abstraction: The Relation of Abstract Painting and Sculpture to Nature in Twentieth-Century American Art* (New York: The Macmillan Company, 1958), p. 79. This book was published in association with the Whitney Museum of American Art in conjunction with an exhibition.

43. For a fuller treatment of the role of peripheral vision in Abstract Expressionist painting, see Robert C. Hobbs, "Early Abstract Expressionism: A Concern with the Unknown Within," in Robert C. Hobbs and Gail Levin, *Abstract Expressionism: The Formative Years* (Ithaca: Cornell University Press, 1981). First published in 1978 in conjunction with a traveling exhibition organized by the Herbert F. Johnson Museum of Art, Cornell University, and the Whitney Museum of American Art, New York.

44. Quoted in Higgins, "Pousette-Dart's Windows," p. 114.

45. Lucy Lippard, "Richard Pousette-Dart: Toward an Invisible Center," *Artforum* (January 1975), p. 53.

46. Quoted in Sawin, "Pousette-Dart's New Work in Black and White," p. 154.

47. Notebook, ca. 1938–39.

Return to Aura: The Late Paintings

Donald Kuspit

Man is the only creature who can see his own death coming; and, when he does, it concentrates his mind wonderfully. He prepares for death by freeing himself from mundane goals and attachments, and turns instead to the cultivation of his own interior garden. . . . In old age, there is a tendency to turn from empathy toward abstraction; to be less involved in life's dramas, more concerned with life's patterns.
 Anthony Storr, Solitude

. . . aura, which is the reflection of the human substance objectified in art works. Today the sense of discomfort with aura is practically universal in modern art. This sensitivity is however blended with latent inhumanity, which is ready to break out again.
 T. W. Adorno, Aesthetic Theory

Richard Pousette-Dart has long eschewed formalist interpretations of his work, so I will not make one. As Paul Kruty writes, "the necessity to approach these paintings, whatever their final meaning, with more than the standard tools of aesthetics is very real."[1] James K. Monte has made perhaps the most thorough, elegant formalist interpretation; it does not begin to address the claims Pousette-Dart makes for his paintings.[2] It ignores, if not completely, the terms he uses to "explain" them. "Paintings," says Pousette-Dart, "are a presence, and they are best known by the spirit they leave with us after we have left them."[3] I will attempt to articulate the spirit of Pousette-Dart's "presences," as he called his paintings. I hope to articulate the presence within their presence, an inner presence which has been variously described—by Pousette-Dart himself and by others who have followed his lead, unquestioningly accepting his words—as religious, spiritual, and transcendental. Is this a legitimate self-interpretation? "The greater the art the more religious," states a poem written by Pousette-Dart, "bursting somehow through the particular to the universal."[4] I want to evaluate the weight of the religious and universal in Pousette-Dart's late paintings, where they seem most realized and which seem most transcendental.

Although I believe that Pousette-Dart is one of the major artist-exemplars of that religiosity without religion (formal doctrine) that permeates the best abstract painting and is the source of its presence—suggesting that it is the psychophysical secular space where sacred painting continues to exist, in an underground, post-iconographic way; that is, unattached to an imagery that can socially be identified as religious—such terms as "religious," "spiritual," and "transcendental" are descriptively and intellectually bankrupt today. They even seem expressively exhausted. However they can still be used in an evocative way, and thus are poetically useful, but what they imply must be freshly stated. Only then can they be legitimately applied to the abstract art that supposedly possesses the qualities they signify, if the claim that the art that has them is not to seem incredible and finally absurd. In other words, I will translate these sanctimonious terms—today as formalist as, and thus not much better than, those used by modernist criticism with its emphasis on "purity"—into a language that speaks more directly to Pousette-Dart's accomplishment and seems more intellectually responsible and sensitive to it.

Behind transcendence and spirituality—the gist of religiosity—stand solitude and aura. Pousette-Dart's late paintings exist under the signs of solitude and aura. One can be dialectically facile and say—correctly, I think—that his late paintings have an aura of solitude and articulate the solitude of aura. Certainly those qualities constitute the characteristic expressive aftereffect of perception of the late works. But they are emotional conclusions that do not begin to explain the ideational sources and material workings of his abstraction. Pousette-Dart's taste for solitude—both as a withdrawal from the world (necessary for creativity) and as an inherently "spiritual" state, desirable in itself—is well known.[5] But this personal factor is hardly transposed directly into or solely responsible for the effect of solitude in the late paintings, although it is no doubt true that in today's world only in solitude does it seem possible to recover one's sense of humanness. If solitude and aura are dialectically necessary to—subjective correlatives for—one another, then, to follow out Adorno's idea, the aura of solitude in Pousette-Dart's late paintings is a sign of their deep human substance.

Aura is Pousette-Dart's weapon against modernity. Aura is "proof" of the existence of the creative "source" essential for psychological survival in the inhuman modern world. Pousette-Dart's "source" is a combination of the *Quelle* of German romanticism and the dynamic unconscious of psychoanalysis, each a depth providing the energy necessary to rise above the painful world to the abstract sublime. John Graham, at one time an intellectual mentor to

the Abstract Expressionists, urged artists to "reestablish a lost contact with the unconscious . . . with the primordial."[6] The motivation for doing so was not entirely disinterested. That is, the primordial unconscious was not simply a revelation, through primitivistic "automatic *écriture*," as Graham called Surrealist automatism, of novel form, which could then be artistically—abstractly—encoded or reshaped. (Pousette-Dart has remarked that "nobody has defined so clearly the principles of dealing with pure form" as "the primitives," who "abstracted from their visual and life experience."[7] This has been an assumption since primitivist artifacts became a source of modern art in the early twentieth century. Presumably the primitives are closer to the unconscious—more psycho-primordial—than the self-styled civilizeds, and thus inherently more artistic.) Nor was the artistic return to the "unconscious"—a return inseparable from the "spiritual turn" (the lower, hidden unconscious fueling the higher, sublime spirit)—a matter of helping, as Adorno writes, to "raise into consciousness diffuse and forgotten experiences without 'rationalizing' them,"[8] of making the inarticulate and inchoate articulate and tangible. More urgently, dependence upon the primitive creative source within the psyche was a matter of life and death: a reaction to and repudiation of—the antidote for and irreconcilable antithesis to—the modern world, indeed, the only way of strengthening oneself against it. It was a strategy of psychological survival, signaling disgust with, alienation from, rejection of, and professed "spiritual" superiority to a disturbing, threatening, damaging, life-distorting modern society.

In a sense, the spiritual turn was a refusal to be tragic. Pousette-Dart once said that he believed in "the triumph of life"; the "tragic approach" occurred only when one had not found oneself, in a self-discovery through which one could "rise above tragedy."[9] However, the tragic continued to haunt Pousette-Dart's "transcendence." In my opinion, the dialectical relationship of the tragic and the transcendental is what gives Pousette-Dart's late paintings credibility and makes them truly religious, that is, eschatological. They encompass both the death-in-life or inner disintegration that is the modern lot—the "quiet desperation" Thoreau, one of Pousette-Dart's American transcendentalist heroes, spoke of—and the reintegration of self signaled by the ideas of salvation, immortality, transcendence. Dealing with these issues in terms of his own concern to sustain his creativity, Pousette-Dart says,

"The artist is a child who survives. Most children don't survive because they're cut off from the source."[10] According to Judith Higgins:

The sickness that Pousette-Dart observes in our society, the "stupendous technical developments that are threatening to destroy us," the specialization and "hyperdevelopment of aspects" [fragmentation], the concern with "power, profit, and greed," the many people who are "walking around like dead light bulbs," having never "found out how to illuminate within themselves"—all this, he believes, comes from being cut off from the creative source of life.[11]

Pousette-Dart is here rearticulating an argument, first made by such pioneering abstract artists as Kandinsky, Malevich, and Mondrian, that the spirituality of abstract art can counteract the materialism of society, which shows itself most forcefully in the reduction of human values, including the absolute value of creativity, to economic value. Through its pursuit of aura for its own sake—art has been connected to "cult value," sharply distinguished from "exhibition value," which is "closely bound up with, and dominated by, the process of economic exchange"[12] —abstract art in effect advocates creativity as an absolute, intangible value, and thus beyond reduction to material value. "Aura is an objective signification beyond all subjective intentions," but it has its subjective uses: the "transcendent tendency" or "distancing effect" inseparable from it is a necessary means of self-identification and self-creation, defending the self against society's reduction of it to a material instrument, exchangeable with and indistinguishable from any similar self.[13]

One of the things psychoanalysis has taught us is that, later in life, as one's own death comes into view, there is a need for self-reidentification—a new sense of integrity. There is a need to altogether distance oneself from social materialism. Inseparable from that pressing need is the desire for self-preservation, psycho-culturally articulated as the fantasy of immortality. Abstraction, which is a kind of codification of aura—which in general signals transcendent dignity, the taking of the self as a "cult object" or fetish, so to speak—has, throughout the history of art, been used to articulate this yearning for immortality. Geometrical abstraction in particular has been used to represent the immortal

100 *Meditation on the Drifting Stars*, 1962–63
Oil on linen, 95½ x 79 inches
Private Collection

—reintegrated, renewed—self, strong enough to meet and withstand death, that is, to face it without disintegrating. Death is the last and most serious, strenuous test of selfhood—its last chance to assert its strength and insist on its solidity in the face of a challenge, in fact, the greatest challenge. Death is triumphant over the body, but it need not be triumphant over the self—that is the message of abstraction, and of religious sensibility.

Wilhelm Worringer, in his famous book *Abstraction and Empathy*, spoke of the "repose" available in "the necessity and irrefragibility of geometric abstraction . . . It was seemingly purified of all dependence upon the things of the outer world, as well as from the contemplating subject itself. It was the only absolute form that could be conceived and attained by man." Commenting on this, the psychoanalyst Anthony Storr remarks that abstraction is thus "linked with detachment from the potentially dangerous object, with safety, and with a sense of personal integrity and power."[14] Solitude is its symbol: geometrical forms are solitary. The simpler they are, the more sublimely, transcendentally, solitary they seem. According to Storr, during the third, final period in life, there is a strong tendency toward "solitary meditation" on and identification with absolute patterns, which powerfully buttress the self. Such patterns, which geometrical forms exemplify, are experienced as hyperobjective; at the same time, they are internalized as the irreducible, indivisible core of the self. Pousette-Dart's late paintings are about such self-symbolizing—even more than that, self-reinstating, self-absolutizing—forms. Not that the tendency to geometrical- and self-absolutization—in the face of the flux that represents nature and that comes to represent the death we all owe to nature, as Freud said—did not exist before, but rather that it becomes an obsessive, all-consuming concern in the late paintings.

If one were to capsule Pousette-Dart's psycho-formal development, one could say that he moves from totemic to geometrical representation of self, from a primitive to an ultra-civilized sense of self. There is a "religious" aspect to both, but the religion becomes less private—less of a kind of mystery cult—and more public, without becoming a belief system specific to and dogmatically held by a particular society. In this Pousette-Dart's religiosity remains detached, transcendental. The source of aura changes from a subjective vision of nature to an objective vision of the trans-natural—the "eternal object," as the philosopher Alfred North Whitehead called geometrical form. Presence is less empathic

and more abstract in import. The self no longer identifies with bizarre natural mystery but with universal trans-natural clarity, which has its own kind of mysteriousness. Pousette-Dart's development can be described in another way: he moves beyond his own anxiety—the nervous fervor typical of his early, conventionally Abstract Expressionist totemic phase—toward a new psycho-visual health. The mythopoetic, archetypal trappings of the Abstract Expressionistic totemic figure is in my opinion an artistic/theoretical superimposition on, as well as elaboration of, a figure that would otherwise be blatantly anxious. It makes the agitation of the Abstract Expressionist figure intellectually decorative. The figure is seriously threatened by disintegration, and in fact seems already in process of disintegration—shaking itself to pieces. In general, Pousette-Dart moves from the self-fragmenting, quasi-vitalist figure to the seemingly self-formed "figure," which is the way geometrical form is psychodynamically experienced. But the late paintings are more than simplistically geometrical: they are not only about healthy, sublime geometrical reintegration transcending the dynamic fragments of a nature beside itself with inner vitality, but they show the process of change from tragic to triumphant sensibility. It is repeated again and again, as if Pousette-Dart were reassuring himself that it is in fact possible to make the change. However, his repetition compulsion also suggests that the change from an anxious empathic to a transcendent abstract mode is a Sisyphean enterprise, always in danger of relapse—a perpetual dialectical struggle.

Totemic Transcendental, 1982–83 (99), epitomizes the dialectical problematic of the late paintings. In a heavily painted—sensualized—field of small agitated forms, some creaturely, others, like the spiral whorl, representing an incomplete, biomorphosized (expressive) geometry—a giant totem/cross appears, easily read as a crucifixion, the fusion of figure and cross. This totemic cross is imbued with the agitated energy of the swampy field, but it holds its own, retains its stability and geomorphic form. The tension between field and figure is irreducible, as is the tension within the figure. There is a synthesis—interpenetration—of field and figure; at the same time, the figure maintains its integrity and separateness, and the field its violent energy.

In *White Circle, Time*, 1979–80 (42), the "figure" is more decisive—an explicit geometrical unity, in contrast to the totem/cross, which, going in all

101 *Sky Presence (Morning)*,
1962–63
Oil on canvas, 43 x 71 inches
Whitney Museum of American Art,
New York
Purchase, with Funds from the
Friends of the Whitney Museum
of American Art

directions at once, signals the coming apart of the self. In other words, the white circle represents integration, the totem/cross represents disintegration. Despite the dominance of the integrative—"positive," triumphant—presence, there is nonetheless a strong disintegrative—"negative," tragic—presence in *White Circle, Time*. The polarization of the emblematic blackness and whiteness constitutes the center of the picture along with the circular forms, with which the "expressionistic" polarization is simultaneous. Both the geometry and the polarization are axiomatic—conceptually fundamental apart from their empirical realization. At the same time, in the agitated field of "radiation" surrounding the center, black and white synthesize inseparably. An undifferentiated chaos of what might be called transcendental "vibrating sensations"—in contrast to the natural ones Cézanne said he was trying to realize when he used the phrase to describe his paintings and those of Impressionism in general—is articulated, as irreducible as the geometry and the polarization. The painting presents three incommensurates, fusing in an abstract image of what might be regarded as a black sun, with an overt white aura or halo, beyond which is an infinite undifferentiated space, as open as the circularity is closed, and combining the density of the central black and white.

These two works signal the alpha and omega of Pousette-Dart's ambition. They epitomize long-standing interests. The one is ambiguously empathic, the other is ambiguously transcendent. It is easy to read both in quasi-naturalistic terms. It is easy to see the one as tragic, and the other as a neo-romantic rendering of the abstract sublime, with its simulated cosmic space. It is easy to find profound "metaphysical" meaning in both works. But in a sense, all these would-be meanings are beside the subliminal religious point, which is tied to the emblematic character of the works—indeed, the emblematic vigor implicit in their rendering of aura. In the case of *Totemic Transcendental* aura is brooding, impacted, and potentially explosive; it exists in and through the agitation—the perpetual motion of the field, chaotic and unresolvable. In the case of *White Circle, Time* aura is dramatically overt—a form of heroic self-assertion. Circularity in and of itself conveys the absoluteness of this self-assertion and the integrity of the self. *White Circle, Time* is obviously ecstatic; I would describe the energy evident in *Totemic Transcendental* as ejaculative as well as anxious—the anxiety is in part about letting go, being spontaneous or uninhibited. The latter is a stage on the way to the former, which

crystallizes or systematizes its libidinous energy. The erotic implications of my terms are not merely metaphorical; part of the meaning of integrity is to integrate impulse, which produces a sense of ecstatic selfhood. Pousette-Dart's painting oscillates between the extremes of empathic release and geometrical control—the ebb and flow of the organic and the absoluteness of the eternal. In this contradiction is the tension between youth and old age, between a merger with nature and the sublime separateness of self, between the Dionysian and Apollonian. What makes Pousette-Dart's last paintings special is that they synthesize these opposites, which of all antitheses seem truly irreconcilable.

I am not entirely happy with Pousette-Dart's use of the terms "time" and "space" in the titles of many of his works. No doubt the simple geometrical forms he uses are timeless, and his intensification of them, by a variety of means, makes them a special kind of space—a space in which all dimensions fuse, and thus a peculiarly spaceless space. Similarly, the effect of time conveyed by the painterly flow or process of his works—even when that flow becomes granular—blurs all differentiations between the temporal dimensions of past, present, and future, suggesting an undifferentiated, atemporal immediacy or timeliness. (It is worth noting that, for all his repudiation of modernity for its detrimental psychosocial effect, Pousette-Dart is happy to use modern technology as a source for his abstract primitivism. "Through perceiving the enlarged granular structure of film, he came to realize that 'all form is made up of so many points of light' and that everything has a minuscule molecular structure."[15]) However, such titles—to pick one of the most noteworthy—as *Time is the Mind of Space, Space is the Body of Time*, 1979–82 (95), force the meaning of the work along a certain poetic path. The visual intensity of the work is compromised by the philosophical dimension accorded it by the titles. For all its limitations, Monte's formalist interpretation reasserts the balance, reminding us that what we go to a painter for is his reconstitution of visuality, his translation of the ordinarily seen into untranslatable, epiphanic visuality. Pousette-Dart's best works convey irreducible visual density, but their titles sometimes make us overlook this. One should not be too eager to read overt meaning into his last paintings—just as one should not read overt meaning into death. The meaning of both will emerge through experience of them, even though experience of death may never be able to be fully stated.

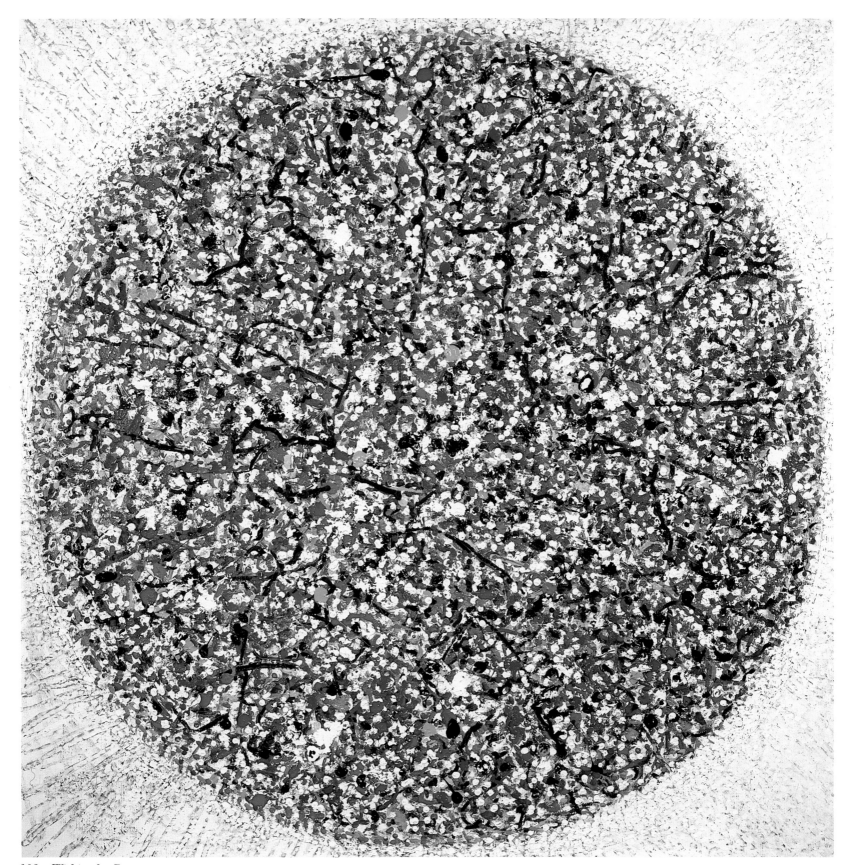

102 *Within the Presence,*
1982–83
Acrylic on linen, 80 x 80 inches
Collection of the artist

103 *Imploding Light*, 1967
Oil on canvas, 80 x 80 inches
Private Collection

104 *Imploding Light Number 2,*
1968–69
Acrylic on linen, 80 x 80 inches
Collection of the artist

105 *Hieroglyph Number 2,*
Black, 1973–74
Acrylic on canvas, 90 x 90 inches
Collection of the artist

106 *Presence, Ramapo Horizon*, 1975
Acrylic on canvas,
72 x 120 inches
The Metropolitan Museum of Art
George A. Hearn Fund, 1982

In fact, it is when he achieves the granular that his visuality is truly ineffable—no longer readable in terms of Worringer's distinction between empathy and abstraction. Thus, for me, his "purely" visual paintings—the works fraught with the deepest, most "inexplicable" psycho-spiritual import—range from *Meditation on the Drifting Stars*, 1962–63 (100), and *Sky Presence (Morning)*, 1962 (101), through *Within the Presence*, 1982–83 (102). The *Imploding Light* paintings of 1967–69 (103,104) and such works as *Radiance*, 1973–74 (89), *Hieroglyph Number 2, Black*, 1973–74 (105), and *Presence, Ramapo Horizon*, 1975 (106), belong to this type of work. These paintings truly have "presence," for in them visuality transcends both empathic process and abstract geometrical language. Visuality seems unconditioned by any precise, clear visual convention. It seems "beyond form," perhaps literally. Its holistic formlessness is Pousette-Dart's answer to that of Pollock, which seems more naturalistic in origin. In fact, Pousette-Dart seems closer to Tobey than Pollock (with whom he is usually compared) in his ultimate interests.

It is when Pousette-Dart moves beyond both the intimate and the distant—inner and outer landscape—that he seems truly spiritual. In fact, his work acquires a certain Oriental atmospheric look, which, deceptively, conveys a lack of concentration and focus, when it is in fact a prelude to the utmost concentration. Atmosphere, as Adorno suggested, is the work of art totalized as aura. Psychodynamically, it is the solitude—absence—of death made into pure visual stuff. It is the spirituality that exists beyond the dialectic of disintegration and integration—beyond the cycles of inner life. It is thus the purest, most unconditional spirituality. The granular atmosphere is the truly gnostic aspect of Pousette-Dart's painting. (The black and white polarization can also be read gnostically, as an articulation of its Manicheanism.) Pousette-Dart's most interesting paintings may be about dissolving the limited self in the oceanic experience in which there is no sense of limit. He may not want to reintegrate the self—secure its boundaries in the face of death—but welcome death as a "solution" to the problem of selfhood. He may want to lose himself in death—turn it into an oceanic experience—for it may be the final transcendence.

Notes

1. Paul Kruty, "Richard Pousette-Dart, Paintings 1939–1985," *Transcending Abstraction: Richard Pousette-Dart, Paintings 1939–1985* (Fort Lauderdale: Museum of Art, 1986), p. 31.

2. James K. Monte, *Richard Pousette-Dart* (New York: Whitney Museum of American Art, 1974).

3. Quoted in Kruty, "Richard Pousette-Dart," p. 31.

4. Quoted in Judith Higgins, "To The Point of Vision: A Profile of Richard Pousette-Dart," in *Transcending Abstraction*, p. 14.

5. Both Dore Ashton and Sam Hunter have remarked on the importance of Pousette-Dart's personal solitariness to his art.

6. John Graham, *System and Dialectics of Art* (New York: Delphic Studios, 1937), p. 33; also quoted in Higgins, "To the Point of Vision," p. 10.

7. Quoted in Higgins, ibid., pp. 16–17.

8. T. W. Adorno, *Aesthetic Theory* (London: Kegan & Routledge Paul, 1984), p. 82.

9. Quoted in Higgins, "To the Point of Vision," p. 16.

10. Ibid., p. 14.

11. Ibid., pp. 14–15.

12. Adorno, *Aesthetic Theory*, p. 67.

13. Ibid., p. 386.

14. Anthony Storr, *Solitude: A Return to the Self* (New York: Free Press, 1988), p. 89.

15. Quoted in Higgins, "To the Point of Vision," p. 20.

Genesis and Metamorphosis: Materials and Techniques

David A. Miller

Pousette-Dart's paintings are distinctly individual; however, there are material and technical consistencies that allow us to group the works by decade. Many works from each decade were examined at the artist's studio, and detailed reports were obtained from institutional and private conservators who have had works by the artist in their care. It must be emphasized that Pousette-Dart has always been and continues to be a highly experimental artist and that the general trends discussed here are not intended to be indicative of all the artist's works of any particular period.

Regardless of decade or medium, Pousette-Dart's approach to painting has always been the same. As he asserts, "I have my own technique, method, and process. I love to paint and every painting is a new experience and departure into the unknown."[1]

Paintings from the 1930s exhibit a notably sophisticated understanding of materials and techniques, although the artist did not have formal training. The rigid strainer frames on which he stretched his early canvases are either simple wood slats from a lumberyard, which Pousette-Dart nailed and glued together, or inexpensive Phleger-type commercial stretcher strips. Rabbit skin glue was used to size the best linen canvas he could obtain. Except for a short period in the 1950s, he always used fine quality linen, as he correctly perceived that the fabric is a crucial element in a painting's structure. In preparation for painting, he freely applied white lead oil grounds to a sized, stretched canvas. Permalba (F. Weber Co.) was the preferred white, both for the ground and paint color. He used Rembrandt, Blockx, and Winsor & Newton tube oil paints, usually unthinned, directly from the tube. He did not add other types of oils, waxes, bulking agents, foodstuffs, or other materials to his paints, as had other artists of his generation. Some of the very small paintings on masonite of the 1930s are heavily coated with Dammar varnish (most likely Grumbacher), while on only a couple of pictures a thin selective retouch varnish was sparingly used "to bring elements together." These early experiments with coating his pictures were almost completely discontinued by the late 1930s to "avoid a mechanical look and to allow the paintings to breathe"; he continues to object to varnishing of his paintings.

Paintings of the 1930s are somewhat traditional in their use of broad, moderately thick passages of color. The build-up of paint is fairly smooth, with low impasto and brushmarking. Pentimenti of prior compositional attempts are often visible in the paintings of this time as a result of much deliberate layering of paint. The construction and appearance of *Head*, 1938–39 (50), are typical of the earliest works. *Primordial Moment*, 1939 (56), is characterized by the use of much thicker, impasted paint. A few of his works from this period have very matte, chalky blacks. Considering the years of storage in the artist's unairconditioned studios or barns, the paintings, with a few exceptions, tend to be in a good state of preservation.

Although Pousette-Dart's general approach to painting remained the same, works of the 1940s exhibit great experimentation with scale, paint layering, and the introduction of mixed media into the structures. In addition, he used materials such as parchment and stone as supports.

The artist's landmark painting, *Symphony Number 1, The Transcendental* (17), was worked on over a period of two years, ca. 1941–42. At 90 by 120 inches, it is one of the first of the "big" New York School paintings, and it elicited many different responses. According to the artist, contemporaries such as Mark Rothko were puzzled as to why Pousette-Dart would want to paint such a large canvas (at that time Rothko was painting small-scale works) and were quite curious as to how Pousette-Dart intended to display and sell such a work. In fact, Marian Willard, Pousette-Dart's dealer, was not able to show this immense work in her gallery. Frustrations of this type led the artist to leave the Willard Gallery, and this painting and several others of this scale were displayed at Peggy Guggenheim's Art of This Century in 1947. According to Pousette-Dart, there were always problems in maneuvering this huge painting, and it had to be removed from its stretcher, rolled, unrolled, and restretched several times, until finally the stretcher was cut and folded to permit transport.

Pousette-Dart dislikes rolling his pictures or having folding stretchers. Only a few large acrylic paintings from the 1970s remain on folding stretchers, currently folded for storage. In 1951, when he moved from Manhattan to Sloatsburg, New York, Pousette-Dart was forced to cut some oversized paintings into smaller sections, rather than folding them, in order to get them through the door. The cuts were made through the centers of vertical stretcher members, allowing the pictures to remain

River Metamorphosis, 1938–39. Oil on linen, 36 x 45 inches. Collection of the artist. Signs of deterioration due to dessication; before treatment, raking light.

Illumination Gothic, 1958. Oil on linen, 72 x 53½ inches. Collection of the artist. Tearing and sagging caused by the weight of the paint; raking light.

on the stretcher frames. The cut edges were glued and nailed through the front of the picture to the stretcher and then reworked with oils and pencil to produce independent images.

The layering that characterizes works of the 1940s has been described by Judith Higgins:

The pigment in some of his works of the late 30s was laid on in thin, flat strokes; but since the early 40s Pousette-Dart's usual practice has been to layer, many times. "Layering," he comments, "is an analogy to life itself." He began Symphony Number 1, The Transcendental *by covering the bare surface with an initial layer of lines, forms, and colors. Over this, as was his practice in works of the 40s (and in some later ones as well), he structured a Cubist scaffolding and then painted over it with as many as 40 layers, building a palimpsest of forms.*[2]

Except in a few cases of relatively thinly painted works, such as *The Edge*, 1943 (62), the paint surfaces of the 1940s become tapestries of endlessly layered brush strokes. Forms, which never quite have a hard edge, emerge and dissolve, providing a myriad of crevices, peaks, and valleys of color and texture. According to one writer, "Pousette-Dart's usage of thick impasto has caused many to link him with Action painting. His direct experience with the materials and lack of preparatory sketches may point towards this, yet, he is not an Action painter in the strictest sense . . . his technique is long, laborious, and calculated."[3]

Conscious of the limitations of the materials, Pousette-Dart experimented with coating the white lead ground with nonabsorbent isolation layers, to "avoid having the pigments look dry." Although several pictures exhibit some traction cracquelure typical of improper use of "lean over fat" colors, most of the paintings are relatively sound because the artist left sensible drying time between the countless layers of paint. Several paintings of this period exhibit tearing of the top tacking edge and sagging, as some canvases are unable to support the sheer volume of paint. In addition, some expandable stretchers are not substantial enough to maintain the proper tension and plane for these elaborately encrusted surfaces.

Besides varying the thickness of the paint surfaces or leaving areas of bare ground color exposed as a design element, as in *Composition Number 1*, 1943 (46), or *Portrait of Pegeen*, 1943 (61), Pousette-Dart began incorporating new elements into his works.

Sand is used selectively, not as a bulking or textural agent, but to mute the tonality of a surface, as in *Fugue Number 2*, 1943 (70), and *Fugue Number 4*, 1947 (1). Pure collage is explored, as in *Untitled (Ricardo)*, 1946–48 (71). It is not surprising to occasionally find "foreign" objects or materials embedded in the thick paint as a deliberate compositional and textural element, such as a shirt button partially covered by paint in the center of *River Metamorphosis*, 1938–39 (52).

Pousette-Dart experimented with watercolors as well. Of particular interest is a group of pictures done with watercolor and pen and ink on gesso boards. Works such as *Prisms*, 1945–46 (107), and *Golden Eye*, 1945–46 (13), exhibit layering similar to Pousette-Dart's approach with oils. However, the layering of many thin, transparent veils of watercolor pigments, illuminated by light reflected from the smooth white gesso grounds, gives these pictures the appearance of stained glass. On some of these works the artist scraped down high points of pigment with a single-edged razor blade to produce a smooth surface. This "abraded" appearance is a deliberate effect. A few of these works were coated after completion with a waxy substance, "perhaps a floor wax."

Pousette-Dart's use of a razor blade to smooth out surfaces was not restricted to watercolors. Scrapers, sandpaper, and palette knives have all been employed to abrade or otherwise alter the surface texture of paintings to help bring the textural, coloristic, and compositional elements into a special visual resonance. "Tuning" is the term that Pousette-Dart uses when talking about how his works reach completion. The critic Martica Sawin refers to "tuning" as "the process used to make all parts of the canvas vibrate in harmony." She adds, "It is a matter of adding more and more touches of color [or removing touches of color] until the painting reaches the right pitch and of keeping them distributed in such a way that no portion has greater intensity than any other and that no dissonance jars the union of color vibration."[4] To Pousette-Dart, "work is a living laboratory of creative activity where my paintings go on and on." He would relish the opportunity to continue "tuning" *all* of his paintings—including pictures now in private or public hands, for "like the orthodox Abstract Expressionists, he never considers his paintings finished. . . . Each painting

goes through many stages, altering its form perhaps a dozen or so times before it approaches that serenity and balance that constitute Pousette-Dart's accomplishment."[5]

A series of color Polaroid photographs taken by the artist documents his working method and the "unpredictability of the growth and transformation of the process." The evolution of *Cathedral*, 1978–80 (108), is typical of work of all decades and media. What is not evident, except upon viewing the completed painting, are the final adjustments to the surface, achieved by sanding down peaks of impasto and dulling down other areas of high paint gloss to keep the elements in a perfect balance. The series of twenty-five Polaroids, entitled "Process," spans a period from June 14 to July 28, 1978; the short working period between phases was made possible by Pousette-Dart's use of acrylics rather than oils for this picture. Done in oil with the same procedures and with appropriate drying time between layers, a canvas of this size (90 by 90 inches) could have taken over a year to execute.

In the 1940s Pousette-Dart used the best materials he could obtain. But for a short period in the 1950s the artist had very little income, and to keep working he was forced to use less expensive materials. Instead of the finest heavy linen canvas, Pousette-Dart used thin, open-weave cotton canvas as painting supports for a few works. This fabric was often tacked and/or glued directly to the face of the simplest possible strainer. The exposed faces of the inexpensive strainers were painted white to also serve as a frame, and sometimes an extra strip molding, also painted white, was added. Although this method of mounting was used primarily because it was easy and inexpensive, Pousette-Dart likes the way it looks and insists that the edges be maintained as they are and not be bent over for tacking if they are ever restored.

As paint was too expensive in those lean times, Pousette-Dart began to explore the use of graphite pencil and titanium white for his images. Works would sometimes receive touches of pigment or a turpentine wash to impart a veil of color. In a few paintings he worked with "a paint brush in one hand and a pencil in the other." These complex, multilayered works fulfill Pousette-Dart's intention to "bring infinite significance to very base materials." The use of common materials had great appeal to an artist who feels he works on "a screen of the spirit." Besides canvas, he used this approach on paper and on plywood, as in *Descending Bird*, 1950–51 (20).

In the early 1950s Pousette-Dart used Magna Colors as well as Magna Medium and Varnish, which were among the first commercially available acrylic resin paints. A review of an exhibition of Pousette-Dart's paintings at the Betty Parsons Gallery in 1958 singles out a picture done with Magna. In *Under the Sea*, "the encrusted and scumbled surfaces give way to a glossy enamel finish."[6] Pousette-Dart does not recall how many pictures were executed with Magna or where they might be. The use of Magna Colors is most likely not indicated on the backs of the pictures. *Path of the Hero* (The Metropolitan Museum of Art), dated 1950 and described as one of his first acrylic paintings, appears to have been executed with Magna Colors. Other innovative experiments with alternate paint media included the thick application of automotive lacquers intended for use on truck bodies in *The Window*, 1952, and the use of marine enamels on other unidentified pictures.

When Pousette-Dart used rich color, especially in the late 1950s, he handled it in a manner very different from that of preceding decades. Pictures such as *Illumination Gothic*, 1958 (82), and *Blood Wedding*, 1958 (84), illustrate the thick impasted application of a cadmium red pigment. The oil paint is laid on even more thickly in these pictures than in the works of the mid- to late 1940s, and the artist emphasizes color more than the linear, totemic forms of earlier works. In describing *Blood Wedding*, critic John Gordon says, "Its rich tapestry-like surface is rent by a vertical band of violent red. Pigment is brushed or troweled on, or squeezed onto the canvas directly from the tube."[7] This focus on pure color and modes of paint application presages the work of the 1960s.

In *Blue Presence Number 1*, 1960, a new technique gains prominence in Pousette-Dart's work: "the point, color in its smallest bit—makes its appearance."[8] Pousette-Dart attributes "working from the point" to his years of developing photographs, where he could see the grains of silver coalescing into an image or, conversely, being broken down, and says "the point is my way to light and is related to the molecular structure of all form."

Throughout the decade the density of paint application increases as more and more points of pure or mixed color are used in the compositions. Pousette-Dart never used a palette, but preferred to apply paint directly from the tube, squeezed or brushed

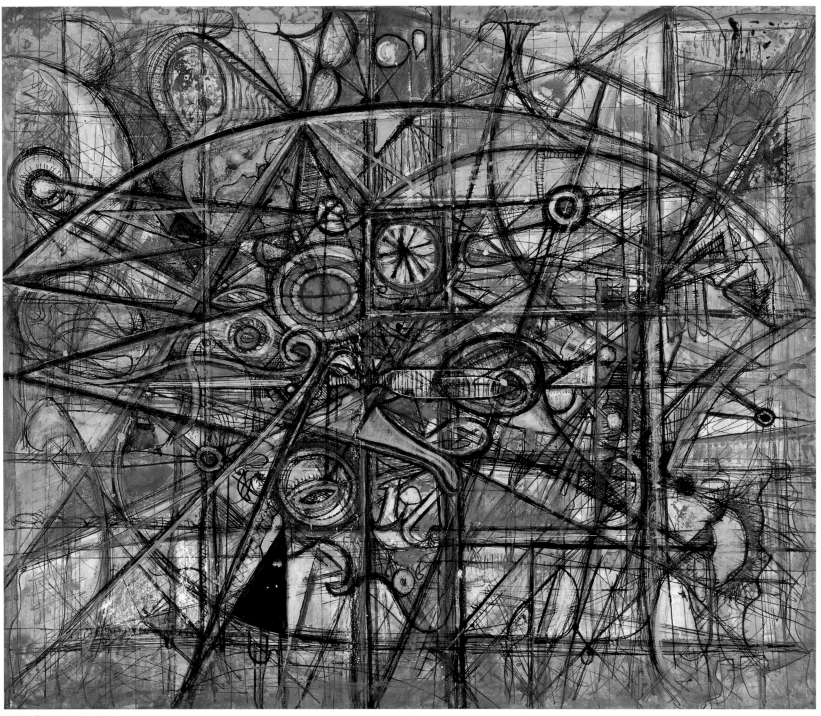

107 *Prisms*, 1945–46
Watercolor and ink on gesso
board, 20 x 24 inches
Collection of the artist

"Process," a series of Polaroid photographs of *Cathedral* taken by Pousette-Dart during the evolution of the painting. These photographs illustrate the transformation of the design as well as how Pousette-Dart changed the orientation of the painting as he worked.

1 June 14

2 June 14

3 June 14

4 June 14

5 June 14

6 June 17

7 June 20

8 June 25

9 June 26

10 June 29

11 July 2

12 July 3

13 July 4

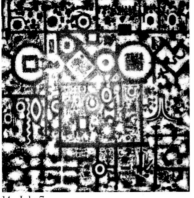

14 July 7

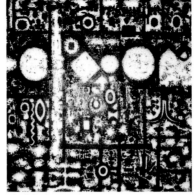

15 July 8

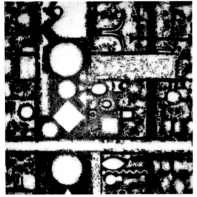

16 July 9

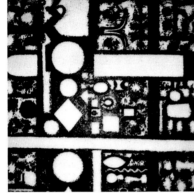

17 July 10

18 July 10

19 July 13

20 July 16

21 July 18

22 July 19

23 July 24

24 July 25

25 July 28

on to the canvas, or mixed in pet food tins, cans, or sea shells. A review from 1951 aptly sums up Pousette-Dart's timeless technique: "A typical picture shows a field of gems built to ponderous thickness by every means of application except water pistol."[9]

Another change in technique occurred in the mid- to late 1960s, when the artist began to use acrylic emulsion paints. Water-based acrylics gave him not only brighter colors, but also the ability to make rapid changes and "tune" his paintings more quickly than with oils. The lighter weight of the colors and their quick drying enabled Pousette-Dart to apply even thicker, more elaborate impastoes than was possible with oils. The acrylics' flexibility, toughness, and durability led him to work in ways he had not fully pursued in the past, including the building up of surfaces to a bas-relief level. Whether initially tacked to a wall or laid flat on the floor, the painting would always be stretched tight on a stretcher or strainer for final "tuning" and display.

In extremely rare cases Pousette-Dart used unprimed linen, but for the vast majority of paintings from the 1960s to the present he primed the canvases with a mixture of half acrylic gesso and half acrylic emulsion medium to produce a white, nonabsorbent ground.

During the transition from oils to acrylics, he also returned at times to the use of commercially preprimed canvas, as he had occasionally in the 1950s. Pousette-Dart also began to have stretchers built and canvases stretched on them, ready for painting. Lou Sgroi sometimes performed this task, delivering stretched canvases to Pousette-Dart's studio for the artist to prime. In the later 1960s Sgroi applied the initial ground layers himself according to the artist's instructions.

Around 1968 Pousette-Dart began to abandon frames in favor of painted, taped, or unfinished sides. He had addressed the confining quality of frames earlier in his career. Both *Primordial Moment*, 1939 (56), and *Abstract Eye*, 1941–43 (64), have painted frames created by extending the composition onto the thin wood strip frames. This was not a common solution, however, and most of his paintings up to 1968 are framed with narrow wood strips, either unfinished wood, gold-faced, or wood simply painted black (except for the paintings of the 1950s, as mentioned). Pousette-Dart never really cared about framing beyond its importance as protection for paintings with fragile surfaces. When

the edges of the canvases are painted or taped, the colors are almost always based on the predominant tonality of the picture. Occasionally Pousette-Dart has gone back and painted the edges of pictures that had been completed years earlier, and sometimes he used acrylic paints for the sides of oil paintings.

Pousette-Dart continued the exploration of acrylic paints and their properties in the 1970s and 1980s. Laura Westby took over building the stretchers as well as stretching and priming the canvases in the 1970s. She also constructed a "revolving" easel so that he could work on a painting from many angles. While continuing to work in various sizes and occasionally in oils, the artist explored a "modular" format. He preferred 90 by 90 inch canvases in the late 1970s, but is currently using six-foot square canvases, though size and format change continually.

Pousette-Dart experimented with many different types of acrylics, including Aqua-Tec (Bocour), Liquitex, Golden, and many others. When using oils, he preferred Grumbacher, Rowney, Winsor & Newton, and Permanent Pigments. He now uses mostly Utrecht New Temp Acrylics, New Temp Standard Gesso, and Pearl Paint Acrylex Acrylic Polymer medium. The polymer medium figures prominently in his work, not only as an additive to the gesso ground, but also as an all-purpose adhesive for collage elements and as a selective frothy "glaze" that intentionally clouds the under- lying tones via air bubbles trapped in the film. Works such as *A Child's Room I*, 1986 (97), onto which Pousette-Dart affixed assorted wooden and vinyl toys picked up from the floors of his grand- children's rooms, are remarkable for the volume of paint, found objects, and collage elements, all well adhered with polymer medium. Gesso also tends to be used as an all-purpose material, either as a ground, surface color, or adhesive.

Pousette-Dart has created surfaces of lush coloration and texture which might cause great dilemmas for the conservators charged with preserving these works, who must balance the need for cleaning to reveal the painting's true coloration with the inher- ent dangers of the process. Pousette-Dart believes that "restorers tend to overclean all paintings and that cleaning makes the white too white—it gets the tonality out of balance." The artist's reworking of some of his paintings over the years could make

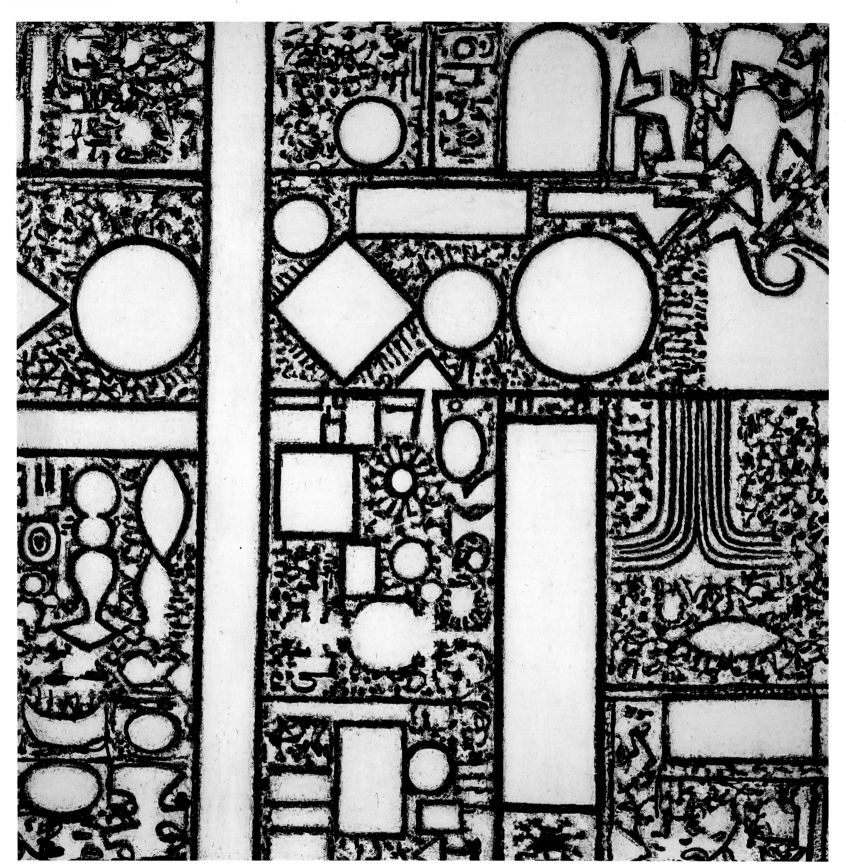

108 *Cathedral*, 1978–80
Acrylic on linen, 90 x 90 inches
Collection of the artist

interpretation of the multilayered structures problematic. Therefore if a painting must be cleaned, it is important to Pousette-Dart that he be consulted, as he maintains that restoration is a cooperative venture.

Paintings are never signed or dated on the front, and Pousette-Dart would prefer not to sign them at all, believing that "art is anonymous" and that "a painting is a signature of itself." But he has signed and dated works, on the back of the canvas (see reverse of *Metamorphosis*). Occasionally the signature and/or date appear more than once. The stretchers may also be signed and dated and/or inscribed with the painting's title, and in many cases inscriptions or indications of "top" have been added.

Proper lighting is extremely important for the perception of Pousette-Dart's works. The colors, patterns, and textures shift dramatically as the color temperature and intensity of a light source change. Overlighting can wash out the subtle color harmonies, and flat lighting fails to reveal the extremely tactile qualities of the intricate impastoes. Low levels of illumination are particularly effective at bringing out the variations in tonality and shimmering effect of Pousette-Dart's (as well as other Abstract Expressionists') paintings. This finding was expertly investigated by Robert Hobbs in the exhibition catalogue *Abstract Expressionism: The Formative Years*; Hobbs also quoted Theodoros Stamos's recollection that he and artists such as

Mark Rothko, Barnett Newman, and Ad Reinhardt insisted on dim lighting at the Betty Parsons Gallery.[10] Pousette-Dart states that "the lights need to be varied for each work." He has never enjoyed installing his own exhibitions and has preferred to leave that responsibility to gallery owners or museum staff, to friends such as Barnett Newman, who "did it for Betty Parsons and was good at it," or to his wife Evelyn.

This study of Richard Pousette-Dart's materials and techniques is far from complete, since it only addresses a limited number of works from the artist's prodigious oeuvre. There are no signs that the artist's creative output or his desire to explore new avenues are beginning to diminish, and many new works are now in progress. His countless existing works in different media—brass carvings, photography, sculpture, three-dimensional paintings, and works on paper, to name a few—cannot be fully documented within the scope of this essay.

When contemplating the sublime, deeply spiritual works of Pousette-Dart's oeuvre, I am reminded of the artist's philosophy toward his life's work: "time has a way of making things more beautiful, although it may eventually erase them." With proper care and responsible custodians, the first half of Pousette-Dart's declaration will certainly be true, and the second half need never come to pass.

Notes

1. All comments by the artist were made to the author in visits to the artist's studio between May 3 and July 25, 1989, or in telephone interviews August 10–14, 1989, and March 1–2, 1990, unless otherwise noted.
2. Judith Higgins, "Pousette-Dart's Windows into the Unknowing," *Art News* (January 1987), p. 112.
3. Rosemary Cohane, "Richard Pousette-Dart: Artistic Sources of an Abstract Expressionist Style." M.A. Thesis (unpublished), Tufts University, May 1982, p. 7.
4. Martica Sawin, "Transcending Shape: Richard Pousette-Dart," *Arts Magazine* (November 1974), pp. 58–59.
5. John Perrault, "Yankee Vedanta," *Art News* (November 1967), p. 55.

6. M. S. [Martica Sawin], "In the Galleries (Parsons)," *Arts* 36 (April 1958), p. 58.
7. John Gordon, *Richard Pousette-Dart* (New York: Whitney Museum of American Art, 1963), p. 13.
8. Ibid., p. 113.
9. Manny Farber, *The Nation* 173 (October 13, 1951), pp. 313–14.
10. Robert Carleton Hobbs and Gail Levin, *Abstract Expressionism: The Formative Years* (Ithaca: Cornell University Press, 1978), pp. 19, 26 n. 28.

I wish to thank Richard and Evelyn Pousette-Dart for their assistance and patience during the many intrusions on their privacy required by this catalogue and exhibition. Thanks are also due to Leonard Bocour for sharing his recollections on the early use of Magna Colors and acrylic paints in general, and to the following museum and private conservators for examining paintings by Pousette-Dart in their care and providing important data: Suzanne Penn and Marigene Butler, Philadelphia Museum of Art; Kenneth Bé and Bruce Miller, Cleveland Museum of Art; James Coddington and Antoinette King, The Museum of Modern Art; Kenneth Moser, The Brooklyn Museum; Gillian McMillan, Guggenheim Museum; Sara Breitberg-Semel and Doron J. Lurie, The Tel Aviv Museum of Art; Joseph Fronek, Los Angeles County Museum of Art; Lucy Belloli and Charlotte Hale, The Metropolitan Museum of Art; Leni Potoff, Leni Potoff, Inc.; and Rustin Levenson and Harriet Irgang, New York Conservation Associates, Ltd. DM

Actual size details illustrating some of
Pousette-Dart's diverse painting techniques.
Fugue Number 4, 1947 (1)
Presence, Genesis, 1975 (86)
Venice, Nightspace, 1981–82 (40)
White Garden, Sky, 1951 (19)

177

Chronology

Harriet G. Warkel

1916
Richard Warren Pousette-Dart is born on June 8 in Saint Paul, Minnesota, to Nathaniel Pousette (1886–1965), a painter and writer, and Flora Louise Dart (1887–1969), a poet. He has two sisters, one older, Louise, and one younger, Helen. His paternal grandfather, Algot E. Pousette, was a French Huguenot artist and silversmith who emigrated to Minnesota.

1918
Pousette-Dart family moves to Valhalla, New York. Father Nathaniel exhibits his paintings and watercolors in New York City and joins an advertising agency.

1922–23
Nathaniel Pousette-Dart edits books on Childe Hassam, Robert Henri, Winslow Homer, John Singer Sargent, Abbott H. Thayer, and J. A. M. Whistler for the *Distinguished American Artists* series.

1924
Encouraged by his father, Richard begins painting at the age of eight. By the age of ten his pencil sketches show his serious interest in art.

1931
Nathaniel Pousette-Dart publishes a monograph on the American printmaker Ernest Haskell.

1935
Graduates from Scarborough School, Scarborough-on-Hudson, New York. For his senior class magazine, *The Beechwood Tree*, he writes an essay entitled "I Have Been Called a Dreamer," which underscores his early commitment to pacifism.

1936
Enrolls in Bard College, Annandale-on-Hudson, New York, which he leaves before the end of the academic year to paint and sculpt on his own.

Flora Louise Pousette-Dart publishes *Poems*.

1936–37
Creates small brass sculptures between two and five inches in height which employ biomorphic and geometric forms that recur in his paintings.

1937
Becomes an assistant to the sculptor Paul Manship and moves to Manhattan. He spends his days working and his nights painting, sculpting, and drawing.

1938
Works full time as a secretary and bookkeeper in Lynn Morgan's photographic studio and paints at night.

Two marriages during this period end in annulment.

1939
Leaves his job in the photographer's studio to paint full time.

1941
First one-man exhibition at Artists' Gallery, New York, October–November. The Artists' Gallery was a nonprofit gallery that gave artists space without charge plus the income from the sale of their works. The sponsors of this gallery included Clive Bell, Josef Hoffmann, Fiske Kimball, Frank Jewett Mather, Jr., Walter Pach, Meyer Shapiro, and James Johnson Sweeney.

1942
Completes *Symphony Number 1, The Transcendental*, one of the first large canvases of Abstract Expressionism.

1943
Has one-man show *Forms in Brass* at the Willard Gallery in October. Marian Willard showed Paul Klee, Lyonel Feininger, Alexander Calder, and David Smith, among others.

Meets Evelyn Gracey, a poet, during his exhibition at the Willard Gallery.

1944
Included in the inaugural exhibition *Forty American Moderns* at Howard Putzel's 67 Gallery, November–December, along with Milton Avery, Stuart Davis, Adolph Gottlieb, Morris Graves, Hans Hofmann, Robert Motherwell, Jackson Pollock, Mark Rothko, and Mark Tobey, among others. For his opening exhibition Putzel selected many of the artists who would later be important members of the New York School.

Exhibits in *Spring Salon for Young Artists*, May–June, at Peggy Guggenheim's Art of This Century gallery along with William Baziotes, David Hare, Motherwell, Pollock, and Hedda Sterne. Peggy Guggenheim exhibited European avant-garde artists along with works by the young New York artists who were later known as Abstract Expressionists. In doing so, she exposed American artists to European influences. Art of This Century became a center of activity for the emerging New York School.

Sculpture by Pousette-Dart's grandfather Algot E. Pousette

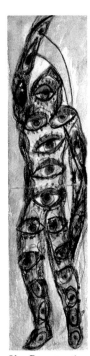

Olga Pousette, *Argus*, n.d. watercolor. Collection of Richard Pousette-Dart.

Evelyn Pousette-Dart, 1951, photographed by Pousette-Dart

Joanna Pousette-Dart, photographed by Pousette-Dart

1944–49
Participates in the annual exhibitions at the Federation of Modern Painters and Sculptors. The Federation was organized in opposition to the Artists' Congress by artists interested in aesthetic values rather than in the political actions advocated by the Artists' Congress. Richard's father was a founding member of this organization.

1945
Has a one-man show, *7 Paintings*, at the Willard Gallery in January.

Exhibits in Howard Putzel's 67 Gallery show *A Problem for Critics* in May–June along with Arshile Gorky, Gottlieb, Hofmann, Lee Krasner, and Rothko.

David Porter Gallery, Washington, D. C., includes Richard in the exhibition *A Painting Prophecy—1950*, May–July.

Exhibits at *Autumn Salon* in October at Art of This Century along with Baziotes, Willem de Kooning, Motherwell, Pollock, Rothko, and Clyfford Still.

1946
Marries Evelyn Gracey. They live at 56th Street near the East River.

Exhibits *The Edge*, 1943, and *Figure*, 1944–45, among other paintings and gouaches at the Willard Gallery one-man show in May.

Willard Gallery holds one-man exhibition *Forms in Brass and Watercolors* in December.

1947
Symphony Number 1, The Transcendental, 1941–42, is exhibited in a one-man show at Art of This Century in March. Peggy Guggenheim purchases *Spirit*, 1946, from this show.

First child, Joanna, is born in April.

Included in The Art Institute of Chicago *58th Annual Exhibition* and the Pennsylvania Academy of the Fine Arts *Annual Exhibition*.

1948
Joins the Betty Parsons Gallery, which opened in 1946 and showed works by Pollock, Rothko, Still, Ad Reinhardt, Bradley Walker Tomlin, and others. Parsons was an innovator in the exhibition of abstract art and was one of the first to exhibit paintings on plain white walls.

In his first year with the Betty Parsons Gallery, has two one-man shows: *Paintings* (March–April) and *Brasses and Photographs* (November–December).

The painting *Spirit* is shown as part of the Peggy Guggenheim collection at the XXIV Venice Biennale.

Elected treasurer of the Federation of Modern Painters and Sculptors the same year that Feininger is president and Gottlieb is Cultural Chairman. Rothko and Tomlin, among others, are members.

Attends meetings and lectures at an informal school in Greenwich Village, called "Subjects of the Artist," which was organized by Baziotes, Hare, Motherwell, and Rothko. This group becomes known as the Eighth Street Club.

1949
The Museum of Modern Art includes him in their exhibition *Contemporary American Painters*.

Becomes a regular exhibitor in the Whitney Museum of American Art's *Annual Exhibition of Contemporary American Sculpture, Watercolors and Drawings*.

1950
Attends a three-day closed conference for artists which was the final activity of Studio 35, established after "Subjects of the Artist" closed in 1949. The moderators were Richard Lippold, Motherwell, and Alfred Barr. Artists in this group are later known as the Abstract Expressionists.

The Museum of Modern Art acquires *Number 11: A Presence*, 1949.

1951
A photo of "The Irascibles," which includes Richard among other New York School artists, is published in the January 15 issue of *Life*.

Receives Guggenheim Fellowship.

Pousette-Dart family moves from New York City to Eagle Valley Road, Sloatsburg. Richard wishes to isolate himself from the commercial pressures of the New York art world.

Lectures at The School of the Museum of Fine Arts, Boston.

Look does a photo essay on the artist entitled "Spontaneous Kaleidoscopes," October 11.

Included in the Museum of Modern Art exhibition *Abstract Painting and Sculpture in America*.

Betty Parsons Gallery presents a one-man show, *Exhibition of Works So Far Completed on Guggenheim Fellowship*.

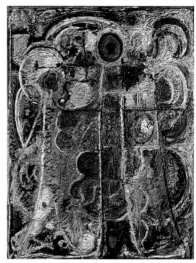

Richard Pousette-Dart, *Spirit*, 1946. Oil on canvas, 103 x 76 inches. Tel Aviv Museum. Gift of Peggy Guggenheim.

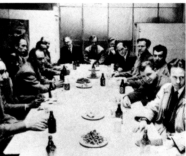

One of the Artists' Sessions at Studio 35 (April 21–23, 1950), photographed by Max Yavno. *Left to right:* Seymour Lipton, Norman Lewis, Jimmy Ernst, Peter Grippe, Adolph Gottlieb, Hans Hofmann, Alfred Barr, Robert Motherwell, Richard Lippold, Willem de Kooning, Ibram Lassaw, James Brooks, Ad Reinhardt, Richard Pousette-Dart. *Not pictured:* Janice Biala, Louise Bourgeois, Herbert Ferber, Robert Goodnough, David Hare, Barnett Newman, Hedda Sterne, Bradley Walker Tomlin.

Jonathan Pousette-Dart at nineteen, 1971, photographed by Pousette-Dart

Self-portrait

1952

Second child, Jonathan, is born in June.

Presents "What is the Relationship between Religion and Art?" at the Union Theological Seminary, December 2, in conjunction with the exhibition *Contemporary Religious Art and Architecture*.

1953

Wins third prize in *Photography* magazine's international competition. Throughout his career photography continues to be an important interest.

Whitney Museum of American Art acquires *The Magnificent*, 1950–51.

1954

The Pousette-Dart family moves to Christmas Hill Road, Monsey, New York.

Peggy Guggenheim gives *Spirit* to the Tel Aviv Museum as part of a bequest of twenty-seven paintings that includes works by Baziotes, Masson, Pollock, and Tanguy. The following year the Tel Aviv Museum uses the Guggenheim bequest as the basis of their first major exhibition of international abstract and Surrealist painting.

1958

The Pousette-Darts move to Suffern, New York, where they currently reside.

Golden Dawn, 1952, is included in the Whitney Museum of American Art exhibition *Nature in Abstraction*.

1959

Receives Ford Foundation Grant from Grants-in-Aid Program for Visual Artists.

1959–61

Teaches painting at the New School for Social Research in New York.

1961

Awarded M. V. Kohnstamm Prize from The Art Institute of Chicago at the *64th Annual American Painting and Sculpture Exhibition* for *Shadow of the Unknown Bird*, 1955–58.

Exhibits at the VI Bienal do Museu de Arte Moderna, São Paulo, Brazil.

1963

First retrospective exhibition is held at the Whitney Museum of American Art.

Whitney Museum of American Art acquires *Sky Presence (Morning)*, 1962–63.

1964

Teaches graduate painting courses at the School of Visual Arts in New York.

The Museum of Modern Art acquires *Radiance*, 1962–63.

1965

Wins second prize at the *29th Biennial of Contemporary American Painting* at The Corcoran Gallery of Art, Washington, D. C.

Awarded Honorary Doctor of Humane Letters by Bard College.

Included in the Los Angeles County Museum exhibition *New York School: The First Generation—Paintings of the 1940s and 1950s*.

Nathaniel Pousette-Dart dies.

1966

Delivers "Convocation Lecture" at the Minneapolis School of Art.

Wins National Council for the Arts Award for Excellence.

1967

Receives The National Endowment for the Arts Award for Individual Artists.

1968–69

Teaches painting at Columbia University in New York, where he also serves as guest critic.

1969

Flora Pousette-Dart dies.

The Museum of Modern Art acquires *Desert*, 1940; *Fugue Number 2*, 1943; and *Chavade*, 1951.

Whitney Museum of American Art acquires *Presence, Ramapo Mist*, 1969.

Included in The Museum of Modern Art exhibition *The New American Painting and Sculpture: The First Generation*.

1969–70

The Museum of Modern Art organizes a circulating exhibition entitled *Richard Pousette-Dart: Presences*.

1970–74

Teaches painting at Sarah Lawrence College, Bronxville, New York.

1971

Travels to Europe for the first time to visit Paris, Chartres Cathedral, Rome, Florence, and London.

The Suffern studio, ca. 1960–62, photographed by Pousette-Dart

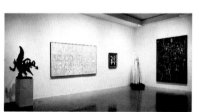

Pousette-Dart paintings in *The New American Painting and Sculpture: The First Generation*, at The Museum of Modern Art, New York, June 18-October 5, 1969. *Left to right: Chavade*, 1951; *Number 11: A Presence*, 1949; *Fugue Number 4*, 1947.

Richard Pousette-Dart

1973
Richard and daughter Joanna both exhibit at the Whitney Museum's *Biennial Exhibition: Contemporary American Art.*

Spends two months in Provence, France, as part of the Summer Program at Sarah Lawrence College. While there he works on watercolors and drawings.

1974
Joins Andrew Crispo Gallery in New York City. Crispo represented Douglas Abdell, Richard Anuszkiewicz, Ilya Bolotowsky, Lowell Nesbitt, and Charles Seliger, among others.

Whitney Museum of American Art organizes a second important exhibition of Pousette-Dart's paintings that focuses on his work from 1963 to 1974, the period following his 1963 retrospective.

Receives mural commission for North Central Bronx Hospital, New York.

1975
Travels to Antibes, France, and stays near Picasso Museum. While there he works on watercolors.

1979
Participates in symposium, "Abstract Expressionism: Idea and Symbol," sponsored by the University of Virginia. Other panelists include Lee Krasner and Robert Motherwell. Gail Levin, Associate Curator, Whitney Museum of American Art, presents a paper, "Richard Pousette-Dart's Painting and Sculpture: Form, Poetry and Significance."

1980
Joins the Marisa del Re Gallery in New York City. The gallery also represents Karel Appel, Conrad Marca-Relli, Kenzo Okada, and George Tooker, among others.

1980–Present
Teaches drawing, painting, color, design, and composition at the Art Students League in New York.

1981
Receives a grant from the Louis Comfort Tiffany Foundation "to honor a distinguished lifetime in art—a serious professional commitment and a level of accomplishment which characterize the ideals of the Foundation."

Exhibits at Marisa del Re Gallery, New York, in a one-man show, *Presences: Black and White, 1978–80*, October–November, which is cited by Hilton Kramer in *The New York Times* as the year's best exhibition.

1982
Invited by The International Committee of the Venice Biennale to exhibit in the Main Pavilion.

Exhibits at Ausstellungsleitung Haus Der Kunst, Munich, Germany, in their exhibition *Amerikanische Malerie: 1930–1980.*

The Metropolitan Museum of Art acquires *Presence, Ramapo Horizon*, 1975.

1983
Invited to be Milton Avery Distinguished Professor of Arts at Bard College.

Included in the exhibition *Modern American Painting* at the Museum of Fine Arts, Houston.

1985
Represented in *Flying Tigers: Painting and Sculpture in New York, 1939–46* at the David Winton Bell Gallery, Brown University, Providence.

1986
One-man exhibition, *Transcending Abstraction: Richard Pousette-Dart, Paintings 1939–1985*, is held at the Museum of Art, Fort Lauderdale.

Participates in *The Spiritual in Art: Abstract Painting 1890–1985* at the Los Angeles County Museum of Art.

1987
Included in the Solomon R. Guggenheim exhibition *Peggy Guggenheim's Other Legacy.*

The Metropolitan Museum of Art acquires *Path of the Hero*, 1950.

1989
Receives the Individual Visual Artist Award from the Arts Council of Rockland County, New York.

1990
Commissioned to do monumental bronze door entitled *Cathedral*, based on the painting of the same title (108), for the facade of the Indianapolis Museum of Art's new pavilion, designed by Edward Larrabee Barnes.

Commissioned to design the Interfaith Center, Northern Kentucky University, Highland Heights.

One-man show, *White Paintings*, is held at the Marisa del Re Gallery, New York, in April.

Exhibitions

1941

One-man
Artists' Gallery, New York

1943

Forms in Brass, Willard Gallery, New York

1944

Group
Spring Salon for Young Artists, Art of This Century, New York
Annual Exhibition, Federation of Modern Painters and Sculptors

1945

One-man
7 Paintings, Willard Gallery, New York

Group
Addison Gallery, Phillips Academy, Andover, Massachusetts
A Problem for Critics, 67 Gallery (Howard Putzel), New York
A Painting Prophecy—1950, David Porter Gallery, Washington, D.C.
Annual Exhibition, Federation of Modern Painters and Sculptors
Autumn Salon, Art of This Century, New York
Portraits for Today by Painters of Today, Mortimer Brandt Gallery, New York

1946

One-man
Forms in Brass and Watercolors, Willard Gallery, New York
Paintings and Gouaches, Willard Gallery, New York

Group
Virginia Museum of Fine Arts, Richmond
Annual Exhibition, Federation of Modern Painters and Sculptors
Modern Homemade Jewelry, The Museum of Modern Art, New York

1947

One-man
Art of This Century, New York

Group
58th Annual Exhibition, The Art Institute of Chicago
The Detroit Institute of Arts
Annual Exhibition, Pennsylvania Academy of the Fine Arts, Philadelphia
Annual Exhibition, Federation of Modern Painters and Sculptors

1948

One-man
Paintings, Betty Parsons Gallery, New York
Brasses and Photographs, Betty Parsons Gallery, New York

Group
Annual Exhibition, Pennsylvania Academy of the Fine Arts, Philadelphia
Peggy Guggenheim's Collection, XXIV Venice Biennale
Annual Exhibition, Federation of Modern Painters and Sculptors
58th Annual American Exhibition, Paintings and Sculpture. Abstract and Surrealist American Art, The Art Institute of Chicago

1949

One-man
Recent Paintings, Betty Parsons Gallery, New York

Group
California Palace of the Legion of Honor, San Francisco
59th Annual American Exhibition, Watercolors and Drawings, The Art Institute of Chicago
Contemporary American Painters, The Museum of Modern Art, New York
Annual Exhibition of Contemporary American Sculpture, Watercolors and Drawings, Whitney Museum of American Art, New York
La Collezione Guggenheim, Palazzo Reale, Milan, and Palazzo Strozzi, Florence
Annual Exhibition, Federation of Modern Painters and Sculptors
Jewelry Exhibition, The University Gallery, University of Minnesota, Minneapolis

1950

One-man
Betty Parsons Gallery, New York

Group
The Corcoran Gallery of Art, Washington, D.C.
The Toledo Museum of Art
Recent Acquisitions, The Museum of Modern Art, New York
Annual Exhibition of Contemporary American Painting, Whitney Museum of American Art, New York

1951

One-man
Watercolors, Betty Parsons Gallery, New York
Exhibitions of Works So Far Completed on Guggenheim Fellowship, Betty Parsons Gallery, New York

Group
Contemporary American Painting, University of Illinois, Urbana
Exhibition of American Abstractionists Loaned by the Parsons Gallery, Museum of Fine Arts, Boston
City Art Museum of Saint Louis
Abstract Painting and Sculpture in America, The Museum of Modern Art, New York
The School of New York, Frank Perls Gallery, New York

Annual Exhibition of Contemporary American Painting, Whitney Museum of American Art, New York
Surrealism and Abstraction/Collection Peggy Guggenheim, Palais des Beaux-Arts, Brussels, and Stedelijk Museum, Amsterdam
Annual Exhibition of Contemporary American Sculpture, Watercolors and Drawings, Whitney Museum of American Art, New York
Third Independent Tokyo Art Exhibition
Moderne Kunst aus der Sammlung Peggy Guggenheim, Kunsthaus, Zurich

1952

Group
Contemporary American Painting Exhibition, University of Illinois, Urbana
Expressionism in American Painting, Albright Art Gallery, Buffalo
An Exhibition of Contemporary Religious Art and Architecture, Union Theological Seminary, New York

1953

One-man
1953 Paintings, Betty Parsons Gallery, New York

Group
Los Angeles County Museum of Art
Contemporary American Painting and Sculpture Exhibition, University of Illinois, Urbana
Annual Exhibition of Contemporary American Painting, Whitney Museum of American Art, New York
Brooks Memorial Art Gallery, Memphis
Contemporary American Watercolors, Art Association of Indianapolis, The John Herron Art Institute

1954

Group
The Corcoran Gallery of Art, Washington, D.C.
The Art Institute of Chicago
The Detroit Institute of Arts
The Toledo Museum of Art
Virginia Museum of Fine Arts, Richmond

1955

One-man
Predominantly White, Betty Parsons Gallery, New York

Group
Young Americans, The Museum of Modern Art, New York
Annual Exhibition of Contemporary American Painting, Whitney Museum of

American Art, New York
The New Decade: 35 American Painters and Sculptors, Whitney Museum of American Art, New York; traveled to San Francisco Museum of Art, University of California at Los Angeles, Colorado Springs Fine Arts Center, City Art Museum of Saint Louis
Abstract and Surrealist Paintings, Tel Aviv Museum, Jerusalem

1956
Group
The Corcoran Gallery of Art, Washington, D.C.
University of Nebraska, Lincoln
Annual Exhibition of Contemporary American Sculpture, Watercolors and Drawings, Whitney Museum of American Art, New York
Andrew Dickson White Museum of Art at Cornell University, Ithaca
Pittsburgh International Exhibition of Contemporary Painting and Sculpture, Department of Fine Arts, Carnegie Institute, Pittsburgh

1957
Group
Contemporary American Painting, University of Illinois, Urbana
American Paintings 1945–1957, The Minneapolis Institute of Arts
Annual Exhibition of Contemporary American Painting, Whitney Museum of American Art, New York
Randolph-Macon Woman's College Art Gallery, Lynchburg, Virginia
62nd Annual American Exhibition, The Art Institute of Chicago

1958
One-man
Betty Parsons Gallery, New York

Group
The Corcoran Gallery of Art, Washington, D.C.
University of Illinois, Urbana
The Detroit Institute of Arts
The Artists' Vision: 1948–1958, Signa Gallery, East Hampton, New York
The Museum and Its Friends, Whitney Museum of American Art, New York
Annual Exhibition of Contemporary American Painting, Whitney Museum of American Art, New York
Nature in Abstraction: The Relation of Abstract Painting and Sculpture to Nature in Twentieth-Century American Art, Whitney Museum of American Art, New York
The 1958 Pittsburgh Bicentennial International Exhibition of Contemporary Painting and Sculpture, Department of Fine Arts, Carnegie Institute, Pittsburgh
American Painting, 1958, Virginia Museum of Fine Arts, Richmond
First Inter-American Exhibition of Paintings and Prints, Instituto Nacional de Bellas Artes, Mexico City

1959
One-man
Betty Parsons Gallery, New York

Group
The Corcoran Gallery of Art, Washington, D.C.
Annual Exhibition of Contemporary American Painting, Whitney Museum of American Art, New York
Documenta II, Kunst Nach 1945, Museum Fridericianum, Kassel, W. Germany

1960
Group
Sixty American Painters, 1960: Abstract Expressionist Paintings of the Fifties, Walker Art Center, Minneapolis
University of Illinois, Urbana
Main Currents of Contemporary American Paintings, The State University of Iowa, Iowa City

1961
One-man
Betty Parsons Gallery, New York

Group
64th Annual American Exhibition, The Art Institute of Chicago
VI Bienal do Museu de Art Moderna, São Paulo
American Abstract Expressionists and Imagists, Solomon R. Guggenheim Museum, New York
The Art of Assemblage, The Museum of Modern Art, New York; traveled to Dallas Museum of Contemporary Art and San Francisco Museum of Art
Pittsburgh International Exhibition of Contemporary Painting and Sculpture, Department of Fine Arts, Carnegie Institute, Pittsburgh
Contemporary American Painting, Annual Exhibition, Whitney Museum of American Art, New York
American Art of Our Century, Whitney Museum of American Art, New York

1962
Group
Continuity and Change, Wadsworth Atheneum, Hartford
Contemporary Painting Selected from 1960–1961 New York Gallery Exhibitions, Yale University Art Gallery, New Haven
65th Annual American Exhibition, The Art Institute of Chicago

1963
One-man
Retrospective exhibition at the Whitney Museum of American Art, New York

Group
22nd International Watercolor Biennial, The Brooklyn Museum
Annual Exhibition of Contemporary American Painting, Whitney Museum of American Art, New York

1964
One-man
Betty Parsons Gallery, New York

Group
Between the Fairs—Twenty-five Years of American Art, 1939–1964, Whitney Museum of American Art, New York

1965
One-man
The Katonah Gallery, Katonah, New York

Group
New York School: The First Generation— Paintings of the 1940s and 1950s, Los Angeles County Museum of Art
Art: An Environment for Faith, San Francisco Museum of Art
29th Biennial of Contemporary American Painting, The Corcoran Gallery of Art, Washington, D.C.
Black and White, The Contemporaries, New York
Annual Exhibition of Contemporary American Painting, Whitney Museum of American Art, New York
Painting Without a Brush, Institute of Contemporary Art, Boston

1966
Group
Sculpture and Painting Today: Selections from the Collection of Susan Morse Hilles, Museum of Fine Arts, Boston
The First Flint Invitational, Flint Institute of Arts, Flint, Michigan
Art of the United States: 1670–1966, Whitney Museum of American Art, New York
Fifty Years of Modern Art, 1916–1966, The Cleveland Museum of Art
26th Annual Exhibition, The Society for Contemporary American Art, The Art Institute of Chicago

1967
One-man
Betty Parsons Gallery, New York

Group
Focus on Light, New Jersey State Museum, Trenton
Annual Exhibition of Contemporary American Painting, Whitney Museum of American Art, New York
27th Annual Exhibition, The Society for Contemporary American Art, The Art Institute of Chicago

1969
Group
*The New American Painting and Sculpture:
The First Generation*, The Museum of
Modern Art, New York
*Annual Exhibition of Contemporary
American Painting*, Whitney Museum of
American Art, New York

1969–70
One-man
Richard Pousette-Dart: Presences, exhibition
organized by The Museum of Modern Art,
New York; traveled to Georgia Museum of
Art, The University of Georgia, Athens;
Washington University Gallery of Art,
Saint Louis; Munson-Williams-Proctor
Institute Museum of Art, Utica; Treat
Gallery, Bates College, Lewiston, Maine;
Grand Rapids Art Museum; Santa Barbara
Museum of Art; Kirkland Fine Arts
Center-Perkinson Gallery, Millikin
University, Decatur, Illinois; Hopkins
Center, Dartmouth College, Hanover, New
Hampshire

1970
One-man
Recent Paintings, Obelisk Gallery, Boston;
traveling exhibition

Group
Recent Acquisitions: Painting and Sculpture,
The Museum of Modern Art, New York

1972
Group
*Modern Painting, Drawing and Sculpture:
Collected by Louise and Joseph Pulitzer,
Jr.*, Fogg Art Museum, Harvard University,
Cambridge, and Wadsworth Atheneum,
Hartford
*Annual Exhibition of Contemporary
American Painting*, Whitney Museum of
American Art, Downtown Branch, New
York

1973
Group
American Art at Mid-Century, I, National
Gallery of Art, Washington, D.C.
*Biennial Exhibition: Contemporary
American Art*, Whitney Museum of
American Art, New York
*The Ciba-Geigy Collection of Contemporary
Paintings*, University Art Museum, The
University of Texas at Austin

1974
One-man
Paintings from 1963–74, Whitney Museum
of American Art, New York
A Selection of Twelve Paintings, Andrew
Crispo Gallery, New York

Group
Twentieth-Century Americans, Andrew
Crispo Gallery, New York
American Art at Mid-Century, National
Gallery of Art, Washington, D. C.

1975
One-man
Allentown Art Museum, Allentown,
Pennsylvania
Edwin A. Ulrich Museum of Art, The
Wichita State University

Group
22 Artists, selected by David Novros, Susan
Caldwell Inc., New York
*Subjects of the Artist, New York Painting
1941–1947*, Whitney Museum of American
Art, Downtown Branch, New York
The Growing Spectrum of American Art,
Joslyn Art Museum, Omaha

1975–77
Group
*American Art Since 1945: From the
Collection of The Museum of Modern Art*,
organized by The Museum of Modern Art,
New York; traveled to Worcester Art
Museum, Worcester, Massachusetts; The
Toledo Museum of Art; The Denver Art
Museum; Fine Arts Gallery of San Diego;
Dallas Museum of Fine Arts; Joslyn Art
Museum, Omaha; Greenville County
Museum, South Carolina; Virginia Museum
of Fine Arts, Richmond

1976
One-man
Recent Paintings, 1975–76, Andrew Crispo
Gallery, New York

Group
American Painting, 1900–1976,
Bicentennial Exhibition, The Katonah
Gallery, Katonah, New York
*American and European Masters: Twentieth
Century*, Andrew Crispo Gallery, New
York
Private Notations: Artists Sketchbooks,
Philadelphia College of Art

1977
Group
Thirty Years of American Art, Whitney
Museum of American Art, New York
*Art '77: A Selection of Works by
Contemporary Artists from New York
Galleries*, Root Art Center, Hamilton
College, Clinton, New York
The Magic Circle, The Bronx Museum of the
Arts
*This is Today: An Exhibition of Works by
Living Artists*, Root Art Center, Hamilton
College, Clinton, New York
New York: The State of Art, New York State
Museum, Albany
Masterpieces of American Art, Andrew
Crispo Gallery, New York

*Perceptions of the Spirit in Twentieth-
Century American Art*, Indianapolis
Museum of Art; traveled to University Art
Museum, Berkeley; Marion Koogler McNay
Art Institute, San Antonio; and Columbus
Gallery of Fine Arts, Ohio

1978
One-man
Drawings, The Arts Club of Chicago and
Andrew Crispo Gallery, New York

Group
*Abstract Expressionism: The Formative
Years*, Herbert F. Johnson Museum of Art,
Cornell University, Ithaca, and Whitney
Museum of American Art, New York;
traveled to Seibu Museum of Art, Toyko
*A Selection of Important Paintings,
1900–1978*, Andrew Crispo Gallery, New
York

1979
Group
Summer Loan Exhibition, The Metropolitan
Museum of Art, New York
*America and Europe: A Century of Modern
Masters from Thyssen-Bornemisza
Collection*, The Art Gallery of Western
Australia, Perth

1980
Group
*The Solomon R. Guggenheim Museum
Collection, 1900–1980*, Solomon R.
Guggenheim Museum, New York
*150 Years of American Nature Paintings: A
Mirror of Creation*, The Vatican Museum,
Braccio di Carlo Magno, Vatican City
State, Rome; Terra Museum of American
Art, Evanston, Illinois
20th-Century American Masters, Andrew
Crispo Gallery, New York
Recent Acquisitions of American Painting,
Andrew Crispo Gallery, New York

1981
One-man
Presences: Black and White, 1978–1980,
Marisa del Re Gallery, New York

Group
Ten American Abstract Masters, Marisa del
Re Gallery, New York
Decade of Transition: 1940–1950, Whitney
Museum of American Art, New York
American Paintings, 1940–1950, Andrew
Crispo Gallery, New York
Drawings, 1900–1970, by American Artists,
Andrew Crispo Gallery, New York
Ciba-Geigy Collects: Aspects of Abstraction,
Sewall Art Gallery, Rice University,
Houston

1982
Group
Solitude—Inner Visions in American Art,
 Terra Museum of American Art, Chicago
Abstract Expressionism Lives!, The Stamford
 Museum and Nature Center, Stamford,
 Connecticut
The Spirit of Paper: Twentieth Century
 Americans, Frances Wolfson Art Gallery,
 New World Center Campus, Miami-Dade
 Community College, Miami
Twentieth-Century Portraits, Galleria degli
 Uffizzi, Florence
30 Painters—Recent Acquisitions, The
 Metropolitian Museum of Art, New York
Paintings of the 1950's, Harcus Krakow
 Gallery, Boston
Amerikanische Malerie: 1930–1980, Haus
 der Kunst, Munich; organized by the
 Whitney Museum of American Art, New
 York
Ten Artists from New York, Sunne Savage
 Gallery, Boston
The Michael and Dorothy Blankfort
 Collection, Los Angeles County Museum of
 Art
Selected Works on Paper, Marisa del Re
 Gallery, New York
International Pavilion of La Biennale di
 Venezia, Venice
Modern American Painting: The Museum of
 Fine Arts, Houston, National Pinakothiki
 Museum, Athens
Seven American Abstract Masters, Marisa del
 Re Gallery, New York
Small Works by Major Artists, Marisa del Re
 Gallery, New York
On the Surface, Israel Museum, Jerusalem

1983
One-man
Time is the Mind of Space, Space is the
 Body of Time (E Series), Marisa del Re
 Gallery, New York
The Vision of a Poet, Schweyer-Galdo
 Gallery, Birmingham, Michigan
Works on Paper, Makler Gallery,
 Philadelphia

Group
Modern American Painting: The Museum of
 Fine Arts, Houston
Important Masters, Betty Parsons Gallery,
 New York
Found Objects in Art, Marisa del Re Gallery,
 New York
International Transpersonal Association
 Exhibition at the VIII International
 Conference, Davos, Switzerland
Student's Choice Exhibition, A & A Gallery,
 Yale University School of Art, New Haven
Nine Contemporary American Masters,
 Marisa del Re Gallery, New York

1984
Group
Relationships: Paintings, Sculpture, and
 Drawings from the Twentieth-Century
 Collection of The Metropolitan Museum of
 Art, Lehman College Art Gallery, Herbert
 H. Lehman College of The City University
 of New York, The Bronx

1985
One-man
Paintings from the 1940's to the Present,
 Virginia Miller Galleries, Coral Gables
 (Miami), Florida

Group
Abstract Relationships, Charles Cowles
 Gallery, New York
Flying Tigers: Painting and Sculpture in
 New York 1939-1946, The David Winton
 Bell Gallery, Brown University, Providence
A Second Talent: Painters and Sculptors
 Who are Also Photographers, The Aldrich
 Museum of Contemporary Art, Ridgefield,
 Connecticut
Masters of the Fifties: American Abstract
 Painting from Pollock to Stella, Marisa del
 Re Gallery, New York

1986
One-man
Black and White Paintings, 1976–1981,
 Virginia Miller Galleries, Coral Gables
 (Miami), Florida
Transcending Abstraction: Richard Pousette-
 Dart, Paintings 1939–1985, Museum of
 Art, Fort Lauderdale, Florida
Recent Paintings, Marisa del Re Gallery,
 New York

Group
The Interpretive Link: Abstract Surrealism
 into Abstract Expressionism, Works on
 Paper 1938–1948, Newport Harbor Art
 Museum, Newport Beach, California
Landscape Painting in the East and West,
 Shizuoko Prefectural Museum of Art, and
 Hyogo Prefectural Museum of Art, Kobe,
 Japan
An American Renaissance, Painting and
 Sculpture Since 1940, Museum of Art,
 Fort Lauderdale, Florida
The Spiritual in Art: Abstract Painting
 1890–1985, Los Angeles County Museum
 of Art; traveled to Museum of
 Contemporary Art, Chicago, and Haags
 Gemeentemuseum, The Hague

1987
Group
Elders of the Tribe, Bernice Steinbaum
 Gallery, New York
Visions of Inner Space: Gestural Painting in
 Modern America, Wight Art Gallery,
 University of California at Los Angeles
Peggy Guggenheim's Other Legacy, Solomon
 R. Guggenheim Museum, New York
Exhibition, Lila Acheson-Wallace Wing, The
 Metropolitan Museum of Art, New York

1988
Group
Recent Acquisitions, Manny Silverman
 Gallery, Los Angeles
Black and White, Marisa del Re Gallery,
 New York

1989
Group
The Linear Image: American Masterworks
 on Paper, Marisa del Re Gallery, New York
Gallery Artists, Marisa del Re Gallery, New
 York

1990
One-man
White Paintings, Marisa del Re Gallery, New
 York
Richard Pousette-Dart: A Retrospective,
 Indianapolis Museum of Art; traveled to
 The Detroit Institute of Arts and The
 Columbus Museum, Georgia

Group
Abstract Expressionism: other dimensions,
 Jane Voorhees Zimmerli Art Museum,
 Rutgers University, New Brunswick;
 traveled to Lowe Art Museum, University
 of Miami, Coral Gables; and Terra
 Museum of American Art, Chicago

185

Public Collections

Addison Gallery of American Art, Andover,
 Massachusetts
Albright-Knox Art Gallery, Buffalo
The Brooklyn Museum
The Cleveland Museum of Art
Collection of the Ciba-Geigy Corporation,
 Ardsdale, New York
The Corcoran Gallery of Art, Washington,
 D.C.
The Detroit Institute of Arts
Hirshhorn Museum & Sculpture Garden,
 Smithsonian Institution, Washington, D.C.
Herbert F. Johnson Museum of Art, Cornell
 University, Ithaca, New York
Indianapolis Museum of Art
Los Angeles County Museum of Art
Maier Museum of Art, Randolph-Macon
 Woman's College, Lynchburg, Virginia
The Metropolitan Museum of Art, New York
Munson-Williams-Proctor Institute, Utica,
 New York
Museum of Fine Arts, Boston
The Museum of Modern Art, New York
National Museum of American Art,
 Smithsonian Institution, Washington, D.C.
The Newark Museum
North Central Bronx Hospital
Oklahoma Art Center, Oklahoma City
Palazzo degli Uffizi, Florence, Italy
Philadelphia Museum of Art
The Joseph and Emily Pulitzer Collection,
 Saint Louis Art Museum
John and Mable Ringling Museum of Art,
 Sarasota
Rose Art Museum, Brandeis University,
 Waltham, Massachusetts
Solomon R. Guggenheim Museum,
 New York
J. B. Speed Art Museum, Louisville
Tel Aviv Museum, Israel
H. H. Thyssen-Bornemisza Collection,
 Lugano, Switzerland
Edwin A. Ulrich Museum of Art, The
 Wichita State University
University of Nebraska Art Galleries,
 Sheldon Memorial Art Gallery, Lincoln
The University of Iowa Museum of Art,
 Iowa City
Virginia Museum of Fine Arts, Richmond
Washington University, Gallery of Art,
 Saint Louis
Whitney Museum of American Art,
 New York

Bibliography

Books, Exhibition Catalogues, and Theses

The Aldrich Museum of Contemporary Art. *Selections from the Collection of Susan Morse Hilles*. Introduction by Larry Aldrich; statement by Susan Morse Hilles. Ridgefield, CT, 1967.

Andrew Crispo Gallery. *Drawings*. New York, 1978.

_____. *Richard Pousette-Dart: Recent Paintings, 1975–76*. New York, 1976.

Arnason, H. H. *History of Modern Art: Painting, Sculpture, Architecture*. New York: Harry N. Abrams, 1968; rev. ed., 1977.

Art of This Century. *Richard Pousette-Dart, One Man Exhibition*. New York, 1947.

The Arts Club of Chicago. *Richard Pousette-Dart Drawings*. Chicago, 1978.

Bell, Clive. *Art*. New York: Frederick A. Stokes Company, 1913.

The David Winton Bell Gallery, Brown University. *Flying Tigers: Paintings and Sculptures in New York 1939–1946*. Introduction by Kermit S. Champa. Providence, RI, 1985.

Brodsky, Horace. *Henri Gaudier-Brzeska 1891–1915*. London: Faber and Faber, 1931.

The Buffalo Fine Arts Academy, Albright Art Gallery. *Expressionism in American Painting*. Foreword by Edgar C. Schenck; introduction by Edgar C. Schenck, Patrick J. Kelleher, and Roger Squire; "European Expressionism in the United States," by Bernard Meyers. Buffalo, 1952.

Burke, Edmund. *A Philosophical Enquiry into the Origins of Our Ideas of the Sublime and the Beautiful* (1757). New York: Columbia University Press, 1958.

CDS Gallery. *The Irascibles*. Curated by Irving Sandler. New York: CDS Gallery, 1988.

Celentano, Frances. "The Origins and Development of Abstract Expressionism in the U.S." New York University, Master's Thesis, 1957.

Cohane, Rosemary. "Artistic Sources of an Abstract Expressionist Style: Richard Pousette-Dart." Tufts University, Master's Thesis, 1982.

Documenta '59: Kunst nach 1945. Introduction by Werner Haftmann. Cologne: Verlag M. Dumont Schauberg, 1959.

Flint Institute of Arts. *Second Flint Invitational*. Foreword by G. Stuart Hodge. Flint, MI, 1969.

Fogg Art Museum, Harvard University. *Modern Painting, Drawing, and Sculpture: Collected by Louise and Joseph Pulitzer, Jr.* vol. 3. Catalogue by Charles Scott Chetham, with contributions by Walter Barker and others; introduction by Agnes Mongan; text by John Gordon. Cambridge, MA, 1971.

Goldwater, Robert. *Primitivism in Modern Art*. New York: Alfred A. Knopf and Random House, 1966.

Goossen, Eugene C. *Betty Parson's Private Collection*. New York: Finch College Museum of Art, 1958.

_____. "Pousette-Dart, Richard (1916–)," *Britannica Encyclopedia of American Art*. Chicago, n.d. (distributed by Simon and Schuster, New York), p. 446.

Graham, John. *System and Dialectics of Art*. New York: Delphic Studios, 1937. Reprinted in *John Graham's System and Dialectics of Art*, with Introduction and notes by Marcia Epstein Allentuck. Baltimore: The Johns Hopkins University Press, 1971.

Hobbs, Robert C., and Gail Levin. *Abstract Expressionism: The Formative Years*. Ithaca, NY: Cornell University Press, 1981. (First published in 1978 in conjunction with a traveling exhibition organized by the Herbert F. Johnson Museum of Art, Cornell University, and the Whitney Museum of American Art, New York.)

Indianapolis Museum of Art. *Perceptions of the Spirit in Twentieth-Century Art*. Catalogue by Jane Dillenberger and John Dillenberger. Indianapolis, 1977.

Kandinsky, Wassily. *Concerning the Spiritual in Art*. Translated by M. T. H. Sadler. New York: Dover Publications, 1977.

Kramer, Hilton. *The Revenge of the Philistines: Art and Culture, 1972–1984*. New York: The Free Press, 1985.

Los Angeles County Museum of Art. *New York School. The First Generation: Paintings of the 1940s and 1950s*. Maurice Tuchman, editor; statements by Pousette-Dart. Los Angeles, 1965. Rev. ed. Greenwich, CT: New York Graphic Society, n.d.

_____. *The Spiritual in Art: Abstract Painting 1890–1985*. New York: Abbeville Press, Inc., in association with the Los Angeles County Museum of Art, 1985.

Marisa del Re Gallery. *Richard Pousette-Dart Presences: Black and White, 1978–1980*. Introduction by Lawrence Campbell. New York, 1981.

_____. *Richard Pousette-Dart*. Essays by Robert C. Hobbs and Sam Hunter. New York: Marisa del Re Gallery, 1986.

_____. *Richard Pousette-Dart (E Series), 1981–1983: Time is the Mind of Space and Space is the Body of Time*. Introduction by Lowery S. Sims. New York, 1983.

_____. *Richard Pousette-Dart. White Paintings*. Essays by Carter Ratcliff and Barbara Rose. New York, 1990.

The Metropolitan Museum of Art. *New York Painting and Sculpture: 1940–1970*. Introduction by Henry Geldzahler; essays in reprint by Harold Rosenberg, Robert Rosenblum, Clement Greenberg, and others. New York: E. P. Dutton, in association with The Metropolitan Museum of Art, 1969.

Modern Artists in America, Vol. 1 (1949/1950). Edited by Robert Motherwell and Ad Reinhardt with documentation by Bernard Karpel. New York: Wittenborn Schultz, Inc., 1949.

Museum of Art, Fort Lauderdale. *Transcending Abstraction: Richard Pousette-Dart, Paintings 1939–1985*. Edited with an introduction by Sam Hunter. Essays by Judith Higgins and Paul Kruty. Fort Lauderdale, 1986.

The Museum of Modern Art. *Abstract Painting and Sculpture in America*. Text by Andrew Carnduff Ritchie. New York, 1951.

_____. *American Art Since 1945: From the Collection of The Museum of Modern Art*. Essay by Alicia Legg. New York, 1975.

_____. *The Art of Assemblage*. Text by William C. Seitz. New York, 1961.

_____. *"Primitivism" in Twentieth-Century Art*. Edited by William Rubin. Vol. II. "Abstract Expressionism," by Kirk Varnedoe. New York, 1984.

_____. *Richard Pousette-Dart: Presences*. Essay by Lucy R. Lippard. New York, 1969.

National Gallery of Art. *American Art of Mid-Century*. Introduction by William C. Seitz. Washington, D. C., 1973.

Newport Harbor Art Museum. *The Interpretive Link: Abstract Surrealism into Abstract Expressionism, Works on Paper 1938–1948*. Organized by Paul Schimmel. Newport Beach, CA, 1986.

The New Jersey State Museum Cultural Center. *Focus on Light*. Text by Lucy R. Lippard. Trenton, 1967.

New York State Museum, Albany. *New York: The State of the Art*. Text by Robert Bishop, William H. Gerdts, and Thomas B. Hess. Albany, 1977.

Nordness, Lee, ed. *Art USA Now*, vol. 2. New York: Viking Press, 1962.

O'Brian, John. *Clement Greenberg: The Collected Essays and Criticism*, vols. 1, 2. Chicago: The University of Chicago Press, 1986.

Betty Parsons Gallery. *Richard Pousette-Dart*. Statement by Raymond F. Piper. New York, 1945.

The Phillips Collection. *John Graham: Artist and Avatar*. Text by Eleanor Green. Washington, D. C., 1987.

Pound, Ezra. *Gaudier-Brzeska: A Memoir*. New York: The Bodley Head, 1916.

Pousette-Dart, Flora. *I Saw Time Open*. New York: Island Press, 1947.

_____. *Poems*. New York: Oquaga Press, ca. 1936.

Pousette-Dart, Nathaniel. *American Painting Today*. New York: Hastings House Publishers, 1956.

_____. *Ernest Haskell: His Life and Work*. New York: P. Spencer Hutson, 1931.

_____, ed. *Childe Hassam*. Introduction by Ernest Haskell. *Distinguished American Artists* series. New York: Frederick A. Stokes Co. Publishers, 1922.

_____, ed. *Robert Henri. Distinguished American Artists* series. New York: Frederick A. Stokes Co. Publishers, 1922.

187

_____, ed. *Winslow Homer. Distinguished American Artists* series. New York: Frederick A. Stokes Co. Publishers, 1923.

_____, ed. *Abbott H. Thayer.* Introduction by Royal Cortissoz. *Distinguished American Artists* series. New York: Frederick A. Stokes Co. Publishers, 1923.

_____, ed. *John Singer Sargent. Distinguished American Artists* series. New York: Frederick A. Stokes Co. Publishers, 1924.

_____, ed. *James Abbott McNeill Whistler.* Introduction by Joseph and Elizabeth Robbins Pennell. *Distinguished American Artists* series. New York: Frederick A. Stokes Co. Publishers, 1924.

Root Art Center, Hamilton College. *This is Today: An Exhibition of Works by Living Artists.* Foreword by Carter Rand. Clinton, NY, 1977.

_____. *Art '77: A Selection of Works by Contemporary Artists from New York Galleries.* Foreword by Dennis Lukas. Clinton, NY, 1977.

Rose, Barbara. *American Art Since 1900.* Rev. ed. New York: Frederick A. Praeger, 1975.

_____. *American Painting: The 20th Century.* (Distributed by World Publishing, Skira, n.d.)

Rosenblum, Robert. *Modern Painting and the Northern Romantic Tradition: Friedrich to Rothko.* New York: Harper & Row, 1975.

Sandler, Irving. *The Triumph of American Painting: A History of Abstract Expressionism.* New York: Praeger Publishers, 1970.

Schweyer-Galdo Galleries. *Richard Pousette-Dart: The Vision of a Poet.* Birmingham, MI, 1983.

Signa Gallery. *The Artist's Vision: 1948–1958.* East Hampton, NY, 1958.

Solomon R. Guggenheim Museum. *American Abstract Expressionists and Imagists.* Foreword by H. H. Arnason. New York, 1961.

The University of Illinois, College of Fine and Applied Arts. *University of Illinois Exhibition of Contemporary American Painting.* Introduction by Rexford Newcomb; essay by Allen S. Weller; statement by Pousette-Dart. Urbana, IL, 1952.

The University of Michigan Museum of Art. *One Hundred Contemporary American Drawings.* Foreword by Albert Mullen; introduction by Dore Ashton. Ann Arbor, 1965.

Virginia Museum of Art. *American Painting, 1970.* Essay by Peter H. Selz. Richmond, 1970.

Wadsworth Atheneum. *Continuity and Change.* Foreword by Samuel Wagstaff, Jr. Hartford, CT, 1962.

Whitney Museum of American Art. *Between the Fairs.* Foreword by Lloyd Goodrich; introduction by John I. H. Baur. New York: Praeger, in association with the Whitney Museum of American Art, 1964.

_____. *Nature in Abstraction: The Relation of Abstract Painting and Sculpture to Nature in Twentieth-Century American Art.* Text by John I. H. Baur. New York: The Macmillan Company, in association with the Whitney Museum of American Art, 1958.

_____. *The New Decade: 35 American Painters and Sculptors.* John I. H. Baur, editor. New York: The Macmillan Company, in association with the Whitney Museum of American Art, 1955.

_____. *Richard Pousette-Dart.* Text by John Gordon; foreword by Lloyd Goodrich. New York, 1963.

_____. *Richard Pousette-Dart.* Text by James K. Monte. New York, 1974.

Willard Gallery. *Richard Pousette-Dart: Forms in Brass and Watercolors.* New York, 1946.

_____. *Seven Paintings, Richard Pousette-Dart.* New York, 1945.

Yale University Art Gallery. *Two Modern Collectors: Susan Morse Hilles, Richard Brown Baker.* Foreword by Andrew Carnduff Ritchie; statements by Susan Morse Hilles and Richard Brown Baker. New Haven, CT, 1963.

Newspaper and Magazine Articles

"Abstract Impressions," *Detroit Free Press,* November 6, 1983, p. 8B.

Adlow, Dorothy. Untitled article. *The Christian Science Monitor,* March 28, 1958, p. 12.

_____. Untitled article. *The Christian Science Monitor,* January 13, 1959, p. 8.

_____. Untitled article. *The Christian Science Monitor,* July 15, 1963, p. 8.

Alloway, Lawrence. "Art." *The Nation* 220 (February 15, 1975), pp. 188–89.

_____. "The View from the 20th Century." *Artforum* 12 (January 1974), pp. 44–45.

Ashton, Dore. "Fifty-Seventh Street." *The Art Digest* 27 (April 1, 1953), pp. 18–19.

_____. "Fifty-Seventh Street in Review." *The Art Digest* 26 (October 1, 1951), p. 18.

"At Whitney: Pousette-Dart Opens April 17." *The Middletown (NY) Times Herald Record,* February 23, 1963, p. 9.

Baker, Kenneth. "Wistful 'Presences.' " *The Christian Science Monitor* (New England edition only), January 26, 1970, p. 6.

Baro, Gene. "New York Letter." *Art International* 25 (March/April 1982), p. 104.

Beckley, Paul. "Art Exhibition Notes." *New York Herald Tribune,* March 30, 1948, p. 23.

Belz, Carl. "Boston." *Artforum* 8 (April 1970), p. 92.

"The Betty Parsons Gallery," *Vogue* 118 (October 1951), pp. 150–151, 194–97.

"Brass Talisman." *Harper's Bazaar* 80 (December 1946), p. 293.

Bennett, Edna. "Pousette-Dart, Modern Painter with a Camera." *Photography* 34 (January 1954), pp. 44–49, 212.

Breuning, Margaret. "Fifty-Seventh Street in Review." *The Art Digest* 24 (April 1, 1950), p. 21.

Browne, Rosalind. "The Modern and the Ancient." *New York Star,* November 19, 1948, Pleasure Section, p. 8.

Burrows, Carlyle. "Directions Shown in Pittsburgh." *New York Herald Tribune,* October 26, 1941, Section 6, p. 8.

_____. "A Fresh Minguzzi." *New York Herald Tribune,* April 16, 1961, Section 4, p. 21.

_____. "Our Watercolors and Some English." *New York Herald Tribune,* April 5, 1959, Section 4, p. 6.

_____. "Significant Modern Works in Museum Accession Show." *New York Herald Tribune,* July 30, 1950, Section 5, p. 4.

Campbell, Lawrence. "Pousette-Dart: Circles and Cycles." *Art News* 62 (May 1963), pp. 42–45, 56–57.

_____. "Reviews and Previews." *Art News* 49 (January 1951), p. 47.

Canaday, John. "About the New American Art: The First Generation Out of Many, One Sort Of." *The New York Times,* June 22, 1969, Section 2, p. D31.

Carlson, Helen. "Traditional Art and Abstractions." *The New York Sun,* April 2, 1948, p. 31.

Cavaliere, Barbara. "Review of Exhibition at Marisa del Re Gallery." *Flash Art* 105 (December 1981/January 1982), p. 54.

Coblentz, Gaston. "In the Art Galleries." *New York Herald Tribune,* March 9, 1947, Section 5, p. 5.

de Kooning, Elaine. "Reviews and Previews." *Art News* 48 (March 1949), p. 46.

Devree, Howard. "Along Gallery Row." *The New York Times,* January 7, 1945, Section 2, p. 8X.

_____. "By Contemporaries." *The New York Times,* March 15, 1953, Section 2, p. 8X.

_____. "Diverse New Shows." *The New York Times,* March 9, 1947, Section 2, p. 7X. (Includes artist's statement.)

_____. "From a Reviewer's Notebook." *The New York Times,* October 17, 1943, Section 2, p. 8X.

_____. "One by One: Old and New." *The New York Times,* May 26, 1946, Section 2, p. 6.

_____. "Round-up and Solo." *The New York Times*, October 18, 1953, Section 2, p. 9X.

Edgar, Natalie. "Reviews and Previews." *Art News* 63 (December 1964), p. 15.

"An Exhibit Opens in New York." *The (Suffern, NY) Sunday Independent*, April 21, 1963, p. 16.

Ellenzweig, Allen. "Arts Reviews." *Arts Magazine* 50 (June 1976), p. 28.

Farber, Manny. "Art." *The Nation* 173 (October 13, 1951), pp. 313–314.

Fitzsimmons, James. "Fifty-Seventh Street in Review." *The Art Digest* 25 (February 1, 1951), p. 18.

Frankenstein, Alfred. "Richard Pousette-Dart." *San Francisco Chronicle*, January 28, 1974, Art Section, p. 33.

Frankfurter, Alfred. "In Search of Art History at the Carnegie." *Art News* 60 (December 1961), pp. 28, 49.

Friedman, B. H. "'The Irascibles': A Split Second in Art History." *Arts Magazine* 53 (September 1978), pp. 96–102.

Gage, Otis. "Four Artists As Jewelers." *Craft Horizons* 15 (May/June 1955), pp. 14–17.

"The Galleries—A Critical Guide." *New York Herald Tribune*, November 28, 1964, p. 9.

Genauer, Emily. "Art Exhibition Notes." *New York Herald Tribune*, September 28, 1951, p. 19.

_____. "Exhibit of an Untaught Genius." *New York Herald Tribune*, April 17, 1963, p. 15.

_____. "Richard Pousette-Dart." *New York Post*, November 16, 1974, p. 14.

George, Laverne. "In the Galleries." *Arts* 30 (November 1955), p. 55.

Gibson, Ann. Editor's Statement, "New Myths for Old: Redefining Abstract Expressionism." *Art Journal* 47 (Fall 1988), pp. 171–73.

Giuliano, Charles. "Pousette-Dart: Exploring Mystery." *Boston After Dark*, January 21–28, 1970, cover and p. 11.

Glueck, Grace. "Deflecting Henry's Show." *The New York Times*, October 19, 1969, Section 2, p. 28. (Includes artist's statement.)

Goodnough, Robert. "Reviews and Previews." *Art News* 50 (November 1951), p. 47.

Greenberg, Clement. "Art Notes." *The Nation* (January 20, 1945). Reprinted in *Clement Greenberg: The Collected Essays and Criticism*, Vol. 2, edited by John O'Brian (Chicago: University of Chicago Press, 1986), pp. 6–7.

_____. "New York Painting Only Yesterday," *Art News* 56 (Summer 1957), pp. 58–59, 84–86.

_____. "Review of a Group Exhibition at the Art of This Century Gallery." *The Nation* (May 27, 1944). Reprinted in *Clement Greenberg: The Collected Essays and Criticism*, Vol. 1, edited by John O'Brian (Chicago: University of Chicago Press, 1986), pp. 209–10.

_____. "Review of Problem for Critics." *The Nation* (June 9, 1945). Reprinted in *Clement Greenberg: The Collected Essays and Criticism*, Vol. 2, edited by John O'Brian (Chicago: University of Chicago Press, 1986), p. 28.

Guest, Barbara. "Reviews and Previews." *Art News* 52 (April 1953), p. 38.

Harris, Susan. "Richard Pousette-Dart." *Arts Magazine* 58 (January 1984), p. 50.

Hess, Thomas B. "Collage as an Historical Method." *Art News* 60 (November 1961), pp. 30–33, 69–71.

_____. "Inside Nature." *Art News* 56 (February 1958), pp. 40–43, 59–65. (Includes artist's statement.)

_____. "Mixed Pickings from Ten Fat Years." *Art News* 54 (Summer 1955), pp. 36–39, 77–78.

_____. "Mutt Furioso." *Art News* 55 (December 1956), pp. 22–25, 64–65.

_____. "Reviews and Previews." *Art News* 49 (May 1950), pp. 52, 54.

Higgins, Judith. "Pousette-Dart's Windows into the Unknowing." *Art News* (January 1987), pp. 109–16.

"'How a Photographer Paints,' Candid Shots by the Editors." *Photography* 34 (January 1954), p. 34.

"Human Image in Abstraction." *Time* 72 (August 11, 1958), p. 48.

Hunter, Sam. "A Group and Singly." *The New York Times*, April 4, 1948, Section 2, p. X11.

"In the Abstract." *New York Herald Tribune*, January 21, 1945, Section 4, p. 7.

"The Johnson Collection." *Arts Magazine* 39 (April 1965), p. 24.

Judge, Jacquelyn. "Portraits: More than a Likeness." *Modern Photography* 19 (November 1955), pp. 64–68, 120, 122.

Kramer, Hilton. "Art: An Abstract Study in White." *The New York Times*, April 7, 1978, Section C, p. 18.

_____. "Art: Paintings of Richard Pousette-Dart at the Whitney Museum." *The Nation* 196 (May 18, 1963), pp. 428–29.

_____. "Art: Pousette-Dart's Abstract Expressionism." *The New York Times*, Friday, October 9, 1981, Section C, p. 23.

_____. "Art: Pousette-Dart Paintings Glow with Color, Light." *The New York Times*, Saturday, April 10, 1976, p. 17.

_____. "Art: Spirit and Substance." *The New York Times*, November 18, 1967, p. 31.

_____. "Can We Place Them with Matisse and Brancusi?" *The New York Times*, June 22, 1969, Section 2, p. D31.

_____. "A Clearer View of the Iceberg." *Art in America* 52 (February 1964), pp. 121, 123–24.

_____. "Episodes from the Sixties." *Art in America* 58 (January/February 1970), pp. 56–61.

_____. "Making Vivid the Spirit of the New York School." *The New York Times*, April 16, 1978, Section 2, p. 26.

_____. "A Modish Revision of History." *The New York Times*, October 19, 1964, Section 2, pp. 29–30.

_____. "Pousette-Dart: The Case of the Odd Man Out." *The New York Times*, November 17, 1974, Section 2K, p. 37.

_____. "Seesawing Reputations: A Generation of Curators Rewrites the History of Abstract Expressionism." *Art and Antiques* (December 1987), pp. 105–6.

_____. "A Year of Treasures, Revisions, and Trends." *The New York Times*, December 27, 1981, Section 2, p. 27.

Kroll, Jack. "Richard Pousette-Dart: Transcendental Expressionist." *Art News* 60 (April 1961), pp. 32–35, 56.

Kruze, A. Z. "At the Art Galleries." *Brooklyn Eagle*, October 26, 1941, Section E, p. 6.

Kuspit, Donald B. "Pousette-Dart in Black and White." *Art in America* 70 (February 1982), pp. 126–28.

Lader, Melvin P. "David Porter's 'Personal Statement: A Painting Prophecy, 1950.'" *Archives of American Art Journal* 28 (November 1, 1988), pp. 17–25.

Lansford, Alonzo. "Fifty-Seventh Street in Review." *The Art Digest* 22 (April 15, 1948), pp. 20–21.

_____. "Fifty-Seventh Street in Review." *The Art Digest* 21 (March 15, 1947), p. 18.

Leider, Philip. "New York School: The First Generation." *Artforum* 4 (September 1965), pp. 3–13.

Levin, Gail. "Richard Pousette-Dart's Emergence as an Abstract Expressionist." *Arts Magazine* 54 (March 1980), pp. 125–29.

_____. "Richard Pousette-Dart's Painting and Sculpture: Form, Poetry and Significance." Delivered at the University of Virginia, Charlottesville, October 13, 1979. Typescript is in the artist's possession.

Lippard, Lucy R. "New York Letter." *Art International* 9 (February 1965), pp. 38–39.

_____. "Richard Pousette-Dart: Toward an Invisible Center." *Artforum* 13 (January 1975), pp. 51–53.

Louchheim, Aline B. "Betty Parsons: Her Gallery, Her Influence." *Vogue* 118 (October 1951), pp. 150–51, 194–97.

Lowengrund, Margaret. "Surface Manipulations." *The Art Digest* 23 (March 15, 1949), p. 15.

Luchak, Jolanne. "Richard Pousette-Dart." *Arts Magazine* 52 (June 1978), p. 33.

McBride, Henry. "Attractions in the Galleries." *The [New York] Sun*, January 6, 1945, p. 9.

_____. "It's Called Expressionism." *Art News* 51 (May 1952), pp. 26–28, 63.

McCue, George. "Pousette-Dart Exhibit Opens at Washington U." *Saint Louis Post Dispatch*, October 6, 1969, Editorials Section, p. 3B.

Merrill, Alison. "Gallery Notes." *New York Herald Tribune*, December 8, 1946, Section 5, p. 10.

"The Metropolitan and Modern Art." *Life* 30 (January 15, 1951), pp. 34–38.

"The Passing Shows." *Art News* 42 (November 1–14, 1943), p. 23.

Pearson, Ralph M. "A Modern Viewpoint." *The Art Digest* 19 (April 15, 1945), p. 29.

Perreault, John. "Yankee Vedanta." *Art News* 66 (November 1967), pp. 54–55, 74–75.

Polcari, Stephen. "Adolph Gottlieb's Allegorical Epic of World War II." *Art Journal* 47 (Fall 1988), pp. 202–7.

Porter, Fairfield. "Reviews and Previews." *Art News* 57 (April 1958), p. 13.

"A Portfolio of Recent Paintings." In *New York: The Art World*, ed. James R. Mellow. *Arts Yearbook* 7, 1964, pp. 64–65.

Pousette-Dart, Nathaniel, ed. *Art and Artists of Today* 1:1 (March 1937) to 1:6 (July 1938).

Pousette-Dart, Richard. "Boston, 1951." Typescript with copies on deposit in the libraries of The Museum of Modern Art, New York, and the Whitney Museum of American Art, New York, of a talk given in 1951 at the School of the Museum of Fine Arts, Boston.

———. "Convocation Lecture." Delivered at the Minneapolis School of Art, November 2, 1966. Typescript is in the artist's possession.

Preston, Stuart. "Art: Pousette-Dart Show." *The New York Times*, April 17, 1963, p. 38.

———. "By Group and Singly." *The New York Times*, March 13, 1949, Section 2, p. 8X.

———. "European Moderns." *The New York Times*, September 30, 1951, Section 2, p. 9X.

———. "On-Beats and Off-Beats: 'Matter Paintings.'" *The New York Times*, November 29, 1964, Section 2, p. 31X.

———. "Wide Freedom for Artist." *The New York Times*, January 19, 1951, p. 23.

Ratcliff, Carter. "Concerning the Spiritual in Pousette-Dart." *Art in America* 62 (November–December 1974), pp. 89–91.

———. "The Whitney Annual, Part I." *Artforum* 10 (April 1972), pp. 28–32.

Raynor, Vivien. "Art: Pousette-Dart's Recent Paintings on Display." *The New York Times*, May 16, 1986, p. C28.

———. "In the Galleries." *Arts* 35 (April 1961), p. 53.

———. "In the Galleries." *Arts Magazine* 37 (September 1963), pp. 56–57.

———. "New York Reviews." *Art News* 80 (December 1982), p. 180.

———. "Profile: Pousette-Dart." *Arts Magazine* 39 (January 1965), pp. 33–39.

Reed, Judith Kaye. "Desire Not Enough." *The Art Digest* 20 (June 1, 1946), p. 13.

"Reviews and Previews." *Art News* 45 (June 1946), p. 49.

"Reviews and Previews." *Art News* 45 (December 1946), p. 53.

"Reviews and Previews." *Art News* 46 (March 1947), p. 43, 46.

"Richard Pousette-Dart." *Arts Magazine* 58 (January 1984), p. 50.

"Richard Pousette-Dart: Presences." *Munson-Williams-Proctor Institute Bulletin* (December 1969), pp. 1–2. (Includes artist's statement.)

Riley, Maude. "Pousette-Dart." *The Art Digest* 19 (January 15, 1945), p. 7.

———. "The Tactile Approach." *The Art Digest* 18 (November 1, 1943), p. 21.

Rosenberg, Harold. "The American Action Painters." *Art News* 51 (December 1952), pp. 34–36, 55–56.

Sawin, Martica. "In the Galleries." *Arts* 32 (April 1958), p. 58.

———. "In the Galleries." *Arts Magazine* 36 (April 1962), p. 58.

———. "New York Letter." *Art International* 3:5–6 (1959), pp. 48–50.

———. "Richard Pousette-Dart." Unpublished essay; typescript on deposit in the library of The Museum of Modern Art, New York.

———. "Richard Pousette-Dart." *Paris/New York, Arts Yearbook* 3, 1959, pp. 144–47.

———. "Pousette-Dart's New Work in Black and White." *Arts Magazine* 56 (October 1981), pp. 154–56.

———. "Transcending Shape: Richard Pousette-Dart." *Arts Magazine* 49 (November 1974), pp. 58–59.

Schuyler, James. "Reviews and Previews." *Art News* 58 (May 1959), p. 15.

"Science with Love." *Newsweek* 61 (May 20, 1963), p. 98.

Siegel, Jeanne. "In the Galleries." *Arts Magazine* 42 (December 1967/January 1968), p. 63.

Silverthorne, Jeanne. "Review." *Artforum* 20 (January 1982), p. 76.

"Spontaneous Kaleidoscopes." *Look* 15 (October 9, 1951), pp. 96–98. (Includes artist's poem.)

"The Sublime is Now." *Tiger's Eye*, No. 6 (December 15, 1948).

"They're Welcome as Flowers in Spring—Annual Show at Legion of Honor." *The Christian Science Monitor*, January 3, 1948, p. 6.

Tillim, Sidney. "In the Galleries." *Arts* 33 (May 1959), p. 55.

Turner, Elisa. "Richard Pousette-Dart." *Art News* 84 (September 1985), p. 121.

Willard, Charlotte. "In the Art Galleries." *New York Post*, November 29, 1964, Section 2 (Magazine Section), p. 14. (Includes artist's statement.)

———. "Space Age Forms." *New York Post*, December 2, 1967, Section 2 (Magazine Section), p. 14.

Illustration Credits

All plates and figures except those listed below were photographed by Stephen Kovacik, Indianapolis Museum of Art:

Plates by number:

3	Pousette-Dart Archives
5	National Museum of American Art
6	Pousette-Dart Archives
7	Pousette-Dart Archives (no. 15)
8	Pousette-Dart Archives
9	Pousette-Dart Archives
16	Emil Ghinger
21	Ellen Wilson
23	Pousette-Dart Archives
28	Lee Stalsworth
29	National Museum of American Art
32	The Museum of Modern Art, New York
48	Private Collection
61	The Detroit Institute of Arts
70	The Museum of Modern Art, New York
76	The Museum of Modern Art, New York
88	Lynton Gardiner, New York
102	Ellen Wilson
106	The Metropolitan Museum of Art

Figures by page:

14, top	Pousette-Dart Archives
14, bottom	*New York Times* Pictures
21	Nina Leen, *Life Magazine*, © 1951 Time, Inc.
22, top	Pousette-Dart Archives
22, bottom	The Phillips Collection
26, top	The Tate Gallery, London
26, bottom	The Museum of Modern Art, New York
28, top	Musée National d'Art Moderne, Centre Georges Pompidou, Paris
33	The Museum of Modern Art, New York
35, top	Scala/Art Resource
35, bottom	Musée Picasso, Paris
74	The Museum of Modern Art, New York
83, top	National Gallery of Art
83, bottom	Pousette-Dart Archives
85, top	Pousette-Dart Archives
85, bottom	Pousette-Dart Archives
87, bottom	The Museum of Modern Art, New York
96, top	The Museum of Modern Art, New York
96, bottom	Scala/Art Resource
98	C. Randall Tosh, Iowa City
102, top	C. Randall Tosh, Iowa City
110, top	C. Randall Tosh, Iowa City
110, bottom	Giraudon/Art Resource
116	Yale University Art Gallery
170	David A. Miller
172–73	Pousette-Dart Archives
178, bottom	Pousette-Dart Archives
179, top left	Pousette-Dart Archives
179, bottom left	Pousette-Dart Archives
179, top right	Tel Aviv Museum
179, bottom right	Max Yavno
180, top left	Pousette-Dart Archives
180, bottom left	Pousette-Dart Archives
180, top right	Pousette-Dart Archives
180, bottom right	The Museum of Modern Art, New York
181	Mal Warskau

Colophon

Richard Pousette-Dart was set in Bodoni,
a modern version of type cut by
Giambattista Bodoni of Parma (1740–1813).

It was printed in four-color process
and duotone as well as bound
by Amilcare Pizzi, S.p.A. of Milan.

The book was designed by Nathan Garland
of New Haven.